GEISHAS
and the
FLOATING WORLD

**Inside Tokyo's
Yoshiwara
Pleasure District**

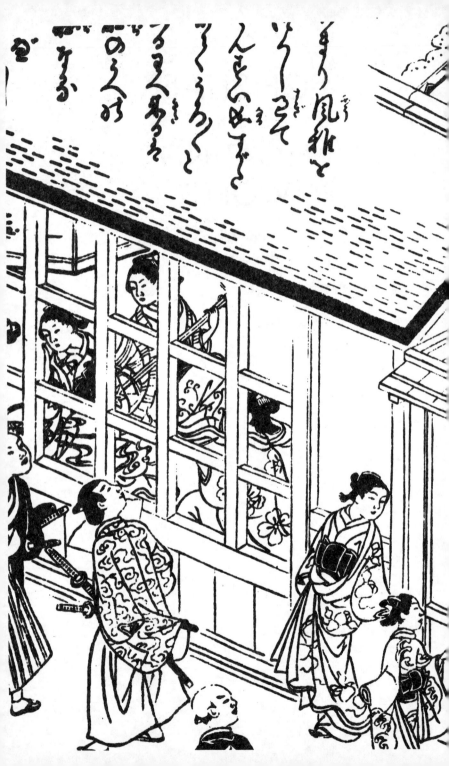

まり風俗と
やう〳〵そ
んをいぬすゝ
てくうろ〳〵と
〳〵る〳〵〳〵
のうくれ
〳〵る
ける
を

GEISHAS
and the
FLOATING
WORLD

*Inside Tokyo's
Yoshiwara
Pleasure District*

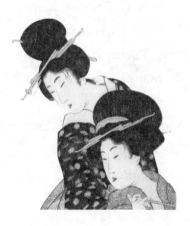

by Stephen and Ethel Longstreet
Introduction by Stephen Mansfield

TUTTLE PUBLISHING
Tokyo • Rutland, Vermont • Singapore

Contents

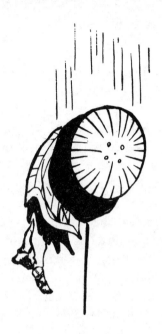

Introduction

Stephen Mansfield

Rumors and superheated accounts of a licensed quarter, where the notions of sin and guilt were suspended in the perfection of advanced forms of sensuality inconceivable in the Judaic-Christian world, had been leaking out of Japan for a long time. The country, feudal in its thinking and structural apparatus, was not quite as hermetically sealed as it liked to think.

With droves of men relocating to the new, de facto capital of Edo (Tokyo) in search of work, a disproportionately male city provided a ready clientele for countless, largely unregulated brothels and bathhouses, the latter staffed by female attendants. Adopting the virtuous ruse that the best method to contain vice was to manage it, Jinemon Shoji, a successful brothel-keeper, presented a petition to the authorities to allow him to establish a legitimate *yukaku*, or pleasure quarter,

one that, by concentrating the flesh trade into a single, easily administrated zone, would lead to the closing down of rival establishments and operations. Striking a suitably outraged tone, Jinemon complained that the unsupervised spread of houses of ill fame was to the "detriment of public morality and welfare." Five years later his request was granted.

The site chosen by the authorities, a mephitic, mosquito-infested marshland to the east of Nihonbashi, was unpromising. Undaunted, Jinemon had the marsh drained, strong walls erected, and a circular moat dug. The prevalence of reeds and rushes lent the quarter its name: Yoshiwara, or Reed Moor. The dismal connotations of the name were addressed by altering a Chinese character and replacing it with an ideogram that could be read as "Field of Good Fortune." The pronunciation of Yoshiwara remained the same.

Like much of Edo, the quarter, rebuilt several times, was the periodic victim of fires. An especially devastating conflagration, known as the *Furisode Kaji*, or "Long-Sleeved Fire," razed the district in 1657, forcing its removal to an outlying area of Nihonzutsumi, a little north of Asakusa's Senso-ji Temple. Edo's interminable conflagrations and other natural calamities endorsed the notion of an indeterminate world, a place of melancholic, but intensely valued evanescence. Adapting the Buddhist concept of *ukiyo*, with its connotations of impermanence, the immateriality of an existence in "which we all suffer," the idea of perpetual pain was extirpated by altering the written character to read "floating world." In the pleasure quarter, this stood for unbridled joy. In the liberal milieu of the Yoshiwara, it was then up to writers and artists to interpret this new approach to life. Author Asai Ryoi did just that in his 1691 work, *Tales of the Floating World*, where he maintained that the true meaning of *ukiyo*, in the contemporary rendering, was "caring little for the poverty facing us

every day, refusing like a gourd floating with the river current, to be disheartened."

Ambivalent feelings about the realities of the flesh trade, its enslavement of young, vulnerable women, have been moderated in the modern age by the stunning works of art and popular literature the Yoshiwara inspired. With a character that was nothing if not theatrical, the quarter provided a vibrant stage for the city's cultural life, an immensely fertile ground for the work of artists, poets, novelists, dancers and musicians. The sybaritic practices of the quarter, the freedoms and social leveling that existed nowhere else, were driven by economic as much as cultural and sexual forces. By the end of the 17th century, the wealth of the merchants far exceeded their lowly social status. In an ironic inversion of the social order, an increasingly wealthy but despised class of traders was now the principal dispenser of largesse in the pleasure quarters, not the socially exalted but impoverished samurai.

As the district catered to all purses, few were turned away from the gates of the Yoshiwara. The impecunious could satisfy their urges in swift, sordid transactions that took place in soiled cribs flung down on reed mats; the affluent could take part in a re-enactment of scenes depicted by the woodblock print masters, participating in languorous, intricate preambles to lovemaking, forms of urbane cultural foreplay and intimacy that would linger until the first rays of morning light, and a gracious, formal parting.

The courtesan's room, a microcosm of prevailing cultural tastes and artifacts, might include an elegant tea set, musical instruments like the koto and shamisen, choice pieces of ceramicware and calligraphy, and copies of erotic prints and love poems. Rarified cuisine was integral to the preliminaries at the higher-ranking houses. Rates depended on class. The most elite courtesans were the *tayu* and *oiran*, a proud and

haughty sorority, followed by the *koshi*. Third, with decidedly less skills and refinement, were the *tsubone*. An even lower order of prostitutes and bathhouse girls were known as *sancha*. The geisha, a practitioner of the arts, whose trade was to ensnare men with her beauty and artistic skills, could refuse a client if he was not to her liking. She was never a prostitute. Often as accomplished as the geisha in song, dance, flower arrangement, the tea ceremony and her knowledge of literary trends, the upper reaches of courtesans might also, in some instances, wield power and influence through their relations with samurai and members of the nobility. The dressing and makeup rooms of the quarter were studios for the manufacturing of elaborate fantasies. They spared little expense in creating a vision of beauty that appeared to be inaccessible, enigmatic and elusive, but could be acquired if the requisite financial transactions were met.

Books on the fashions of the Yoshiwara have left detailed accounts. Camellia oil was applied to the face of a courtesan, a pink surface added as an undercoating before a finishing of white makeup. Drama was added to the ivory visage with the application of black, penciled eyebrows, rimmed with red, a color associated with the erotic. The mouth was painted a bright vermillion, the nape of the neck brushed with white masque. The vision was completed with extraordinary coiffures: black, lacquered wigs, bedizened with jeweled and tortoiseshell pins, and red combs sculpted from the beaks of the kingfisher. These mounted headpieces were similar to those worn by court ladies. Dyed kimonos were embroidered in silk and decorated with flowers and seasonal themes. Undergarments were made from claret- and scarlet-colored silk crepe and purple satin, edged with costly gold and silver thread. In this manner, women were re-created as works of art, figurines in a radiant gallery.

At its most contrived and costly, a customer could expect to pass the night in the company of an exquisitely groomed woman who, in the words of the authors of this scrupulously researched and observed work, was, "alert, graceful, compliant, painted, wigged, as no wife at home ever was." Such goddesses were able to "produce carnal anarchy." Master artists like Harunobu, Kiyonaga, Utamaro and Hokusai created unsurpassed *bijin-ga*, woodblock prints of beautiful Yoshiwara courtesans and geisha. There were also images of kabuki actors, frequent visitors to the quarter. The decision by the authorities to banish kabuki theaters, deemed a risk to public morals, to the relatively remote Yoshiwara district was supposed to make the art form inaccessible to audiences, but by locating the plays in the same area as the pleasure houses, they inadvertently created the most vibrant entertainment quarter in the city.

Judging from the degree to which the popular arts were soaked in the erotic, Edo was a city manifestly fixated on the sexual. The proliferation of skillfully created pornographic *shunga* prints among the largely male populace of Edo was often inspired by life in the Yoshiwara. Less depictions of the growing decadence of the city, these prints celebrated the elegance and subtle eroticism that was possible amid the suffering and squalor of Edo life. Illustrations of tumescent male genitalia producing transports of delight may have been exaggerated, but other details ring true. The half-consumed pots of tea, sweets and sake, fans, leaves of erotic poetry, or an overturned bath stool create scenes of disarray and abandonment. Great care was taken in these prints with clothing, often of a sumptuous, multilayered kind, and the manner in which it was stripped away or left to hang in voluptuous folds. Shunga portrayed customers and courtesans in studies of sexual relations that were fresh and invigorating. One-dimensional prints may have reflected aspects of reality, but the women of the

Yoshiwara were decidedly three-dimensional, achieving, in the case of the most exalted courtesans, an additional visual dimension as idealizations of female sensuality, apparitions of transcendent beauty.

There was a dark side to the pleasure quarter, however, that was less well-documented. Even among the elite ranks of the Yoshiwara, life expectancy was short. Essentially captives, its women were often afflicted by existential anxieties and premonitions, given to lapses of ennui, melancholia and neurosis. Unhealthy, confined lives, sleep deprivation and poor diets led to incidents of beriberi, dyspepsia, tuberculosis, heart disease and alcoholism. Venereal diseases were common even before the arrival of foreigners, whose patronage of the quarter would add alarmingly to the rate of transmission. The unclaimed bodies of women who died in the Yoshiwara were disposed of in the most unceremonious manner, many ending up at Jokan-ji, a gloomy temple located in nearby Minowa, a district where the lower orders resided. It was there that bodies were, literally, tossed over the temple walls, where priests would cremate them and dispose of the remains in unmarked, collective graves. The temple remains a dismal place even today, the earth of the compound damp, the air heavy with mildew and incense.

The Yoshiwara, the city's most celebrated pleasure quarter, staggered on into the last century, more a curio of the past than a vibrant seedbed of culture. It had long lost its art world cachet, and was filled with shabby restaurants, public baths, shooting galleries and penny arcades. Its clientele had changed from a wealthier, discerning patron to a more egalitarian mix of road workers, navies, truck drivers, stevedores and barrowmen from the Tsukiji wholesale fish market. During the final days of the post-war occupation, the Yoshiwara was well-supported by American servicemen.

Smidgens of the old hospitality and grace persisted, but as the Yoshiwara adapted to Western entertainment customs, it became, in the words of the authors, "more and more a curious part of quaint nighttime Japan, and more a nest of ordinary prostitution, with surviving ritual manners and procedures only a veneer for expanded business ventures." Licensed prostitution, which had struck such consternation and much surreptitious interest among foreigners, came to an end on March 31, 1958, though sex industry bosses were able to bribe enough Diet members to ensure that the legislation passed on sex-related work was compromised. The author Arthur Koestler, susceptible to the nostalgia generated by the quarter's cultural role, would write that "old-guard sensualists fought in rage and bitterness to save the Yoshiwara. . . . Men with memories of better times and wilder joys fought the government. But puritanism had come in with TV, Coke and stretch pants." The area where the pleasure quarter once stood continues to exist today in Senzoku 4-chome, a district blighted with the architectural kitsch of soaplands, massage parlors and intimidating-looking doormen and barkers. The sex workers here, more time-driven and cynical, are a mix of older Japanese and Southeast Asian women.

What would the authors of this classic book have made of today's degraded versions of the pleasure quarters? The essential difference between the women who work in today's parlors and pink salons, employees who supplement their incomes as striptease artists or adult video stars, is that the most stunning, artistically accomplished courtesans of the Yoshiwara were icons of high fashion, immortalized by some of the finest artists of the day. Geishas, where they still exist, have become career women with their own investment portfolios. The only thing to have survived from the old pleasure quarter

in today's tawdry version of the floating world is impeccable service and well-practiced flattery.

Despite our reservations concerning the moral propriety of the flesh trade, the quarter supported a connoisseurship of taste that went far beyond carnal dissipation. Ultimately, it is the exalted courtesans, the pampered, arrogant *grandes dames* of the pleasure quarter that we remember, even pay tribute to. Fixed in our collective memories of the floating world are women in towering clogs, white makeup, robes of silk brocade and damask, toenails decorated in vermillion, lips painted in a rouge made from the juice of the safflower or in a gloss of phosphorescent green. The popular novelist Shozan understood the theatrical spell a courtesan could cast, her head "ornamented by a dazzling crown of hairpins made from the finest tortoise shell, which glitter around her head like the lambent aureole of a saint." The acme of fashion, Edo's occasional public parades by courtesans were akin to the appearance of idols, voluptuous apparitions that provided the illusion of transcendental sensuality. The writer Saikaku Ihara left us with a number of vivid descriptions, including that of a procession that took place in 1689, where he glimpsed a courtesan who had "arranged her clothing in such a manner that her red crepe de chine undergarment will casually flap open, revealing a momentary flash of white ankle, or even thigh. When men see such a sight, they go insane."

In the Yoshiwara, men paid ungrudgingly to be in the company of sirens. Even if it ruined them.

Foreword

For over a hundred years the Western world has heard whispers of the pleasure city, Yoshiwara, set behind its walls in the city of Edo itself, which is today called Tokyo. Here was an Oriental Deer Park, the place for the hedonists, the women-seekers, the sensual pleasure-hunters of old Japan. Many myths and legends encircled the secrets of the Yoshiwara, and still do. In time other Japanese cities tried to copy the original, sometimes even calling their district for geishas and courtesans and pretty waitress girls a Yoshiwara.

This book is an attempt to look behind the legends, to go beyond the thousands of images of the posing, dancing, bathing, serving girls that the printmakers sent around the world. We tried to discover the history, identify the founders, habits, rituals, and beauties of the place.

When the tales and the first pictures came to Europe, brought by travelers, Navy personnel, and dealers in china and art objects, they created a romantic cult, a dream far from reality. Essays were written by bemused writers admiring the images of the women of the East drawn by the masters of the prints and their followers. European artists like Whistler and Beardsley were influenced by their style and began to collect the blue porcelain observed in such works. Fashion designers and decorators moved to merge its graceful patterns with *art nouveau*.

The mode of living that lay behind all this excitement was not discovered or even desired. The surface glow was enough. The secrets of the Yoshiwara remained secret but for the descriptions of a few daring travelers who penetrated the place itself, insisting—in their reports—that they went to

see and not to indulge themselves.

Before details are lost or buried in specialists' files, it seems time to produce this book, and to publish prints that illuminate the text. This is not a history of Japan, its arts, or its traditions, but a great deal of that is here, as it touched the lives of the women slaves of the Yoshiwara.

Thirty years ago we bought a Japanese color print of a grand courtesan parading in her brocaded silk, with iridescent decor, escorted by her maid, a work of the artist Kunisada. It was a poor, late period print, over-ornate, over-colored with garish dyes, and too cluttered with detail. But it was the beginning of an education in the mysterious condition of pleasure women in Japan, in the art and social history of so much of their lives, their passions, their tragedies. Our collections of prints and scrolls, sculptures of geishas and courtesans, and books which our society considers erotic later filled many shelves. Then it occurred to us that a study of the women of the Yoshiwara and a history of the place itself would be a fascinating project.

We were friends for many years of the late Judson D. Metzgar—certainly the most knowing expert on prints of the geishas and the courtesans, the *oshaku* (dancers) of Kabuki, the green-tea houses. We began to form a plan and develop sources of original texts. We hunted out various publications (and they are few) on the subject, in both Japanese and other languages. We have illustrated this book from these collections, much of it the work of Hokusai, Utamaro, and their schools.

This book, created for the general reader, contains material that the student and the specialist of Japan may also find of interest, but it makes no claim to be a definitive text. Rather, it is a social history of a special place with some of the customs of a society that in morals, manners, and sexual

patterns differs a great deal from our own—or once did. The world of the Yoshiwara, the charm of the true geisha, the grandeur of the courtesan, the pitiful condition of the slave prostitute, the grasping keepers and owners of the teahouse brothels are now gone.

We have tried to avoid the impressions that hasty popularizations of the history of women in Japan have given out and that the modern Japanese has been too eager to accept in his desire to be just like us. We have sorted out documents, texts, and prints that would bring into clear focus an era that no longer exists except on paper and on old walls. We give a history of the Yoshiwara, a set of dates, and investigate sexual habits, traditions, and conditions—all merged in an enclosed pleasure park of the city of Tokyo, called Edo not so long ago.

The period covered is from the 17th century to just after World War Two.

Few Westerners have really penetrated the world of these women and their way of life, beyond the brief sorties made by banal visitors. We are left to think of the geisha and courtesan as an ornate work of art, a coif stuck with jeweled pins. Women of Japan, to many, are still legend and comic opera—pretty colored costumes, more dream than truth. We think of "three little maids are we" in Gilbert and Sullivan's *Mikado*, but is there any hint they would actually have been prostitutes, held in slavery, trained since childhood in the trade and not just pretty characters given to Victorian rhyming and extravagant grimaces and gestures? Or we remember Lafcadio Hearn's polite tales and ghost stories. For we hear strains of the opera *Madame Butterfly*, the extravagantly exquisite and tragic love of a geisha for a U.S. Navy man (never the East and West shall meet, but in song).

Some of our vision is marred by the memory of Pearl Harbor, the warlords and the double-dealers in high hats. But

postwar entertainments in Technicolor brought back the old dreamlike mood, as in the film Sayonara, which presented images of polite and willing slave-like girls thanking us "Ah so!" for their defeat. And tourists go on to find rock and roll, baseball, hot dogs, and young people who have become like ourselves, materialists, gadget prone.

In these Western visions, we have never seen the Yoshiwara. Lost are the splendid geishas, the grand courtesans, the waitress girls of the prints of Harunobu, Toyokuni, Utamaro, Hokusai, and others of the recent past. In the jet age, it is difficult to fit the Yoshiwara into our picture of modern Japan.

Japanese Events Concerning the Yoshiwara

660 B.C.	Legendary founding of Japan—Emperor Jimmu
300 B.C.	First of the Yamato ruling line.
	Shinto religion established.
594 A.D.	Buddhism set up as the state religion.
710	Empress Gemmyo sets up capital at Nara.
794	Capital moved from Nara to Kyoto.
858	The Fujiwara family rules Japan through the Emperor.
1002	Lady Sei Shonagon writes her *Pillow Book*.
1008-1020	Lady Murasaki writes the novel *The Tale of Genji*.
1191	Zen Buddhism comes from China.
1192	Yoritomo is given the title of Shogun—Dictator of Japan—at Kamakura.
1205	The Hojo shoguns take over rule of the country.
1253	Nichiren Buddhism established in Japan.
1333	Emperor Godaigo takes back imperial rule.
1338	Muromachi shoguns take over the country.
1543	First Portuguese arrive, bringing firearms to Japan.
1570	One port, Nagasaki, opened to foreign trade.
1603	The Tokugawa shoguns (1603-1867) take over rule of Japan, set up a new capital of Edo (later called Tokyo).
1609	Dutch established as traders; Portuguese driven out. Brothels scattered throughout city of Edo.

Japan from the Yoshiwara Period to Its End

1612	Shogu Jingemori petitions for all brothels to have their own district in Edo.
1617	Petition granted for the Yoshiwara district.
1626	Yoshiwara completed November 28th.
1656	Yoshiwara ordered to move to site near Nihonzutsumi district.
	Old Yoshiwara burns down.
1657	New Yoshiwara opens.
	First black-and-white prints of Yoshiwara.
1789-1800	New classes of brothels and courtesans established.
1814-1825	Japan fully closed to the world.
	First colored prints of Yoshiwara.
1853	Commodore Perry, U.S.N., and fleet arrive at Uraga, Japan.
1854	Second visit by Perry.
	U.S.-Japan Kanagawa agreement signed.
1855	Great Edo earthquake.
1859	Ports open to foreign trade.
	Foreigners visit the Yoshiwara.
	Prints of geishas, courtesans, and foreigners appear.
1867	End of shogunate rule.
	Emperor Meiji on throne.
1868-1900	Many brothels and teahouses adopt Western furniture and costumes for a time.
1873	Universal military service.
	Yoshiwara visited by country recruits.
	Great classic prints of geishas and courtesans.
1879	Ex-President U. S. Grant visits Japan. Some members of staff visit Yoshiwara.

1894-5	Sino-Japanese War.
	Yoshiwara crowded.
1899	126 brothels are listed in the Yoshiwara.
	Last of the traditional prints of geishas and
	courtesans became highly colored and wild.
1904	Russo-Japanese War.
	Yoshiwara becomes one of Tokyo's sights.
1912	Death of Meiji Emperor.
	Decline of geisha culture.
1920-1935	Invasion of China by foreign powers.
	Yoshiwara becomes a facade of the past.
1945	End of U.S.-Japanese war.
	Japanese women become Westernized.
1959	After protest by traditionalists, the Yoshiwara is
	abolished.

Acknowledgments

While it is always impressive to list many works and persons that have in some way been of help in writing a book, the list for this one would be too long, and perhaps too impressive. As our reading and collecting goes back thirty years, the references would soon be longer than the book. We try to mention in the text the source of most of the material we quoted directly, though sometimes the authors are anonymous.

However, we must set down a few of the sources that have been most helpful.

Judson D. Metzgar, the noted collector of Japanese prints, erotic or historic, taught us a great deal about the artists and their subjects. Part of his collection we now own. The collections of the Bibliothèque Nationale, the Boston Museum of Fine Arts, the Library of Congress, the Fogg Museum, the Metropolitan Museum of Art, the Nezu and Nagoo Museums, the Tokyo National Museum, the Koryu-ji Museum of Kyoto, and the Bunkakan in Nara were outstanding sources. Two private collectors of exotic texts and outré graphic art related to the women of the Yoshiwara asked not to be named.

Thanks are due to Yamamoto Otsuka, who helped us in the translation of the Japanese poetry and texts, who hunted down clues to material unknown in the West, and who brought us the manuscript of Shogi Okada.

Books that have been of special help to fill in the historic background of the world of courtesans and their guests are: *History of Japan,* Engelbert Kaempfer; *Maker of Modern Japan,* Arthur L. Sadler; *Chats on Japanese Prints,* Arthur Ficke; *Estampes Erotiques Primitives du Japon,* Shibui Kiyoshi; *250 Years of Ukiyo-e,* Takahashi Seiichiro; *The Nightless City,* Joseph

DeBecker; *Japanese Theatre,* Faubion Bowers; *The Tale of Genji,* Shikibu Murasaki; *The Western World and Japan,* George S. Sansom; *Japanese Thought in the Meiji Era,* Kosaka Masaka; *Japan Since Perry,* Yansaga Chitoshi; *The Black Ship Scroll,* Oliver Statler; *A Daughter of the Samurai,* Etsu Sugimoto; *Le Theatre Japonais,* Iacovieff and Elisseef; *The Love Suicide at Amijima* (tr.), Donald Shively; *Heike Monogatari* (tr.), A. L. Sadler; *Japanese Literature,* Donald Keene; *With Perry in Japan,* diary of Edward McCauley; *Journal of Townsend Harris;* the writings of Ernest Fenollosa, Lafcadio Hearn; *Utamaro, le Peintre des Maisons Vertes,* Edmond de Goncourt, and certain catalogues of items for sale in "sex shops," many active until recent times.

We have earnestly attempted to give credit to original old sources wherever we could, and have, of course, made great efforts to avoid errors. They will occur, and they are ours, not those of the people and institutions that have been so helpful. In some cases we have been unable either to name or date popular folk poetry.

Living only for the moment, giving all our time to the pleasures of the moon, the snow, cherry blossoms and maple leaves. Singing songs, drinking sake, caressing each other, just drifting, drifting. Never giving a care if we had no money, never sad in our hearts. Only like a plant moving on the river's current; this is what is called *ukiyo*—The Floating World...

Tales of the Floating World
Asai Ryoi, 1661

Be prepared for the fact that in Japan there is no sin, Original or otherwise...

The Kimono Mind
Bernard Rudofsky

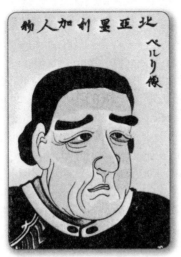

Commodore Perry; unsigned.

When I no longer exist
Will I remember
Beyond this world
Our last time together?
—*Anonymous*

CHAPTER 1 Perry Opens the World of the Yoshiwara

It was in 1853 that the outside world, crass, material, adventurous, broke into Japan and heard the shockingly delightful details of the Yoshiwara, a city of women kept for men's pleasure.

For 250 years, heavy with crests, surrounded by shouting swordsmen, the Tokugawa shoguns—"barbarian-destroying generals"—had ruled the nation and kept it a closed country. The Emperor, a direct descendant of the sun itself, was powerless. He lived with placidly loyal nobles and concubines in a golden court in Kyoto.

There were five kinds of people in the land: the *daimyo*, lords; the samurai, warriors; the farmers; the newly rich, vul-

gar merchants; and the craftsmen or artisans, which included the actors, printmakers, writers, and the geishas and courtesans. The leaders of the Tokugawa shoguns were the *bakufu,* a military governing council, which ruled in the name of the Emperor, while keeping the Emperor himself a harmless figurehead to be respected.

There was no outside contact with a dim, far-off world but for some Dutch traders confined to a small offshore island next to Nagasaki. All other foreign influence was repelled with violence and sealed off. So the samurai and their lords sat content, not realizing that the trader and merchant class had, over the years, been busy acquiring the wealth of the land, along with a growing desire for pleasuring with the grand courtesans and seeking all the joys and comforts they could buy in the geisha houses. They patronized the artists and the actors, who were beginning to mock slyly, with expressionless faces, the iron-armored strutters with their two swords and ribbon-tied topknots. They kept the most famous of the courtesans, and hired the best geishas for their orgies.

Edo (afterward called Tokyo) was then a great city. Rice, drunken pleasure, and women, as well as business, were Edo's reasons for existence. The country people said of the place, "A true citizen of Edo never keeps a coin overnight in his pocket."

A 17th-century Dutch traveler wrote of Edo:

What tends to promote luxury, and to gratify all sensual pleasures and diversions, may be had here at as easy a rate as anywhere. The town is a universal theatre of pleasures and diversions; plays are to be seen daily both in public and private houses. Mountebanks, jugglers who can play some artful tricks, and all show people who have either some uncommon or monstrous animal to display, resort thither from all parts

of the Empire, being sure to get a better penny here than anywhere else…. Some years ago, our East India Company sent over from Batavia a Casuar—a large bird who would swallow stones and hot coals—as a present to the Emperor.

Once a year, an envoy of the Dutch was permitted on the mainland to visit the shogun's palace at Edo—the Hall of the Hundred Mats.

After being compelled to make many degrading obeisances, to crawl on his hands and knees… then, kneeling, he bows his forehead to the ground, and retires, crawling backward, without being permitted to look up or utter a single word.

Then the day came when, with four black ships, another envoy, flying a flag of stars and bars, was approaching—one who would not kneel, bow, make obeisances, or crawl backward. He was not given to cajoling flattery.

On a July day, the 8th, 1853, the United States steam frigate *Susquehanna,* with over a hundred cannon run out of its ports, carried Matthew Calbraith Perry, Commodore of an Orient invasion fleet. The squadron included not only the *Susquehanna,* but the steamer *Mississippi* and the sloops-of-war *Plymouth* and *Saratoga.* They rounded Cape Sagami, saw the snow-topped sacred mountain, Fuji, and faced the great bay of Edo.

The drums and fifes played General Quarters. Officers took battle stations; cutlasses and pikes appeared on holystoned decks. U.S. Marines formed ranks; fire-control crews stood by at the ready; and the pumps were manned.

They were there to burst open the locked doors of Japan —that group of secret islands. The Commodore had come officially from a nation that spoke of its "Manifest Destiny,"

with orders to negotiate a treaty of commerce (and "friend-ship"), and the Secretary of State had added: "Make no use of force except for defense, if attacked." An ironic order—the Commodore was empowered to decide what would or could be defined as "attack."

The invasion fleet (already called by the shore-watchers "the black ships of evil men") dropped anchors under Fuji. The flagship signaled "No communication with shore; permit none from shore."

It was 5 o'clock in the afternoon; the tidal suck rolled the warships slightly as dozens of small Japanese ships crowded around; and when the natives tried to board, pikes and bayo-nets fended them off.

An official-looking boat appeared with a Japanese aboard who spoke some Dutch, so it took a Dutch-speaking sailor to insist the Americans "could confer only with the highest in rank." When a Japanese "Vice-Governor" appeared, the Commodore ordered the crowd of other Japanese boats to withdraw, or his gunners would open fire. Perry won that concession. The first of many. There was a hint of savagery in his orders.

That night, the Japanese manned their shore forts, sent up rockets, and lit beacon fires. By morning, there was a con-ference with the "Governor" of the district (there were de-vious depths in Japanese titles), Kayama Yezaimon, on the flagship.

Delays and threats were made, and only by the 14th of July did the Americans come ashore at Uraga to face 5,000 Japanese soldiers. Ashore, too, came 200 American sailors and Marines, 40 officers, and 40 musicians tootling and drumming. The Commodore (his officers insisted he meet the color and pomp and noise of the natives) came ashore all gold buttons

and braid, sword and epaulettes in place, and to his own thirteen-gun salute. He claimed, wrongly, to be the "highest-ranking officer in the U.S. Navy," and the Japanese hissed and called him "Admiral."

The ships' guns were loaded, and, wrote an officer, "Any treachery... would have met with serious revenge."

No need for that. The ship's band blared out "Hail, Columbia." Letters and credentials were presented, translations made. Good. So. The Japanese blandly said, "As your letter has been received, you can now depart."

The Commodore said he would be back the following year with a larger fleet. Wrote one of his officers in his diary, "Thus closed this eventful day, one which will be a day to be noted in the history of Japan, one on which the key was put into the lock, and a beginning made to do away with the long seclusion of this nation."

The Commodore was made of sterner stuff. As an observer put it, "The islanders knew they were in the talons of an eagle." Perry wrote to inform the Japanese regent and his council that it would be wisdom "to abrogate those laws and customs which are not suited to the present age."

Upon departure, Commodore Perry added—much like later armed Americans in Asia—that he was there only to obtain "a perfect permanent and universal Peace." *Ah so!*

It was a strange land for Americans to witness for the first time: holy myths, samurai codes, and a confusing history.

In the eight days spent in Japan, the Commander and his staff must have had some hints of courtesan and geisha "customs." Such sexual practices—frowned on publicly, at least by Americans—were to fade gradually from the scene by the 20th century, but would retain their ritual native patterns for some time. The remnant of the Yoshiwara finally disappeared,

but not prostitutes, not commercial sex. As for the geishas, a contemporary news report states:

> Though Tokyo's 600 aging Geishas still keep up their tradi-
> tional routine—the three daily sessions in the public baths, the
> facial massage with costly nightingale dung, the rubbing of the
> feet with pumice stone—their number is steadily dwindling.

What was to hold the most interest for the invaders and those who followed them (so often New Englanders, descendants of Puritans and hell-fire preachers—people sex-shamed, sex-haunted) was the institution of the Yoshiwara, the moat-surrounded pleasure section of Edo. It was a city in itself with its prostitute slave girls, grand courtesans, green-tea houses, and brothels, its Lolita waitress girls, geishas, and other entertainers. All were there to amuse, to excite the sexual proclivities of any Japanese male who could afford their services, skills, and attractions.

The institution of Yoshiwara—for the American soon called all pleasure districts in Japanese cities by that name—shocked the invaders and those who followed them. They neither understood the Japanese sexual mores, nor tried to. But this did not, in most cases, keep them from becoming patrons of the courtesans and geishas when they could. They failed to see fully that everything in Japan was part of the whole, the sexual pattern, the art of the screen, the Harunobu, Utamaro, Hokusai woodcut prints, the elaborate manners of conduct, the Shinto-Buddhist rituals, the very act of *cha-no-yu* (tea ceremony) or *ikebana* (arranging flowers).

Set in a stern Hebrew-Christian piety, the Americans were stunned to find girl-children sold into brothels, together with festivals of blossoms, gay and wonderful costuming, the crab armor of the samurai (who could cut down a commoner with-

out punishment, just to test a swordblade). All was set rigidly in a social, national, religious culture that determined the proper deportment. The invaders could not adjust to such a way of life—the island scheme of things: One must not gaze directly at the Emperor; one must accept the proper place of even the lowliest prostitute.

The Americans, being sinning males, soon became well acquainted with the famed geisha and courtesan houses along the river Sumida. A geisha party that meant soft glow from many-colored lanterns, the dissonant sounds of the samisen, a mossy garden with elegant trees, a banquet with pickled sea-urchin eggs, green tea, dried seaweed, bonito entrails, mushrooms, and cuttlefish served with maple leaves and chrysanthemums. After all, it presented the courtesans and the geisha girls themselves, in lacquered wigs and colorful kimonos, sake from porcelain vases; bone-white, powdered, painted geishas performed slow and discreet dances, sang their sad, seductive love invitations:

> On the piled high snow
> The night rain.
> —*Akimokyo*

The courtesans came with their maids to offer their skills, their knowledge, their bodies to the "white devils," these barbarians who had broken in on their isolation.

The Great Gate: Hiroshige, 1797-1858

There in the reed marsh
The bird sounds in sorrow
Can it be remembering
Something better to forget?
—*Folk poem*

CHAPTER 2 The Pleasure City

At the beginning of the 17th century, a wild new time was settling into a new city. Ieyasu, the first of the Tokugawa shoguns, in the beginning of his reign, had gone to the bare lands near the east coast. Ignoring the older traditions of the city of Kamakura, he built his capital on a reedy marsh where there were no hills, at the site of a tiny village called Edo. A great moat was dug, and the small stone castle already there was greatly enlarged. It was not long before there was the business district of Nihonbashi, a grand park at Ueno, shops, theaters, and jugglers at Asakusa, the Yosukuni shrine.

At first, courtesans and brothel-keepers had no fixed district. A petition was presented to the shogun to permit the creation of a *Keisei-machi* (courtesan's quarter), but it was rejected with the monosyllabic reticence of absolute power.

In 1612, an assignation house and brothel-keeper, one Shogu Jingemori, again asked for a special district, stating his case piously:

> Houses of ill fame, of prostitutes, are scattered all over our city, oh here and there in all directions. This, for good and proper reasons, is harmful to public morality and welfare…. As things stand at present, when a person visits a whorehouse, he may hire and disport himself with *yujo* (courtesans) to his heart's content, give himself up to pleasure and licentiousness so much he is unable to discriminate as to his social standing and fortune, or prevent the neglect of his occupation or business. He may often stay in a brothel for days on end, giving himself up to lust and revel. As long as his money holds out, the keeper of the house will continue to pleasure him as a guest. In consequence, this makes for neglect of duty toward masters, embezzlement, theft and more… . Still the keepers of the whorehouses will allow guilty ones to remain at their pleasures as long as the money lasts.
>
> Although it is forbidden by law to kidnap children, yet, even in this city, the practice of kidnapping female children and enticing girls away from their homes under false pretences is being resorted to by certain vicious and unprincipled rascals.
>
> It is a positive fact that some evil-minded persons make it a regular profession to take in the daughters of poor people under the pretext of adopting them as their own children, but when the girls grow up, they are sent out to service as concubines or prostitutes, and in this manner the individuals who have adopted them reap a golden harvest.
>
> If the prostitute houses be all collected into one place, strict enquiries will be made as to the matter of kidnapping and as to the engagement of adopted children, and should any cases occur in which such reprehensible acts are attempted, information will be immediately given to the authorities.

Although the condition of the country is peaceful, yet it is not long since the subjugation of Mino province was accomplished, and consequently it may be that there are many ronin [lordless samurai] prowling about seeking for an opportunity to work mischief.

The brothel-keepers will pay special attention to this matter and will cause searching enquiries to be made about persons who may be found loafing in the prostitute quarters. Should they discover any suspicious characters, they will not fail to report the same to the authorities forthwith.

It will be deemed a great favor if the august authorities will grant this petition in the fullness of their magnanimous mercy.

Shogu Jingemori, good citizen that he was, continued, pointing out that a special district for brothels had special virtues. In staccato bursts of logic, he wove his tenacious reasons on a scroll in good black ink brushwork for the shogun's officials to think over. The idea was taken under consideration in due time, and in 1617, Shogu was told that a prostitute quarter could be set up, a *Fukiya-machi*.

Afterward, the relenting judgment of the first Tokugawa shogun was told in the *Legacy of Ieyasu*:

Virtuous men have said, both in poetry and classic works, that houses of debauch, for women of pleasure and for streetwalkers, are the worm-eaten sports of cities and towns. But these are necessary evils, and if they be forcibly abolished, men of unrighteous principles will become like raveled thread.

Prostitutes were ordered to stay out of the rest of the city, and he, Shogu, was to be *Keisei-machi Nanushi*—Director of the Courtesan Quarter. A few ground rules were set up, and in the main they were followed. Architecture was prescribed,

and at the same time the shogun's government took the opportunity to check on its enemies:

> Brothels must not be built of too imposing an appearance, and the inhabitants of the prostitute district shall have the same duties to the city as firemen or any other ordinary residents in other parts of Edo.
>
> Proper enquiries shall be made of any visitor to a brothel, no matter whether he is a gentleman or ordinary citizen. In case any suspicious individual appears, the information shall be carried to the *Bugyo-sho,* Office of the City Governor.

There was joy and much sake in the flesh trade. The land set aside for the site of the pleasure district was a low bog, grown over with reeds and rushes, filled with frogs and insects. Shogu was a skilled promoter and a quick worker. The swamp was filled in, a moat dug, and a tall wooden wall put around it.

It was the reeds and rushes that first named the place—Yoshiwara, Reed Moor, but a slight change in Chinese brushwork and the two Japanese characters that spell out "Reed Moor" resulted in the words "Joyful Moor," still pronounced Yoshiwara. The entrepreneurs found the second meaning of the name more pleasing to the guests.

By the tenth month of the third year of *Kan-ei*, the 28th of November, 1626, the Yoshiwara was in confident working order, inhabited by geishas and courtesans and doing business. Merchants, samurai, actors, and artists came to the green-tea houses, tickled the *kokyo*—courtesans in training—and went to frolic with their mistresses.

Forty-four years later the land was needed for official buildings of another nature. The Yoshiwara managers were told they would have to take up the bedding and teapots and move elsewhere, to outlying Nihonzutsumi. There was much more

space there, and while the old place kept only daytime hours, at the new site the district was to be truly libertine—with day and night pleasures, and no closing hours. Also whoring was abolished in rival places where prostitutes had been procured, such as the five hundred bathhouses in the city—where sinliness was next to cleanliness. Besides which, the people of the Yoshiwara were to be free of certain duties, such as acting as firemen in times of conflagrations. And 10,500 *ryo,* an impressive sum of money, was granted to assist in the great cost of moving and rebuilding. But there was a Japanese saying: "One must create chaos to make a world."

Fire was the great disaster, brought on sometimes by earthquake, but usually by careless accidents with charcoal fires or by overturned lanterns or lamps.

The *Moto* (Old) Yoshiwara had shared the flames. It burned in 1646 and 1654. Built of wood and paper panels, matted with rush, roofed with straw, it burned quickly. The courtesans, geishas, maids, and servants fled with bundles, rolls of cloth, pets, crickets, whatever could be carried out. Firemen could do little but halt the spread of flames. The fear of fire was always present in the Yoshiwara.

However, the great fire of 1657, the *Furisode kaji*—Fire of the Long-Sleeved Garment (disasters had poetic names in those days)—made moving easier.

On March 2, 1657, flames broke out in the Hommyo temple in Hongo and went through the city of Edo like a dragon, raging for three days and three nights. Nearly 110,000 people lost their lives, and Yoshiwara vanished. Of those who had died in the fire, the priests said, "We are a remarkable people, and death is not the end for us as for other people."

The story is that the fire was started by a priest of the temple, in a nonconformist frenzy, attempting to burn in a

brazier a garment supposed to be unlucky. A wind came up, blew the blazing garment to the wooden ceiling, and spread the fire to burn down the city.

By September of 1657, the *Shin* (New) Yoshiwara was finished. Close by, just a teacup's throw away, was the Asakusa temple. Pictures of the period show the monks visiting the brothels wearing rush baskets called *amigasa* on their heads to keep from being recognized.

Streets were named after the number of green-tea houses, such as *Gojukken machi* (Fifty-House Street). The entrance area to the place was *Omon-guchi* (Entrance to the Great Gate), and the gate itself was the *O-Mon* (the Great Gate).

The new Yoshiwara was twice as large as the old one. About 18 acres of ground, 1,075 feet north to south, 715 feet east to west.

For self-indulgent guests, there were five streets surrounded by a moat and given over to shops that soon became *cha-ya* (teahouses).

Another fire got started in the bathhouse of one Ichibei as he heated the water in January of 1677, and down went the place again to soot and ash. Girls fleeing, chilly again; bare feet kicking, arms full of poor treasures. During that same year, a heavy rain put out another fire, and only part of a street was destroyed.

Only doctors could enter the Yoshiwara riding in a sedan chair or palanquin. All others came on foot. Swords and daggers always were forbidden, so (as in American Western films) weapons were parked with attendants. The romantic reason is that the drunken samurai might go chopping about him. And A. B. Mitford, in *Tales of Old Japan,* states that "it is known that some of the women inside so loathed their existence that they would put an end to it, could they but get hold of a weapon."

The Japanese writer Ochi Koji gives us a more cheerful picture in a poem attached to the Great Gate:

> A dream of springtide
> When the streets
> Are full of cherry blossoms.
>
> Tidings of autumn
> When the streets
> Are lined with lighted lanterns
> On both sides.

The scene is recalled in an 18th-century text:

Tidings of the autumn when the streets are lined on either side with lighted *toro* (lanterns), refer to the custom of hanging lanterns in front of every teahouse in the Naka-no-cho during one month from the first day to the last day of the seventh month (old calendar). These *toro* were first hung out as an offering to the soul of one Tamagiku, a popular courtesan in olden days. When one enters the great gate at the time of this festival it is a very pretty sight to see the rows of lanterns after they are lighted up.

Some of these lanterns bear pictures by celebrated painters and are therefore quite works of art, and the effect of the display is heightened at times by artificial flowers being placed between them. It is said that the approach of autumn is heralded by the cry of the wild geese, but that is also foretold by the display of lanterns in the Naka-no-cho during the festival of the dead. The sight of these lanterns moreover reminds the sightseers of the words of an old poem which runs: "Alas! it is the night when the dead Tamagiku comes to visit the *toro.*"

Almost a century after the fire of 1677, the Yoshiwara burned down again, in 1768. The same thing happened in 1771, 1772, 1781, and 1784—but why go on? By the end of the 19th century, there were at least twenty more great fires.

Through the thousands of woodcut prints, guidebooks to the Yoshiwara, and histories we can picture the place before Perry came.

The last of the night-revelers are moving toward *O-Mon*, the Great Gate. Here the watchmen stand to prevent escape of the women, prisoners of over a hundred and fifty brothels and four hundred teahouses—hundreds of carefully trained geishas and several thousand courtesans.

Fat, drunken men with shaved heads are firmly held up by the strong arms of pleasure-house servants. The poet Kyorai wrote with the wisdom of a man with a hangover and empty pockets.

> The night was cool
> I got stiff joints
> And went home…

Hiroshige has a famous print of the scene (at the beginning of this chapter). The head watchman, some old scarred samurai, is bowing, for perhaps some of the drunkards are from the shogun's castle, as the crested but rumpled robes show. The gray-haired head watchman looks on. He is an old ronin, an outlaw samurai whose lord has been killed in battle.

Other artists' prints set the scene: The sun rises higher. In a long line the teahouses and pleasure houses remain silent after a night of music, dancing, food, refined and detailed debauchery. The only things alive are wood and charcoal fires, lit by some early risers, a cat moving with disdainful dignity between puddles, a servant running with a covered tray from some eating place. Otherwise, the floating world of Joyful Moor sleeps, weary, drugged by sake and other bought pleasures. Along the main center street, the Naka-no-cho, flowering cherry trees scent the morning. The bright blossoms are already falling from the trees, trees that never bear fruit. Behind the high fences that

separated the establishments, nodding fawn-pink and peach-pink blossoms contrast brightly with the weathered timber.

The life of the place still seems to exist, as we turn the pile of colored pictures, prints so prized now, once considered a vulgar folk art. They were created for the Yoshiwara customers at first, and then for those of the Kabuki theater. Those who patronized the Yoshiwara also made the Kabuki popular. The connection was close. The actors themselves spent a great deal of time in the Yoshiwara—and the geishas and courtesans were great patrons of theater and admirers of actors.

Gentlemen came to the Yoshiwara in litters or palanquins, but as only a hundred of these litters were for public use, many guests came on horseback. Styles change—litter and horse travel went out of fashion in the Meiji period in the 19th century. New styles came in. The *jinrikisha*, or rickshaw, took over. The rickshaw men were pushers and active touts for the brothels. They would stop men on the street and ask, "*Danna, naka made ikaga desu Yoshiwara?* (Boss, how'd you like a trip to the Yoshiwara?)" One had to bargain over the cost of transportation, set a proper fee. Then, grasping the shafts and his lantern, the puller was off, rushing a prospect to his destination.

For faster travel, or with a fat customer, a pusher would be added to the puller, and so three times the fee was demanded as one man had to make his way back with no rickshaw to pull for hire. The brothel keeper paid the puller a fee for steering a guest to him, and then added it to the guest's bill. Shady rickshaw men steered country folk to clip joints, and some even robbed passengers.

The fame of the Yoshiwara began with the opening of Japan to the modern world. Though it flourished and even expanded at times, it began to lose its romantic overtones, never to be fully reestablished.

With customs changed to imitate the Western world, the Yoshiwara became more and more a curious part of quaint nightime Japan, and more a nest of ordinary prostitution, with surviving ritual manners and procedures only a veneer for expanded business ventures.

By the beginning of the 20th century, the Yoshiwara was no longer exclusive and privileged. The city had prospered, and Yoshiwara had become only one of six licensed quarters. Other pleasure sections were Susaki, Shinagawa, Shinjuku, Itabashi, and Senju. The Yoshiwara, being the pioneer, was the largest, and the one visitors most wanted to see.

Not all travelers got their impressions from such books as *Madame Chrysantheme* or *Madame Prune,* by such chic writers as Pierre Loti. In the 1920s, in strange and entertaining English, a certain T. Fujimoto issued a guidebook to the sporting night life of Yoshiwara.

When you enter the gate you come into a broad street, on both sides of which you see regular rows of two-story houses. The street is called Naka-no-cho (Middle Street), and all these houses on both sides are called *Hikite-chaya* (guide houses for the visitors). You would hear the mellow tune of samisen and the sound of drums flowing down from the upstairs room of some of these houses.

You go on along one side of the street and find many houses, whose front consists of a large room, and the street side of the room is protected with wood lattice; you may call it their "show-rooms." In the room, girls dressed in red and purple sit down in a row, exposing their painted faces for onlookers thronging by the lattice and shamelessly smoking their long bamboo pipes.

Two young men of student style come along to an establishment with a "showroom." A girl in the room finds them out, calls the name of one of the two, and they approach the out-

side of the lattice. She and another girl, both being in intimacy with them, come near the lattice and persuade them to come up into the house. The young fellows smoke the pipes given by the sweethearts, and at last are obliged to accept their entreaties. They turn for the entrance and disappear; the two girls go out of the room at the same time to attend their fellows.

You go on further and arrive at another street, *Kyo-machi*. It is the most prosperous and bustling street among others, and beautiful girls are collected in the second-class houses of the street. You notice in the throng restaurant boys carrying boxes of dishes, or maidservants hurrying away with bottles of sake. Looking into the shops and criticizing girls, you come round at another end of Naka-no-cho.

Spring and summer nights are the most flourishing seasons in Yoshiwara throughout the year. In spring, several hundreds of cherry trees are planted in the street of Naka-no-cho, and all the branches of the trees in full blossom are illuminated with thousands of small electric lights. At the foot of the trees, paper lanterns, each held on the top of its leg, about one yard long, are lighted, forming a regular line-like fence around the ground of cherry trees. When the night breeze blows the blossoms, it is a very striking view to see white petals falling down like snowflakes over the lanterns.

Toward evening the male and the female on their way back from picnic to Ueno and Mukojima (the two places most famous for cherry flowers) pour in here to see the night cherry flowers of Yoshiwara. Specially wives and girls like to visit Yoshiwara in this season, because it is the best opportunity for them to have a full observation on brothels and harlots, as they can go round the brothel streets in company with their men.

Even in 1920, Yoshiwara was still Yoshiwara, the streets, the lanterns, the flowering trees were the same in old manuscripts,

in the prints of the 18th and 19th centuries, and in the awkward English of the 20th-century guidebook.

There were those Japanese—inclined toward the West, even educated in Europe and America—who felt that the Yoshiwara was hardly the place to introduce Westerners to the native culture. In the late 19th century they set up a kind of rival to the Yoshiwara, an institution where visitors to Japan and Japanese could mix on a polite social level.

The proper London *Times Literary Supplement* took notice of this genteel rival to the Yoshiwara: "At the beginning of the 1880s the Japanese Government commissioned a British architect to design a spacious building in Tokyo to be known as the Rokumeikan, the Hall of the Baying Stag, or the Deer Cry Pavilion. Opened in 1883, the Rokumeikan was intended to be the place where Japan's leaders might enjoy (in the words of the Foreign Minister) social intercourse with foreigners upon a grand scale."

At first this laudable intention seems to have been realized. On gala nights at the *Rokumeikan,* Ministers of State and former *daimyo,* correctly attired in swallowtail coats and black waistcoats, danced with the wives and daughters of foreign diplomats. It was all white ties and bustles (for Japanese ladies did not wear kimono at the *Rokumeikan*), as in a drawing by George Du Maurier. The entire venture, in fact, was part of the government's campaign to prove to Europeans and Americans that Japan had become a modern civilized state. After a brief moment of glory, the Deer Cry Pavilion lost favor among the Japanese as a fashionable rendezvous.

The Yoshiwara continued to prosper. It was Mark Twain who was supposed to have said, "You can't beat sex if you're looking for pleasure."

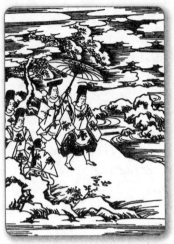

A high lord on his way to Edo; unsigned, 1608.

Under flowering blossoms
No one is a stranger
Or a lonely one ...
—*Issa*

CHAPTER **3** Two Journeys to Edo

The glory of the Edo Yoshiwara was famous, or notorious, in all the islands of Japan among the nobles, the merchants, and the wild young men of good families. In the text of Shogi Okada (near the end of the 18th century), there is a description of a Lord Ito and his party journeying along the famous Tokai Road to Edo, and toward the pleasures of the Yoshiwara:

> Lord Ito in the enclosed space of the palanquin was unused to riding in a litter on a country road. His breakfast of rice and gruel and green tea, taken an hour ago at Kyoto, rode uneasy in his stomach. He cursed Ebisu, one of the seven gods of luck. He could see dimly through the fine yellow

silk curtains and hear the slap of sandaled feet of the four men who moved quickly, despite the heavy weight of the palanquin on their strong brown shoulders. He could hear the shrill shouts of the servants crying out, "Bow down! Bow down!" as they passed a group of farm people standing in a field near the road in the early morning sun. The straw and unpainted timber sides of the simple huts in the village were set in an irregular pattern along the sides of the Tokaido, the great road with its fifty-three way stations that ran from Kyoto to the capital at Edo.

The procession was past the village, rolling along at a good walk. He put his head to one side and looked out through a slit in the canary-yellow curtains. The four shouters up front were strutting along, followed by the two fat servants carrying their plumed warning staffs of office, and behind them came members of his court, his servants, all the things that made such an impressive journey-party.

He came once a year to Edo—such was the rule of the shogun—but the court of the shogun's castle was not all that drew him. It was Edo itself: Such a city! Such noise, so much doing, in the *sumo* rings, at the Kabuki, and, best of all, the pleasures of the Yoshiwara! He looked at the dozen samurai— those who serve. The samurai always amused him: bully-boys, bare-kneed, in heavy leggings and flopping sandals treading the earth grandly, proud of their gay coats, their crab-shaped armor, the two swords pushed with patterned care through the belts around their hips. They had a professional walk, a cock-on-the-dungheap attitude: the way they cut the air with a swagger, peering out from under their big, round hats with warlike grimaces, with mask-like features.

The samurai of this period of the Tokugawa dictatorship were as dangerous as they looked. There was nothing to prevent their cutting down any peasant or merchant whom they

met. This right was theirs to keep them fierce and strong, ready for service to their lord, their *daimyo.*

Behind the sword-carriers came servants in the livery of Lord Ito bearing his colorful seal-crest on their gray garments. They carried the bedding, the boxes of personal gear and clothing, the portable shrines, the hundred other items small and large of travel and ritual that people set so much store by. Lord Ito in the palanquin figured they had miles to go yet, and he moaned, rubbing his shoulders free of a new cramp.

Lord Ito was a *daimyo*—great name—and a *hatamoto*—a banner knight of the Tokugawa. He was one of the barons of the islands, and he traveled in his palanquin, swaying, two dozen servants with tall piles of boxes and bundles, the banners, the men leading the graceful overbred horses, all in proper order. Looking the other way, he saw a long line of more samurai bringing up the rear, with servants carrying the warning plumes and the last shouter warning the village they had just passed, "Bow down! Bow down!" not to dare to lift their dusty heads until the procession was out of sight.

Lord Ito was aware the swaying of the palanquin had stopped. The shouts of "Bow down! Bow down!" were being repeated. He looked out. They were in the shade of great pine trees. He saw the courtyard of an inn—a *tsukiyana*—in a hilly garden. A row of inn servants, men and women, were kneeling almost prone on the ground, while the samurai ran about scowling, stuck full of swords. He threw his sandaled feet out of the litter and his body followed, and he stood stretching his aching joints in the white sunlight, glad to be on steady ground.

A fat man and thin man had risen to their knees among the inn servants, but kept their heads down. Lord Ito's chief servant stepped forward, legs apart, his wide belly held up with dignity, as he barked orders to the inn's owner. The bowing

that was expected for such a great lord took place, and Lord Ito walked in the sun wearing splendidly colored ceremonial robes in which gold and red predominated. He paid no attention to the prone servants and bowing attendants. He was a lord of the *hatamoto* class, and that was still something… "We live on the edge of the great deep," the priests said, and some day he, too, would shave his head in token of retirement from the world and enter the monastery of Zenshoji at Asakusa… .

Servants were lifting their heads, waiting for him to alight. Several of the samurai made growling sounds and reached for swords, or fingered their ornate iron sword-guards, the *tsuba*. He entered the inn to many low bows.

Lord Ito and his nobles, seated on mats inside the cool, scented comfort of the inn, under the great cedar beams, had water poured over their hands from gourds. They dried their hands with towels handed them by kneeling servant girls. Lord Ito helped himself to *sashimi to kyuri,* enjoying the cucumbers and raw fish in lime juice.

He refused the *kamo no koma-giri*; chopped duck croquettes would not travel well in the jolting litter. A noble lord said, "The sake isn't bad; it's Nigori sake from Akita."

Lord Ito took the offered white bowl of warm rice wine and took a deep swallow. The warm wet napkins came around with the golden limes, and Lord Ito, at ease on his haunches, said, "We will rest and change from our robes to travel clothes."

Lord Ito said he would rest. He followed a little maid in white socks and a dark-blue sash into a mat-floored room. Sleeping pads were laid out. The gray paper walls closed in on him. One red lacquered tray by the mats held a rough speckled stone, a twig of olive-green pine, a lotus flower, and several small, smooth, blue pebbles. There was nothing else in the room. He lay down on the sleeping pads and put his hands behind his head and stared at the roof rafters…

> It had been a long year since he had been in Yoshiwara. He
> thought of the women there, immensely beautiful, extrava-
> gantly slender, perilous, extremely exquisite, and he slept…

Lord Ito's code of morality had taken centuries to settle into
the patterns he accepted. Without much thought about his
habits, his position in the shogun society remained as un-
changing as the high peak of Fuji.

This attitude remained constant. No matter if it was the
time of the Tokugawa shoguns (1630-1853) who ruled as dic-
tators, or the Meiji Restoration (1867), the male identified as
a sacred mountain, a warlord, or a God-Emperor, was the
dominant image. And there could be no great changes, for
an ancient principle was that "People must be made to obey
and not to learn." And the elemental outlet was sexual, a
connoisseurship of female flesh.

The men were not all dandies, court nobles, or discreet lov-
ers fearful of being seen. During the Empo era (1673-1680)
there lived a promoter, a millionaire named Bunzaemon (an
early Texas type), a hoot-and-holler wheeler-dealer who made
fortunes in everything he touched, from pickles to lumber.
Ebullient, rude, facetious, bright—we see his type every day.
He bid on and filled government contracts, perhaps mostly
through bribes. He set up companies and organizations like a
modern master of holding companies and stock-market opera-
tions. He built temples, tombs; bought, sold, commissioned
among the scuffling stoats and ferrets of official bribe-takers
and -givers.

He entertained shogun officials with women, wine, song,
and little (and not so little) gifts of cash. He hired pleasure
boats for tours of the Sumida River for government officials.
Bunzaemon used prostitutes, geishas, music-makers, and

comic dancers for amusing his guests, and loaded sake, food, and fireworks on his armada of pleasure boats. After feasting and entertaining, all the men wearing reed hats (as today the Las Vegas sports wear Stetsons), they moved toward the Yoshiwara's Great Gate. Some seer had written, "Lust will not keep; something must be done with it."

At the Yoshiwara, Bunzaemon was the visiting potentate, the Big Daddy with the dough, the big spender of all times. As with many rich men, Bunzaemon had an urgency for show.

Traveling with his yes-men, the hired entertainers, he once appeared at the Yoshiwara and asked the cost of hiring the entire place—girls, teahouses, brothels, and all, closing the Great Gate tightly, and keeping *all* strangers out.

After a little head-rubbing, adding, and bowing, the price for one night—full control for Bunzaemon and his private party—was set at 23,000 yen.

The Great Gate was closed, sake bottles were opened; the high and low courtesans, the geishas, and the servants went wild with joy. It was a binge still remembered by some historians who said things were better—and men were men—in those days!

In 1698, Bunzaemon was building temples at Ueno; the money came in as if it were as common as rice-cakes. Again the payoff to the officials was a river party with singers, comics, poets, and actors added to the girls. Fireworks lit up the sky. At a temple visit of the party, a poor farmer asked a guest poet to send up a prayer for rain, and Bunzaemon said, "Why not?"

A real rain resulted. For the rich, the gods would unplug their ears, the farmers said. To celebrate this miracle, the only answer was to buy up the Yoshiwara again for a night of orgy. The other rich men sneered at Bunzaemon and his beautiful courtesans, saying, "Anyone could buy women's bodies with

money." Bunzaemon, like most rich men, was most likely schizophrenic and paranoid, and he felt his charm—not just his wealth—made him popular with the famous whores.

He invited his critics, three of the richest men, to the Yoshiwara and sent ahead to buy up everything: every courtesan and geisha, the food, the sake, the music.

It was a wild time, the Yoshiwara turning out en masse for the great sport. The three rich men arrived to order food, *Oshaku* (dancers), courtesans. The servants bowed: "So sorry, but there is not a bite to eat, a sip of warm wine —not even a lowly prostitute—available in the whole Yoshiwara. The Honorable Bunzaemon has bought up everything in the place. *Gomen nasai*—excuse, please."

The three rich men showed their money. Bunzaemon laughed, and the three men turned away in rage. But worse humiliation was in store for the moneybags. Bunzaemon had hired every boat and litter; if they left the Yoshiwara hungry, sober, and womanless, it would have to be on foot—and that is how they left.

Bunzaemon is a modern man to us, a bit out of place in the Japan of swordsmen, manners, *bimbo Kuge,* ritual, the fear of loss of face, of dignity.

He is modern in his vulgarity, the power of the purse. We can see Bunzaemon in Los Angeles, in Las Vegas, in Washington, in Dallas, in New York nightclubs, aware of the power of the buck for show, for ego-building. The buying of art today is Bunzaemonian, and that of endowed foundations. It has replaced closing the Yoshiwara for three nights to all but friends. Bunzaemon is here. How Bunzaemon would have loved our robber barons, our kingmakers, and buyers of high office today.

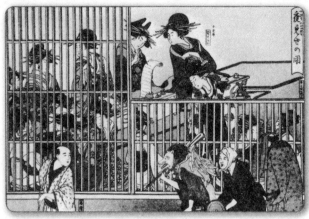

Courtesans on display: Utamaro, 1753-1806.

A night in spring
Spent in your arms
Did it happen
Only in my dream?
Yet unlucky me
They gossip about us...
—*Folk poem*

CHAPTER **4** Brothels and Teahouses

The brothels were classified in that sanguine Japanese manner of labeling and putting everything in proper order. Prices were fitted to the beauty and fame and skill of the woman.

Omaagaki—first class; *Hammagaki*—second class; *Daicho komise*—third class; and so on down to fifth class. The lowest had little refinement or time for prolonged love-play.

Establishments had a grill or cage front, behind which the women were on display. Some of the most famous print artists depicted these street scenes. Large lattice houses were the most costly, and the lowest houses had horizontal bars instead of vertical ones, so a man—no matter how befuddled by *sake*—could not mistake the cost and class of the woman he was seeking.

Why so many teahouses? The *mizujaya,* or water teahouses, were really for serving only tea. The *hikite-jaya* were "introducing" teahouses. To the Japanese this was a matter of saving face, of dignity, of catering to the male drive in ease. *Hikite-jaya* had guides to the houses of the courtesans (known as *iro-jaya* or love teahouses). No trembling, precarious self-introductions, but prepared introductions, formal and polite, between the women and the guests at the guide houses. Maids bowed and dipped, received the guests at the teahouse, and made them comfortable. These maids—today we would call them hostesses—were greatly skilled in keeping the guests pleased and comfortable, no matter how eccentric or capricious.

Everyone ran out to greet a guest, crying out *"Irrasshai—* you are most welcome."

The "welcome" is described in the polite words of Fujimoto, the guidebook writer quoted in Chapter 3, who sets the scene in the Meiji Restoration period, after Perry had invaded and European influence became evident in subtle ways.

The hostess and maids of the house receive you very hospitably and lead you to a room upstairs.

New green mats on the floor of the room, beautiful flowers full in a large pot on the alcove, and a valuable old picture hung against the alcove-wall—everything in the room makes you comfortable. A clever-looking maid comes up with a tea-set and serves you a cup of tea and cakes, and then asks you whether you want to take sake and some dishes. After you gave order about them, you add to hire geisha (singing-and-dancing-girls) and *taikomochi* (jesters), and the maid hurries down the staircase, in compliance with your orders. In another room of the house samisen is heard, and guests are singing some fashionable songs, and young girls seem to be dancing.

In a few minutes the hostess and two maid-servants, all in stylish dresses, come up and bring a complete set of utensils for sake. On a table several dishes are arranged.

The author does not describe the dishes, but from other sources we know what was served, especially when a group of men have arrived at a private party. Lots of sake, say a *tokkuri* (a gallon wine jar), and lots of *hamaguri-meshi* (good food: clam-and-rice) produced in a guest an amorous nature; it also made for a larger bill, of course. An early menu of the grand cuisine of the Yoshiwara shows the following house special, available to guests who wanted to throw a real party: burdock root fried in *goma* oil; Arame seaweed; bean curd in oil; fish, chopped, seasoned with sake; mushrooms; fern-shoots; sole; boiled ginger roots; lotus root; squid; conch stew; clams; dried bonito; boiled rice balls; pickled greens; and other goodies.

Special dishes were fried fish (tempura) and roast eel (*kabayaki*).

In his uncertain English, the guide author continues with the next scene:

Not long before there appear a singing- and two dancing-girls and a jester in the room. First, you give a cup to each of them and after several exchanges of cups the singer takes up her samisen. She plays and the jester sings, with two young dancing-girls waiting upon you near your side. If you know any songs you may sing, and now the dancing-girls begin to dance, and at last the jester performs his funny dances, mingled with the two little lasses.

Now, it is near 12 p.m. and the hostess comes and warns you it is late. Then you, guided by a maid-servant of the house, and followed by three girls and the jester, leave the house for the ultimate end. The house where you are introduced

is a first-rate house called *Kadoyebi-ro*. It is situated at the first corner of Kyomachi Street and the building in four stories with the European appearance is said to have more than one hundred rooms. There live more than thirty girls in this house, all young and beautiful. To each of them two young waitresses and an old maid-servant are attached—attending their mistress on all business night and day.

When you enter the house you are first conducted into a drawing-room; the room is a very large one, finely decorated in fashion. You sit down on a large futon (cushion) of crepe, and your followers—singers and jester—take their seats behind you. As the girl who is to be your mate this night is beforehand appointed by yourself, or selected already by the hostess of the guide-house, the two waitresses of your girl are sent here to conduct you to her own room.

The abode of your mate consists of three rooms on the second story; the first room is a parlour, the second a reception-room, and the third the bedroom. Guided by the two waitresses you enter the second room, and are served tea and cake. The singing- and dancing-girls and jester, who have followed you up to the room, now take leave; but if you wish to take more sake here, and to have them attend further, they are glad to remain and assist your pleasure. If you are a new guest to your girl, she does not appear until you get in bedroom, and this is the general rule through the first-class brothels; but if you wish to see and talk with your girl in the reception-room, and to take sake together with her, you should [later] pay 5 yen extra, which is called *najimikin* (intimacy money)... . She is licensed to come to your side, as you are now to be treated equal to her intimate customer, though you are a new visitor first in this night. At 1 a.m. geisha and *taikomochi* leave the room, and you go to bed. It is entirely given up to your own convenience whether you will leave the house at 2 or 3 a.m. or stay till morning... .

As the restrained guidebook author was not very explicit about the rooms, we should retrace the steps to fill in:

The larger room where the courtesans waited for the guest was the *zashiki,* furnished with eight mats. It contained an alcove or *tokonoma* for ritual offerings and small objects, scrolls, and examples of calligraphy, usually poetry in Chinese characters. These two folk poems were typical:

> I feel emptiness
> Grow on the mountain.
> The flowers
> The eyes of the world
> Have all gone away.

> Even if I try to hide
> My love shows on my face
> So plain, he asks
> "What are you thinking of?"

There were shelves, too, with flowers in vases of Kutani ceramics and musical instruments: the koto, samisen, gekkin, ni-genkin; and sometimes small figures of animals, a mirror, novels, or theater playbills.

There was a shelf to hold the guest's garments and a folding screen. The inner room had shelving for bedding, drawers for the girl's robes and often a hibachi of glowing charcoal, a teapot of metal, *yochaki*—a tea-set, dishes and bowls, and what, in the West, would serve as a chamberpot, but here was a lacquer tub with earlike handles.

After greetings, the couple retired to the smaller inner room, the *tsugi no ma* (only four mats).

The courtesan paid for the décor and upkeep of her rooms, and the cleaning, too. An admiring guest, say a *bakuchi-uchi*

(a professional gambler), would often stand the cost of refurnishing the place in which he passed so many happy nights. Just for luck, if not for love.

A courtesan was judged by the splendor of her rooms, and as the costs were heavy, she was often in debt to the loan shark or the brothel-keeper. At such a time a devoted admirer with money was always welcome. The futon or sleeping-mat was a good sign of the status of a courtesan. Red crepe with black velvet borders showed class. Three futon, one on top of the other, was the norm in a first-class house. Two futon was definitely second-rate, and of inferior stuff, such as calico, fit only for the *benjo* (the john).

A final coverlet went over this and, in season, a mosquito net. One of the most charming of Utamaro's prints is of a couple getting under a mosquito net, with a book of poems and a floor lantern. Long ago some poet wrote of the subdued tones of such scenes:

> Yellow chrysanthemum
> And white—
> Any other colors do not matter.

We shall write of the courtesan's skills, her sensual arts, and her life in later chapters. Let us leave her now as she sinks down on the sleeping pad beside her lover for the night: alert, graceful, compliant, painted, wigged, as no wife at home ever was. The guest expects the courtesan to produce carnal anarchy for him, personally.

Colors were often used to signify the kind of courtesan found in a house. Pale-brown curtains were a sign of a high-class *Tayu.* Blue curtains were for lower-class *Mise-joro* with whom fornication *(tsutsumotase)* was cheap and hasty. The maids who cried out *"Ojara!* Come in" outside the teahouses

were usually prostitutes. In such a lower-class brothel, the girls often worked and lived all together in one large room. When they entertained guests, the couples were divided by screens.

There was also love on the water at boating teahouses *(fune-yado),* where boats were for hire to take geishas and courtesans for a cooling trip along the river, to float, eat, drink, make love, listen to music and see the fireworks span an inky sky on festive nights. Many beautiful woodcut prints exist showing these boating parties on the river: compositions of playboys, sports, thrill-hunters, businessmen entertaining buyers, the courtesans in their amazingly beautiful costumes, geishas with their samisens, lanterns strung over the hundreds of boats, and the magenta, hot-yellow, angry-red fireworks and skyrockets going off in clusters above the moon bridges.

Far from Yoshiwara—to make a footnote in our history—the same drama was being played at the same time in another style. Halfway around the world, the anonymous author of *The Shakespeare Theatre* could note that "the site chosen for the Globe was another playground outside of the city's jurisdiction, a region of somewhat unsavory character... This was also the region occupied by many houses of ill fame, licensed by the Bishop of Winchester and the source of substantial revenue to him. But it was easily accessible either from London Bridge or by means of the cheap boats operated by the London watermen, and it had the advantage of being beyond the authority of the Puritan aldermen..."

London or Edo, bawdy life went on.

In the 19th century, the earliest Western visitors to the Yoshiwara found it difficult to sit on the *tatami* mats cross-legged *à la japonaise.* When the green-tea houses and brothels of the Yoshiwara sometimes turned to Western furniture, they bought chairs and often cut off the legs. The courtesans

disliked European beds raised off the floor, with soft pillows and mattresses that gave way, instead of the hard floor mats. Western beds were the fashion for some time. It is interesting that the brothels were proudest of the European chamber-pot placed properly under each imported bed, as seen in Western travel.

During the short period after the Americans opened Japan to the world and the Emperor came to power and the shoguns left—known as the Meiji Restoration—Yoshiwara houses were built higher than the two stories previously permitted, and the designs were thought of as European style.

The Yamada-ro brothel even got up their courtesans in foreign costumes—lacy drawers, feather boas, long skirts, rosebud garters, and other frou-frou. Several other houses had to follow suit for a while or seem out of fashion. It was a maddening time of change and confusion.

Even European saucers and plates were imported; but knives and forks were not provided. These strange tools seemed dangerous weapons, and so the customers ate from poor copies of Wedgewood and Spode with wooden chopsticks.

The Yamada-ro brothel, always the pace-setter, brought over three Loochoan prostitutes, and there was gossip in Japan of London whores and French tarts, but it never got beyond rumor. Even the Loochoans ceased to excite. The European clothes were discarded, the high beds were sold off, and everything went back to the native style, on traditional futon.

The Costs of Courtesan Pleasures
It was Lord Chesterfield, known in his day as a whoremonger, who said of sexual intercourse that the moment of satisfaction was fleeting, the position ridiculous, and the expense damnable. Few have gone into the costs of pleasuring in the Yoshiwara. Fewer still have been able to estimate in terms of

today's money the prices of the favors of the grand courtesans and the lesser prostitutes.

Today's money, in the U.S.A., often seems printed on snow-flakes, but keeping the current value of the dollar in mind, one can try to come close to the value of money in Japan. One silver *kemme* was about 273,000 yen or $763. One gold *ryo* was worth the equal of about 16,000 yen today, or about $45; the *ichibu-koben* and the copper *kommen* both about 4,000 yen, or $11.40; one silver *momme* 272 yen or 75 cents. One copper *monsen* was worth about one penny.

The cost of a courtesan's favors depended upon her class. Highest were the *tayu* (or *oiran),* the great dames, the spirited queens of the Yoshiwara, full of pride. Next in rank were the *koshi.* Trailing third were the girls of the *tsubone* class. There was also a semi-professional class, the *sancha,* drawn from bathhouse girls and common streetwalkers.

The *Tayu-class* courtesan cost at one time 58 *momme,* with an additional 18 *momme* for her attendant, or about $58. The lowest ranking girl of all would be about 40 cents. So there was a wide price range for the seekers of women.

However, there were always extras—special costs and services added to the price of a grand courtesan's favors. Food, sake, entertainers, tips to a dozen palms. The average sporting gentle-man could spend about 150 *momme* an evening, or nearly $115. This is about the price for entertaining an average high-class, top call girl in New York or Los Angeles, but then no American call girl has the skills, charm, wit, costumes, or attending staff of a *Tayu* of the top rank. Nor, it might be added, the respect or fame, unless they become entertainment personalities.

In old Japan (even today), a man's social position often was determined in part by the sort of mistress he set up in her own quarters. The novelist Saikaku estimated that to keep a grand courtesan in style would cost a man about 29 silver

kemme, at that period worth $22,000, a year. One story tells of a playboy who in five years of wild spending in the Floating World ran through a fortune of a million and a half dollars.

The average price range, which began at $58, went to $14 and then slid, as we have stated, to 40 cents for the lowest rank of prostitute, a *hashi-joro*.

The teahouse system had its faults. At times, they permitted their places to be used for intrigues, illicit romances, and men and women accused of "loose morals"—which meant cheating a hardworking brothel keeper out of some of his business in the *nijimi* trade.

In Yoshiwara, income came from every source: the heavy tipping added to the bills, costs of food, geishas, a huge mark-up on sake. Visitors tipped *chadai*—tea money, for any little service. On special holidays the staffs expected presents or cash (in the manner of our apartment house doormen, mailmen, parking lot boys, and cops on the beat).

There were also low-class clip joints—*bori-jaya*—where threats, blackmail, violence, and robbery could catch a yokel in for a spree. They used touts, with small gratuities and large hopes, to pull in the gulls with their talk of special delights within. Flattery took over inside; food and sake appeared—not ordered—and too many geishas showed up unasked, to sing and dance. Items were run up and the sake bottle was refilled.

The poor trapped victim couldn't even settle his bill and run. No one would take his money or permit him to leave. And the sake kept coming. Night and day could pass in orgy until at last the victim would collapse into sleep. Then his pockets were searched and, if he had the sum needed, the dance went on; if not, clipped and emptied, he was pushed out into the stringent day.

If a guest's spending power was overestimated, a loud-voiced hoodlum *tsuki-uma* was sent to live with the victim

until he paid up before the muscle (in modern terms) was applied to him.

Much traffic in the Yoshiwara consisted of sightseeing visitors—tourists and even women were admitted to look the place over. Passes were issued at ticket teahouses *(kitte-jaya)* outside the gates. Some were fun-seekers with no money to spend; they first came to see the sights, inspect the women behind the bars, and talk big. As many of these were poor law students *(horitsu),* the free lookers were all called the *horitsu.* Often a *horitsu* would blackmail a brothel-keeper for a free visit by pointing out an infraction by the house of some regulation or law.

In the first-class brothels, there was usually no talk of costs—not even at morning was there a word of money—as an attendant led the guest back to the introduction teahouse. Here he was hit with one bill that included everything. The teahouse took his money, the hostess bowed and was tipped, and everything was paid for: geishas, food, drink, the night of love, all from the one final payment. A hungover, depleted guest wasn't very able to make out the intricate bill presented to him with many bows.

There was even a credit system: a well-known, free-spending guest could run up an account over months. If he tried to welsh by giving his business to a new teahouse, the grapevine soon revealed it, and a bad sexual credit risk was locked out of the teahouses and brothels.

Passion cannot be self-contained, like an egg, so said the brothel-keepers.

Fujimoto mentions the cheaper brothels:

If you visit the second or third class houses the proceeding is utterly different, and very simple. One point, however, very important for goers to lower-class houses is that they must be always very attentive, otherwise his purse would be squeezed out by clerks and maid-servants of the place. Those in these

houses, as well as girls themselves, cannot be said honest and kind, and if they see a guest to be a provincial or unaccustomed to this quarter, their endeavors to put him into temptations are so dreadful that he would be at last compelled to spend all the money in his pocket.

A profligate, whose habit is to visit the quarter every night, comes up to his acquainted house, and next morning he has no money in his pocket. If his intimate girl loves him, she would be kind enough to advance for him; but if not, she refuses to take charge for his bill.

In these lower-class houses, where the prostitutes were more exploited, there were often great fights, guests accusing the girls of stealing, bad manners, or not trying their best. Then the house guards or bouncers of the Yoshiwara would move in and make order. There is a famous print by Utamaro of such a brannigan.

As a district, Yoshiwara had an economy that was often in trouble. No personal tax was paid by an individual on either *shugi* (tips) or *gyokudai* (fees). But in time some political official—even as today—got the idea of taxing any sort of income to defray the expenses of running the Yoshiwara. All taxes sound so sensible at first.

When the business morality of the geishas was at low ebb, it was hinted that taxes would help their morale or, it was said, make them "responsible."

Advertising became popular in Japan in the middle of the 19th century, and the Yoshiwara folk would issue broadsides, throwaways, describing the charms and graces of the courtesans and the comfort of their houses. Here is a translation (in part) of an 1848 announcement of reduced prices, signed Manji-ya Mokichi:

Should any woman be unsatisfactory, another will be substituted... . By reason of your kind patronage and favor, for which I am extremely grateful, I have been enabled to continue the business of brothel-keeping for many years, but regret to observe that there are signs that the prosperity of the Yoshiwara is on the wane. I have therefore hit upon a different plan of carrying on the profession, and have decided not to receive any guests sent from teahouses in future, but to conduct my business on cheap and expeditious lines at the "spot cash" prices mentioned below... .

I propose to pay scrupulous attention to the quality of *sake,* food, and bedding. I shall be greatly obliged if you will kindly inform your friends of the improvements introduced by me, and earnestly beg that you will favor me with a visit, either in the daytime or nighttime, coming directly to my establishment without making your arrangement through a teahouse.

We supply the Masamune brand of sake, and our cuisine is fully equal to that of the leading restaurants. Tips and gratuities to "lady friends" and geishas may be given according to the discretion of guests.

Another advertiser, Daiku-ya Bunshiro, admits he is going after the mass market:

I have devised new style of dance which is performed by my *yugo* to accompaniment of popular songs. This dance is something like that anciently performed by *shira-byoshi* (singing girls) and I am confident that it will prove a source of pleasure to my august patrons. Persons coming to my establishment, either through the medium of teahouses or direct, will be treated with all possible courtesy and attention... . As regards the question of expenses, the aim of my house will be

to make prices as moderate as may be compatible with doing everything conducive to the entertainment of guests.

Bath houses were popular both within and outside of Yoshiwara, though only in the latter was sex likely to dominate the steamy delight. The bathing habits of the Japanese were full of tradition. What they were once like we see in the guidebook by T. Fujimoto, *The Shady Side of Tokyo,* written in his piquant English:

Bathing of the Japanese is far beyond the simple object of cleaning their body, but is so evolved that they take bath to wash their *life!...* The lattice doors were shut at the entrance of the bath-house, and if they entered the door, in front there was a large staircase which led to a room upstairs. On upstairs there were two or three large rooms, and here they found three or four nice young girls, who supplied them with a bath-gown. Putting off their clothes and taking the gown, they went down the stairs, and, throwing off the gown into a basket at the downstairs room, they went into the bathing-room. After they finished their bath, they put on the gown, and coming up again to the upstairs room, one of the girls served them a cup of tea or *sakurayu* (the latter is the hot water in which two or three cherry flowers salted down are floating).

What a nice taste and fragrance the *sakurayu* had, being seasoned with light salt emitted out of the flowers and flavored with their perfume! Guests would take cakes which could be supplied by the girls. In these rooms chess and checkers were furnished, and the customers to the house would be glad to play games. Young men were very happy to gossip with the waitresses, and spent their leisure time in the evening. These girls in the upstairs of the bathhouse seem to have been selected out of the beautiful maidens, and we often found among

them such belles that even geisha of the age could not match them in their charm and beauty.

Besides the common hot bath-houses, there is a special kind of bath-house where business of restaurant is taken together at the same time. They are called the *onsen-ryori,* which means the bath-restaurant. One summer evening you visit a bath-restaurant called the Ikaho near the Ueno Park, around which some three or four famous *onsen-ryori* are situated. At the entrance of the Ikaho there stands a large wooden gate of the pure Japanese style, and the courtyard of some ten yards long leads from the gate to the door of the house. A large two-storied building is divided into many rooms, to one of which you are shown by one of the waiting-maids. First of all she brings a bath-gown *(yukata)* and asks you to take a bath if you please. A *banto* serves tubs of pure hot water, and washes your back with soap. After you get out of the room and put on the bathgown, you come to the toilet-room connected with the dressroom and give a touch to your hair. Coming back to your room, you sit down on the *zabuton* and try to smoke. Just then the waitress appears again, and prepares a table of dishes and sake. In a room beyond the courtyard, sound of samisen and voice of singing are heard, and your maid tells you that three beautiful geisha from the Yanagibashi circle are attending the guests of that room. In the hall downstairs a dinner-party of young students seems to be at the height of pleasure. Through all seasons, citizens of every rank come to the bath-restaurants, and are fond of making merry after washing away the dirt of daytime.

A late 19th-century Japanese guidebook describes night life early in the century, taking the reader through the famous geisha district of Tokyo, Shimbashi, not far from the theater section and Yoshiwara:

Being now past twelve, and feeling somewhat hungry, you wish to take something. Coming again at the crossroads of Owaricho, you enter the Cafe Lion at the south-east corner. Here you can prefer any kind of wine, European and Japanese, beer, Masamune (genuine Japanese sake), whisky, liqueur, vodka, and so on—and may pine after the evenings of Paris or London, or dream of the pleasure at Berlin or St. Petersburg. Most of the guests assembled in this house are young gentlemen of so-called new taste; a party of three or four comes by... accompanied by young beautiful geisha (singing-girls) of Shimbashi, and occupies a room upstairs. The laughter of the girls echoes in the room, and their crimson sleeves wave around the table. About the middle of the staircase you meet a young lady stepping down, and fragrance from her body strikes at your nose at the moment of passing closely. Is she a madam, daughter, or street-walker? The saloon upstairs is full of the confused odour of wine and tobacco smoke. Here you see the young officers of the Embassies and Legations; famous lawyers and politicians; assistant professors of botany and physiology; authors and critics—groups of these various ranks take their seats round the tables and are smoking, drinking, eating, and remonstrating. The place most crowded in the Cafe is the bar downstairs, and here all classes of people, from the highest to the lowest, are taking refreshment—men of music, stage, or brush; merchants, students, workmen, and laborers; all come in and out by turns.

In the Cafe there are young waitresses, about twenty in number, their breasts being covered with snow-white aprons. They are all beautiful, their white face smiling on love, and their red hair ribbon flying in show. There are not a few young customers who come to the Cafe every night and sue the waitresses, and the manager of the shop was smiling when he told once to a customer, "Our waitresses must be young and beautiful, but these beauties do not stay long and go home shortly on

pretense of some family reasons." It is the fact that the girls here are found always to be renewing. Being sued by the hand of young blood, the weak females could not refuse it. Some of them may have been taken wives, but most are perhaps fallen in the abysses of ruin, after a momentary dream of honeylove.

Leaving here you go on some fifty or sixty yards to south, and, turning a corner to east, you come near the river bank. The part of Ginza along the small river is called Sanjukken-bori, and, though the quarter is near the center of Ginza, streets about here are rather dark, all houses and shops being not so much illumined as in the main street. You find a number of houses very fashionably built, and furnished with gates or doors of elegant form. On the roof or gate lamp you can read the name of each of these houses, and at times a *rikisha* with rubber tire wheels runs out of the gate, leaving in the air behind it the perfume of white rose. What kind of business is taken in these graceful houses? They are called *machiai* or waiting houses. In Ginza there are many large and small restaurants, and the largest and most famous among them are the Kagetsu, Matsumatoro, Kinrokutei, and Fukkitei, amounting to twenty-four or -five in all. Around the quarters of the restaurants and waiting-houses there are the alleys of geisha, and six hundred and eighty-four large and small so-called *Shimbashi geisha* (singing-and-dancing-girls of the Shimbashi circle) live in their houses built in rows on the both sides of the narrow roads called Ita-jimmichi, Nakadori, Komparu, and Shigaraki-jimmichi.

It is not unreasonable that there we find a great number of *machiai,* not only at Sanjukken-bori, but also in all by-streets not far distant to those dens of geisha, and these waiting-houses within the boundary of the Ginza quarter are counted to sixty-six at present. The profession of the geisha is to wait upon guests in the restaurants and to assist their pleasure by singing and dancing; but the so-called *machiai* are also their favourite

and important haunts. Besides the geisha you often find young females, with the appearance of a mixture of professional and unprofessional, come in and out of *machiai* of lower class.

The amusement most favorite for the lowest class is gambling, and almost all of them confined by rain assemble in the large room. The result of contesting is noisy quarrels or severe fights. A maiden is weeping at the dark corner of a small separate room, where she has been kidnapped by some roguish *rikisha-man*. Quarrels are not rare among the laborers and their unfaithful wives, and the bloody disturbances take place often. The sake drinking is followed by severe struggles, and some are severely wounded.

If rain continues four or five days they have no means to pay the room rent and to purchase food. Someone is compelled to borrow money from his inmate by mortgaging his wife for three or four nights, and if he cannot pay back the money in due time, the woman is taken to be the wife of the creditor—for only 2 or 3 *yen*.

The most miserable case is the wife of a laborer abandoned by her husband. Owing to the continued rain, both the husband and wife cannot find any way to work, and as they cannot pay the rent the host or his clerk urges for the payment without a slight mercy. After quarrels between the husband and wife, at last the man goes out to make money, but does not come back to the inn forever. If the abandoned wife is not very old, the host comes to her, taking advantage of the opportunity, and persuades her to become a courtesan of Asakusa Park, or of Yoshiwara or Susaki. By this the host cannot only recover the room rent, but also grasps a certain amount of money as commission.

In the countryside, teahouses and bath houses could sometimes provide little Yoshiwaras in themselves. Clement Scott,

the Victorian traveler, author of *Soiled Doves,* which will be quoted later on the "immorality" of the Japanese, barely manages to hide his actual experiences with Japanese women. In this travel letter sent home, he tells rather obviously how he had fallen into a nest of prostitutes and "wayside-inn maids," who were also available to the guests.

Up at Myanoshita came our first temptation. At the gate of a tea-house opposite the mountain hotel stood the funny but inevitable little Japanese girls, gaily bowing and smirking, their little pudgy hands stuck into the folds of their padded 'kimonos', asking the 'honorable' gentlemen to come in and rest and laugh and chaff with them, and take just one cup of their 'honorable' tea. Tea in a modern Japanese tea-house in these days of civilization means, I fear, whiskey with or without water, and the Japanese matted floor has been turned into something very suspiciously like a saloon or public house 'bar.' The romance of the Japanese tea-house is an absolute myth. Peach blossoms may surround it, but the almond-eyed maidens are employed here to tempt the traveler to drink *and* romp.

The Japanese Circe, as usual, beckoned in the wanderer. I certainly did not 'answer with a sigh', for the 'maiden breast' of modern Japan would be little 'rest' for me, unless fashion, form and complexion alter very much. The mountaineer knows well the temptations of Myanoshita and the teahouses in the immediate neighborhood... .

I found at Kaikatei the most curious and cozy little hostelry I have ever come across in my many travels and adventures. A crowd of Japanese servant-girls stood on the threshold to welcome us. They bowed to the ground, they grinned, they chirped like sparrows, and in a few minutes they shuffled after us over the clean white boards—slippetty-sloppety—always

down at heel but ever anxious to be cheerful and obliging. I am literally taken possession of by O. Do-San. She is a harmless but chronic grinner, but as playful as a kitten and as babbling as a baby. She dances with delight when she sees my dressing bag, and examines it with the curiosity of a child who plays with your watch and blows it open. She tries on the dressing suit, grinning all the time from ear to ear and uttering un-earthly grunts. She toys with the scent bottles and looks into my face, and, for the hundredth time, bursts out laughing.

My room is a little box, protected alone from the air by paper screens, adorned with Japanese devices and warmed by a square box of charcoal stirred into lambent life by brass knitting-needles. Besides, O. Do-San announces that the 'hon-orable' bath is ready. She shuffles along the clean white floor in advance of me, and in less than five minutes I am neck deep in sulphur-water that has bubbled into the bath scalding hot from the depths of the earth, a bath whose hot water comes into the tub so scalding that you can scarcely bear it!... Soothed, softened and refreshed, we sit down to dinner, and an excellent one it is. The walk has done us good; the hot, sulphur water has given the first quietus to 'prickly heat' and, among many other good things, we are to have a new fish from the sea as small but sweeter than perch, and a slice of wild boar killed yesterday in the snow-covered forests that crown the hills.

The life at our hotel is very primitive, but none the less de-lightful. When the dinner is cleared away, nearly all the little Japanese maids assemble in the little sitting-room and mix freely and merrily with the guests. Here I intended to stay a day; but here, in spite of myself, I rested a good week. There is so much to see and do, 'sampling' the mountain teahouses and hearing the chatter of these bobbing and courtesying 'little maids from school' who seem to interest and console the jaded and experienced traveler.

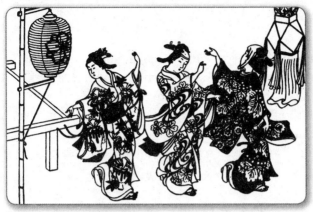
Geishas dancing: Sukenobu, 1674-1754.

What do you think
How long the long night
When you are alone
There weeping.
—Folk poem

CHAPTER 5 Geishas and Courtesans

The word *Gei* translates as "art," and the word *Sha* as "person." So a geisha is a person of artistic talents: that of singing, reciting, making jests, entertaining, performing the tea ceremony, tickling the fatties among the guests, and whispering obscene jokes to jolly the customers. Their popular instrument, a sort of banjo, is called a *samisen,* the head of it said to be made of catskin, and it was first imported as a music-maker from Okinawa. It is also shaped as a sort of drum called *taiko* and choruses of geishas formed drum ensembles as popular entertainers, playing and singing, and the girls were called *taiko joro* (drum whores).

A Victorian lady traveler, Isabella Bird, in her book *Unbeaten Tracks in Japan,* liked neither the sexual morals nor the love music of the geishas. Of their singing she wrote, "The vocal performance was most excruciating. It seems to consist of a hyena-like howl, long and high, a high voice being equivalent

to a good voice, varied by frequent guttural half suppressed sounds, a bleat, or more respectfully an impure shake... eminently distressing to European ears."

It should be pointed out that American and European voices praising Western love impressed the geishas and courtesans as merely "the bellowing of animals, the rasping of barbarians," to quote from a 19th-century letter.

It was in the 17th century that the term *geisha* was really established in Edo, meaning a trade in singing and dancing entertainment. They were not by definition prostitutes, and could not compete with the professional courtesans of the Yoshiwara at parties—against union rules. But they were sexually available, and to keep a geisha had a certain social value, like collecting art has for the rich today in America.

Geishas wear their hair even today in the traditional Japanese *maga,* often owning many wigs. Traditional Japanese makeup of historic ritual was used, the costumes were colorful, and often a geisha had on her back all she owned. Their manners were impeccable, and their whole desire was to please, whether the man was the one-sword farmer or the two-sword samurai.

The apprentice geisha was called *maiko* or *hangyoku,* and both young and mature geisha of course wore the kimono and the sash called the obi. A great deal of romantic nonsense has been written about the geisha, even among the Japanese. Actually she was and is a trade: entertainment is her business, set rigidly in the social order of the past. Novelists and poets have created a kind of literature about her. But, as with the dancehall whores of the Western American legends, girls with hearts of gold (and often a front tooth of the same metal), it is not too true to the facts.

For this and some other reasons, the most misunderstood and over-romanticized women in Japan have been the geishas.

They were trained as entertainers of men, not as prostitutes, being educated to arrange flowers, perform the tea ceremony, play an instrument, and sing and dance. For a party, they also told amusing stories, tickled the fat or shy guest, bowed to the bolder ones, giggled at obscenities, served and helped with the chopsticks of a guest who wanted to be fed or was too drunk or amorous to try.

The geishas were not for everyone. They were costly to hire. It was customary for a party that the host reserve a number of geishas at a teahouse, but a formal introduction to the house had to be made. Not everyone could walk in from the street and demand the best geishas' services. There was a kind of urbane boulevardier manner in hiring geishas.

It was an honor to be admitted, to order which geishas one wanted and how many. And how many *maiko,* the young apprentice geishas who danced so charmingly to the playing of the samisen—these child-like Lolitas.

The guests, having left shoes at the door and having been bowed in by maids to the matting of the main room, all sat on the floor and listened and stared at the girls in their many-layered robes, or kimonos. Sake was served—warm, of course—in three grades, and the guests would proceed to get drunk and make erotic jests. The geishas would repeat the latest scandal, gossip, or tell the newest funny story. Food would be brought in from outside and the guests were prepared for a gay evening. The girls pressed close to the guest, pushed their knees against him, and the fumes of the warm sake filled the place. When the guests felt venal, then the picture-books of the Yoshiwara's courtesans would be sent for, and the guests would pick and decide, ask for some to be brought in, or they could move on with much fumbling and laughter to the houses where the courtesans waited.

This did not mean the geishas were moral prudes or ritual virgins. They, too, had lovers. They, too, favored a rich man with their bodies. But not at a geisha teahouse. On the job, their function was to smile and bow.

Their training would begin often at five or six years of age; later on, ten or twelve was the age for their apprenticeship. The modern geisha is usually the daughter of an older geisha. But the trade is much run-down now, and under the dead white thick makeup, most geishas are middle-aged, their bodies thick-waisted. They are the tiring remains of an art in progressive decay.

In the old classic days, they were young, creatures of beauty made immortal by thousands of masterworks in colored woodcut prints. We still see them standing under the cherry blossoms, playing with puppies, arms around each other on a bridge, set before us with their impeccable coiffures, all ornate with pins and ribbons and flower blooms. They exist in rare robes held well against their slim bodies, standing balanced on the *getas* (raised platform footwear), in their stockinged feet, girls eternally moving in slow dances of exquisite grace.

The men and women dancers who appeared at parties often mixed with the courtesans, but they knew their place —as artists. Even the Japanese themselves have often had difficulty deciding when a geisha was not a courtesan: The distinction has always been traditional, if not actual. The craft became degraded into prostitution so that, in 1872, laws were made to keep for "the true artist" any right to the name geisha.

In time of war, the geishas, living in antipathy and bewilderment, were enlisted to keep officers "happy," and were treated as mere sexual partners, rather than as artists. The free geishas—even those who owned themselves—had a hard time of it, despite their organizations, which were rather like trade unions. The geisha was usually in debt, being burdened with buying many exotic costumes, supporting servants, and

living a gaudy life, careless of money. She usually had a rich lover or protector who kept her, and to whom, in theory, she was faithful. But, inflamed by popular pornographic novels and erotic plays, and sentimental as any dancehall girl, the geisha would keep a lover on the side at times, in spite of the rich man who pressed his attentions on her. The geisha's trade, however, was never that of prostitution. She could choose whom she wanted to go to the mat with, and not—as with most classes of courtesans—have to take whatever trade came in. The ambition of a geisha, if not owned or under contract to a house, was to own an eating-place of her own, or a green-tea house where she could own her own geishas, and provide courtesans for guests. Assembling women for men's carnal pleasures was a way of life few questioned.

How did the Japanese themselves feel about the geisha and the courtesan when they began to view the outside world? After World War I a booklet was printed in Japan in English, or at least in the English of the journalist Aisaburo Akiyama. It is about the geisha, and my copy is bound in part of a geisha robe. We find in it another definition of "geisha."

The term geisha literally means "accomplished person," and a geisha is needless to say the fair sex, generally very young and good looking, latently playing an important role in the social function of modern Japan. Most geishas are conversant with singing and dancing or with some other light accomplishments, and they wait upon guests as professional entertainers during a dinner or a garden party or the like, to say nothing of certain delicate services occasionally rendered, but of course very furtively.

Now, looking over records in the days of yore, the origin of geisha might be traced indirectly to those women who

had been leading a bohemian life in the Nara period (710-794 A.D.), wandering along coastwise towns in order to offer pleasant hours to provincial dignitaries and travelers on governmental missions. It is said that, being far away from the capital where very little comfort could be had, these officials felt lonely and cheerless, but found a mighty consolation in these women, who had evidently a slight knowledge of poetry and were trained to sing and to dance as well.

These later writers had a lower or perhaps clearer view of the women of the Yoshiwara, and one finds in their texts a kind of ironic attitude. Some, in the effort to give us the picture in early-20th-century English, strike a bittersweet note. The Akiyama booklet on the geisha has a sympathetic viewpoint expressed in shaky English.

Originally, both men and women professionally living on light accomplishments inseparably went under the name of "geisha", although men were called *"otoko geisha"* or male geisha, and women *"onna geisha"* or female geisha. Subsequently the term *"onna"* was dropped, so that the *onna geisha* came to be called simply geisha, and the *otoko geisha* or male geisha changed simultaneously their name into *"hokan"* or jester.

Strange to say, almost all geishas understand remarkably well what might be conveniently termed man-psychology, so that they are thoroughly well versed in the art, or rather tricks, of pleasing men of different characters, ideas, and temperaments, irrespective of age and standing. And it may be said that an efficient geisha-girl is a veritable teacher of sociology—of course, to men.

Viewed in this light, geisha-girls are almost forced, as it were, to commit spiritual suicide, so that it is but natural they abandon themselves to desperation, eventually making

themselves like a rudderless boat floating on the wild ocean. Unless they are safely picked up as decent wives in the early stages of life, they shall have to die as indecent old misses.

Geisha-girls are immensely superstitious and strangely religious, believing in all sorts of gods and Buddhas for which they have miniature shrines installed in their respective homes. In spite of the fact that they are sleepyheads, they get up early in the morning and visit their revered shrines winter and summer. . . not from the pure religious motive but from the unique desire to be favored with cheatable patrons whose purses are full of gold.

Through all ages, women are said, rightly or not, to be a puzzle. If that be the case, geisha-girls are certainly the queen of all puzzles and into the bargain a Gordian knot almost impossible to untie. These puzzlers are mysteriously equipped with a magic art to bewitch men, particularly of the higher classes, to whom they cling in the form of a beautiful bacteria... .

He concludes sadly, depicting the end of a geisha's days:

Frankly speaking, the closing pages of the geisha life is like a withering flower whose pretty color and fragrant scent have forever gone, nobody caring even to spare a glance to it and more so to touch it any more. But let us look back upon a geisha in the prime of age, enjoying a peerless popularity, attired in silk and brocade kimonos, ruining countless riches and dignitaries, depriving them of high ranks and wealth, and finally making them bow down under their slender knees. Showered with amorous arrows from all sides, with her fame spread far and wide, she triumphantly displayed scenes enviable to lovelorn persons and was as boastful as a peacock.

As fast as fleeting clouds, all these turned out in the twinkling of an eye nothing but a passing dream... In vain she

wished for a palatial vehicle that is being ridden by somebody else now-a-days. Fortune had passed off without lingering at her door. Her beauty and pride have all gone side by side. Now that she begins to wish for mental contentment and restful days, her once attractive look and unstained chastity are no more. Presently the devils attack her in the form of dejection and desperation. Then too late, too late! Alas, our poor girl!

As tradition gave way a bit at the turn of the century, the differences between geisha and courtesan became harder to define. Tradition was still a gloss of habit and manners in the relationship of men and women seeking or selling pleasure, but rules were not as rigid as they had once been. The Japanese journalist, T. Fujimoto, quoted in an earlier chapter, once reported an interview with a geisha-courtesan herself, giving her own words, or rather *his* translation of them into English with a 19th-century flavor that somehow retains the Japanese idiom.

We girls of gay circles are altogether said to be fickle, faithless, two-tongued, and plotful, and there may be such a tendency among some of them, but according to my impartial judgment—I know the true features of our circles very well, as I have grown up and still live in them—criticism or blames against us should be done after the discrimination on the kind or qualities of girls were properly done. The girls who have suffered pains or experiences within the society of the geisha profession are much kinder and more compassionate, and have greater inclination to sympathize with others, than the common, unprofessional girls.

It was a time when I was a dancing-girl *(oshaku)* of only thirteen years old in my present house, and, among many girls in this house, there was a young geisha named Kohana, who was in love with a young gentleman, a son of a rich merchant.

One day the mistress and all the girls of the house went to a theater, but I, being sick on the day, was left at home together with an old maid-servant. About 3 P.M. the girl Kohana unexpectedly came back alone, and told me that, feeling a strong headache, she could not help to be in the theater. After less than half an hour, her lover, the young gentleman, came in too, and confined himself in a room upstairs together with the girl. They seemed to be talking very secretly, and after some twenty minutes, suddenly I was called by Kohana. When I went up to their room, I was surprised to find that the little finger of the young man's left hand was wrapped up with a piece of paper, which was stained with bleeding. Presenting a razor before my face, the girl said to me, 'I pray you to cut my little finger.' At that moment I understood that the man cut his finger himself, but she could not be bold enough to cut that of her own herself, nor he could be so cruel to do it for his sweetheart.

It is an old custom in Japan that lovers cut their little fingers for the sign of true love between each other, and the cutting is done by the way of striking a razor put on the finger with the wooden pillow of the female. Applying the razor on her finger, the girl repeated, 'Please, strike the razor by the pillow with all your might!' But I, being a little girl of only thirteen, was very afraid. I took up the pillow, and, shutting my eyes struck it on the razor. When the blood gushed forth from her white slender finger, she was gazing at the bleeding finger. She smiled, but her face was as pale as a ghost. I was struck with fright, and began to cry out. Her lover turned away his face and could not see the cruel scene.

The cause of the finger-cutting was that the young gentleman had to go to America on his business and stay there for two or three years. To be parted for a long time was very bitter for the two, and, in order to show the unchangeable love between each other, the girl proposed to perform the old

method of oath to show firmness of mind. Thus the young lovers parted with tears.

Sir, how do you think if you know that the going abroad of the young gentleman was a lie? He did not go to America, but on the contrary he married a young lady! One day, two years after the tragic parting, Kohana, the abandoned girl, met with her old lover, accompanied by his wife, in the street of Ginza. She stopped, and felt her heart about to burst out. But the cold-blooded brute turned away its face and escaped off. What a pity the girl was deceived by such a fox! The honest girl cut the finger by her true heart, but the man by his mere whim.

Our world comes after sunset every day throughout the year, though we are rarely hired in daytime. We pass every evening at restaurants or *machiai* (waiting-houses); but those unhappy girls who are unpopular and are compelled to stay at their own houses are ridiculed under the sarcastic name of *ochahiki* geisha. Everyday life of our society's girls is various, but we generally get up at six in the morning, except those who were detained at *machiai* till very late the previous night, who keep sleeping to about ten or eleven. Getting out of bed at six, and after washing the face, we sit down before the mirror on the toilet stand and begin to comb the hair—it takes for combing more than half an hour.

On the other side, *oshaku* or smaller girls are already aroused and driven out of bed by the mistress of the house, and very busy to sweep and clean the rooms. When all the rooms are cleaned up, they must offer lights to the God of Luck on the altar honoured in the mistress's room. As soon as they finish breakfast they are sent out to the master of dancing. When we finish breakfast it is about nine, and most of the younger geisha go out to their masters for the exercise of *samisen*. The older girls who remain at home read letters from their lovers

or acquainted guests, and those who were late last night are yawning and hardly get out of bed at about ten.

At eleven we go out for the hairdressing, and there spend one hour at least, chattering with girls assembled from various houses. Coming back from the hairdresser, we go to the bathhouse; the polishing instruments carried to the bath are numerous—at least seven kinds. Chatters and twitters in the bath while cleaning and polishing are very noisy. When we come back from the bath it is past one, and we take tiffin. Sometimes we are invited by the mistress of a restaurant or *machiai* to the theater, and we are much pleased to spend the afternoon by seeing our favorite actor's performance. If we are at home in afternoon we take up a *samisen,* and kill time by playing on it; but the accomplished older girls are requested to teach or review dancing, singing, and *samisen* for the smaller dancing-girls *(oshaku)* in the leisure time every afternoon.

Approaching the tea-time (3 P.M.) there are heard cries of cake-peddlers in these geisha alleys, and small girls, some eleven or twelve years old, are seen to peep out of their entrance door and buy something from them.

After dark those girls who are not yet hired go out for rambling in the *ennichi* street near their house. When the girls, who have finished dressing, are on the point to go out from their house for the restaurant, it is a custom in our society that the mistress of the house strikes sparks with flint and steal against the back of the girls, wishing good luck of the evening. We first call at the guild office, and, accompanied by the *hakoya,* go to the restaurant. You know very well how we are after the appearance in presence of the guests in the restaurants. We are very busy, and become toil-worn if we have to wait upon a great party attended by a great number of guests.

Sometimes there is such a case that, according to a previous promise, we meet with the customers at a restaurant or

waiting-house and set out from there for an excursion, commonly to a hot-bath resort in an adjacent province. On that occasion we are dressed like ladies or daughters, and take the automobile or the train in night. How happy we are to take pleasures quietly at the mineral bath, while all the expenses for the hotel, and the fees for ourselves, are paid by the customers.

If we are hired to the *machiai,* it is generally after ten or eleven, and there is no need to tell further about merriment *there* as you know very well. Talking one another about the events or guests in this night, we take tea and cakes, and then go to bed.

In the 20th century, the decline of the geisha culture speeded up. What remains is mostly show business, like the Shimbashi Embujo, the geishas' own theater in Tokyo, where their show, *Azuma Odori,* attracts thousands, mostly tourists. But it is dancing, singing, and drama, rather than the old culture of private parties, erotic stories, pinches and hugs for the male guests. The show is best described in Japan as "Girls' Opera."

The plight of the modern geisha is shown by a letter written to the monthly publication *Bungei Shunju* by a Buddhist priest, who in his youth, he admits, was a wild playboy among the geishas and courtesans. He has a cousin who is a geisha, and his interests, in his old age, seem personal for family reasons as well as moral. He writes in part of what was, and what is now the changing scene. He is old and perhaps no longer thinks in terms of the poet:

> The garden in spring
> Filled with peach blossoms
> Lighting the path
> Of a girl walking.

His realistic text is more to the point:

As geisha themselves know very well, if their accomplishments remain old-fashioned they cannot hope to survive in this fast-moving world. Speaking quite frankly, I myself have no longer any interest in the atmosphere of the Flower and Willow World. But the geisha are like a worm which continues to survive after it is cut into pieces. Why? Simply because in the unanimous opinion of the public they have been supported by politicians and wealthy businessmen. The Shimbashi geisha quarter, which is the top-ranking one of its kind, is known as a place of luxurious, exorbitantly expensive and disgustingly snobbish entertainments distasteful to the common people... .

If the Prime Minister really thinks the three evils, corruption, poverty, and violence, should be eliminated and realizes that it is a supreme duty for politicians to devote themselves to the campaign against such evils, he should not allow the geisha quarters to continue while abolishing the licensed quarters which were a kind of necessary evil for some people. Politicians and capitalists are not justified in monopolizing pleasure while they deprive the general masses of that pleasure. The first thing that statesmen should do is to endeavor to abolish inequalities and give equal rights to all people. If the statesmen of this country neglect this, their supreme duty, the Shimbashi gay quarters will continue and may even finally dominate the politics of this country with their magical power. But if someone should now widen the extremely narrow gates to the paradises of Shimbashi, Akasaka, and Yanagibashi so that they are accessible to everybody, he would be remembered forever as a really great statesman. It is ironical that the gate to paradise is so narrow and that to hell so wide.

My geisha cousin has spent more than thirty years in that unfathomable world called Shimbashi. It is painful for me

to advocate the abolition of the geisha quarters where she has lived for so many years. Although I think that the geisha quarters should go, I cannot help wondering if it is the right thing for me to try and enforce their abolition when I think of my cousin. I remember a poem she once wrote:

> When the autumn rain falls,
> My heart aches for somebody.

It cannot be a man, it must refer to her youth before she became a geisha.

The *tayu*—the grand courtesans of the Yoshiwara— were often as well educated and as skilled in song and dance as the geisha. If they were famous and much desired, they could wield power and influence, not only among the merchants and samurai, but reaching to the lords and even to the court of the shogun. Their dramatic silhouette is often on the fringe of history.

The lowly courtesan in a popular brothel might be summoned by having her name shrilled out, but the *tayu* of top rank appeared in her own good time, in her best bizarre silks and sashes, her bow of top rank billowing as she floated in. Her maid carried the sake cup of greeting to a common guest, but she, herself, offered it to a lord, a crested court official.

Her face and what is seen of her arms and hands would be thick with dead-white makeup, the heavy hairdo stuck with pins and elaborate ornaments, she slowly swayed forward off her feet to sink down to the mat, her stiff colored robes ballooning around her like a diving-bell into delightful patterns. It was theatrically effective and a splendor of idealized sexuality.

The wise guest would expect from the *tayu* her skilled services; she was trained to a degree that would confound even

the most debauched of Western rakes. Sometimes the guest would call his companion *ichiya-zuma,* one-night-wife. And some few young men even fell in love with courtesans. Stories from the 17th and 18th centuries do tell a few sad, romantic tales, *à la Camille,* of the tragic endings to such affairs, the happiest (or at least, the most satisfactory to romantic readers) being those that ended in mutual suicide in some pretty spot.

Drink was usually the courtesans' big problem. But in the 19th century, opium-smoking made a little progress in the Yoshiwara. The British, in the Opium War, had forced the Chinese to submit to the drug—opium was a major crop of English-held India and had to have a market. A contemporary description of the process of opium-smoking is fully detailed, using Chinese opium terms, as they were often used in Japan:

> She pulled a floor lantern closer, opened the flat dragon-decorated box and took out the outfit for smoking. She held up the *yeng-tsiang* pipe of orange wood in her hand, lit the small lamp, and from a metal box took up a pill of *gow hop.* She rolled it smooth between thumb and first finger, then put the pill on a *yen hauch* needle and held it in the blue flame coming from the perforated glass of the globe of the *ken-ten* lamp.
>
> The pill cooked and sizzled and with the *tsha* knife she carefully placed the pill in the bowl of the pipe. She took three long pulls of the opium, then sighed in sadness and lay down on her sleeping pad and took three more pulls. She began to drift placidly into peace and quiet. A smile came to the sleeper's face. In the sweet, strong smell of the room, she escaped from a world of reproach and demands.

One can get a very clear impression of what a man's ideal concept of a desirable geisha or courtesan was from a 17th-century book, *The Man Who Spent His Life in Love,* a work

of *ukiyo-zoshi* (demimonde fiction). The author was Ihara Saikaku, and it was popular until modern times.

> When I am asked what type of woman I would like to hug close in my arms. I desire a mellow girl between fifteen and eighteen years of age. Her face holds the glaze of poise, is smoothly rounded, her color is pale pearl-pink cherry blossoms. Her features contain no single flaw. The eyes are not narrow, the brows are thick, but do not grow close together. The nose is so straight, the mouth so small, all the teeth white and regular. As for ears, charmingly long with the most delicate rims, and stand away from the hair so that one can see where they join the head.

In an old text, *Tales of Old Japan,* there is another such description:

> A peerlessly beautiful girl of 16 was neither too fat nor too thin, neither too tall nor too short. Her face was oval, like a melon-seed, and her complexion fair and white. Her eyes were narrow and bright, her teeth small and even, her nose was aquiline, and her mouth delicately formed, with lovely red lips. Her eyebrows were long and fine. She had a profusion of long black hair. She spoke modestly, with a soft, sweet voice…

The Japanese belle of ancient times described by Nagayo Sensai, who wrote that she had a white face, a long slender throat and neck, a narrow but bud-breasted chest, small grasping thighs, small feet and hands, emphasized the ethereal character of the Japanese ideal of beauty: delicate, pale, slender, almost uncanny.

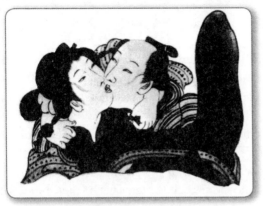

The rare kiss: School of Kunisada, 1786-1864.

In the dawn while I know
It grows dark again
I dislike the coming day.
—*Anon.*

CHAPTER **6** Erotic Talents

So sang many a geisha after a night of entertaining. For the Western mind to understand something of the sexual attitude of the Japanese, one must go to a writer like Colette for a truthful insight into the love act, the instincts of women, the fierce intimacies and exact images, the whole phenomenon that our culture calls eroticism.

She writes the charged phrase, *"Ces plaisirs qu'on nomme, a la légère, physique* (these pleasures that are lightly called physical)," aware that these pleasures actually shake our society like recurring earthquakes. The Japanese did not take these pleasures "lightly." They could agree with Colette's remark: "Restless ghosts unrecovered from wounds sustained… when they crashed headlong or sidelong against that barrier reef, mysterious and incomprehensible, the human body…"

This can explain why suicide and tragic endings occur so often in tales of geishas and courtesans—"the flesh, always

the flesh, the mysteries and betrayals and frustrations and surprises of the flesh."

Yes, there was love in the Yoshiwara, for all the price tags.

The Colette of Japan is Sei Shonagon, writing in the year 1002, long before the Yoshiwara was begun. She sets the mood of certain ideas of love, of physical passion, of classic fornication, and the sadness, the bittersweet of the women's emotions in a culture where the female role is ritual.

Here are some notes from her *Pillow Book,* a personal book of thoughts:

> One has been expecting someone, and late at night, a stealthy tapping on the door. One sends the maid to see who is there, and lies waiting, with a slight flutter of the breast. But the name she brings back is that of someone else; he holds no interest for us at all....

> He should not pull up his trousers the moment he wakes up. No, he should first come close to one's ear, and in a whisper finish saying what was left half-said during the night.. . .
>
> After he has slipped away, she stands gazing after him with precious recollections of those last moments. For the delight in a lover depends so much on the grace of his leaving.

Few writers have captured so well the emotional content of lives dedicated and trained to sexual pleasure.

The Japanese translation of the *Kama Sutra* served as a companion to the pillow books—and was detailed (among other subjects) on types of kissing and welcomed by the inmates of the Yoshiwara willing to please, and the guest earnestly willing to accept the refinement.

Yet kissing was supposed to be unknown in old Japan.

Lafcadio Hearn, writing of life outside the Yoshiwara, noted that in Japanese literature kisses and embraces had no existence.

> Kisses and embraces are simply unknown in Japan as tokens of affection, if we except the solitary fact that Japanese mothers, like mothers all over the world, lip and hug their little ones at times. After babyhood there is no more hugging or kisses; such actions are held to be immodest. Never do girls kiss one another; never do parents kiss or embrace their children who have become able to walk, and this holds true of all classes. Hand-clasping is also foreign to them. On meeting after a long absence they smile, perhaps cry a little, may even stroke each other, but that is all. Japanese affection is chiefly in acts of exquisite courtesy and kindness.

Hearn does not mention the love kiss between men and women, or the sexual kiss, the meeting of lips in erotic pleasure. But the embraces of lovers are common enough in the woodcut prints, and the erotic prints show some forms of erotic kissing.

It seems natural enough for seeking, curious lovers to kiss. But however it came to the Yoshiwara—brought by sailors and other visitors, or of a secret tradition—kisses and embraces were for sale.

The Japanese editions of the *Kama Sutra* list various kinds of kissing:

> The kiss nominal—when a girl only touches the mouth of her lover with her own, but does not herself do it. The throbbing kiss—when a girl, setting aside her bashfulness a little, wishes to touch the lip that is pressed into her mouth, and with that object moves her lower lip, but not the upper one. The touching kiss—when a girl touches her lover's lip with her tongue, and having shut her eyes, places her hands on

those of her lover. The kiss straight—when the lips of two
lovers are brought into direct contact with each other. The
bent kiss—when the heads of two lovers are bent toward each
other, and when bent, kissing takes place.

And there are texts that extend the range of the kiss to the
nape of the neck, the junction of the neck and shoulder, the ear
lobes and inside, the shoulder, underneath the upper arm, in-
side the forearm, shoulder blade muscle, the palms, the waist,
small of the back, the hips, behind the knees, the bottoms of
the feet: the fingers, the knees, buttocks, stomach. "Any part
of the body can be kissed, tongued, nipped, bitten."

Our best guides to the exotic skills of the courtesans are
the surviving woodcut prints, which, with a frankness and
even a kind of puckish humor, show us the copulating styles
of the Yoshiwara. To our sense of morality they are obscene
images and often ridiculous: the postures, positions, groupings
of two or more, the courtesans and guests often partly clothed.
And an enigma exists for us in the strange calm stare of all
the actors in these erotic dramas— expressionless, mask-like,
genitalia caricatured. They appear as figures in a world we
shall never fully understand.

Let us follow a guest as he enters the house of a grand
courtesan of the Yoshiwara as described by Shogi Okada in
a manuscript dated about 1794.

After the bowing, the greetings, the ceremonial drink, the
visitor was undressed, often by maids who then left. He was
usually not nude, but wore a light robe open in front. The
courtesan was undressed but she too wore a light robe. In
the erotic prints her elaborate hairdress was never touched
or disarranged. "There is the play of hands, the touching of
parts, dry or moist. The neck of the girl is the lust produc-
ing wonder and pleasure of the guest." Certainly the shaved,

painted nape of the white neck was the erotic pleasure goal of the first sexual play of two partners. It can be compared to the American delight in large breasts of actresses, the English hedonists' pleasure in well-rounded buttocks.

Passion was expected of a woman whose big toes were bent back—*oyayubi sotte*—just as in our culture red-headed women are supposed to be the most ardent. In the *shunga,* the erotic prints called "spring pictures," we often see the big toe bent back.

While kisses were considered indecent in public, even on stage, kissing, licking, biting, caressing, and near strangling of the neck in private was ardent and expected.

The Japanese have carefully charted the erotogenic zones in both partners for their pleasure, noting how to explore them with tongue and mouth and hands. The neck we have spoken of. The Japanese breasts were usually—by our standards—too flat and small. They are "the budding flowers of the body and should be breathed on and touched with hand and tongue."

Popular among intellectuals visiting the Yoshiwara was the text of the poet Ovid (there are many translations into Japanese) on the reaction to sexual pleasures.

> Love's climax never should be rushed, I say,
> But worked up softly, lingering all the way.
> The parts a woman loves to have caressed
> Once found, caress, though modesty protest.
> You'll see her eyes lit up with trembling gleams,
> As sunlight glitters in pellucid streams;
> Then plaintive tones and loving murmurs rise
> And playful words and softly sounding sighs.
> But ne'er must you with fuller sail outpace
> Your consort, nor she beat you in the race:

> Together reach the goal: 'tis rapture's height
> When man and woman in collapse unite.

A Japanese poet on the subject is never so vivid:

> To recall old love
> Like snow moving,
> Or images of ducks
> Drifting together in a group
> In their sleep.

What was the true sexual reality of the Yoshiwara? So many myths have been presented in Western culture about the sexual conduct of the Yoshiwara courtesans that it is difficult to sort out the facts.

One cannot trust the erotic novels or the pornographic books. They, like Western erotica, are often fantasy, written from the wild imagination of hack writers, pleasing both publisher and public: adults, the *maiko* (apprentice geishas), and *tayozoku* (juvenile delinquents). The writers were often evoking their own hidden dreams. One has but to look at erotic art to see the huge unrealistic penises, those monster scarlet male engines of generation, to grasp that popular exotica bore little connection with reality.

Learned texts are rare. In Okada's manuscript, there is a passage attempting to show what the actual lovemaking of the Yoshiwara consisted of. As many of its terms and wordings for fellatio and cunnilingus are in jargon, and sexual games are described in compounded words that have no meaning in direct translation, we will have to use Western terms in translating Okada's text.

In the manuscript, the old *gohiki,* the customers of the Yoshiwara, speak of fornication as "matching the bird to the

nest." Fellatio, the oral stimulation of the male genitalia, is called in terms of native botany, "twirling the stem," and in the same manner cunnilingus, female oral gratification, the male is engaged in "seeking the seed" (the clitoris). Rear copulation is "splitting the melon." Mutual masturbation is "dew mingling." An erection is "a tree of flesh," pubic hair "black moss," an orgasm "bursting fruit."

The Japanese in those pre-Freudian days had no guilt feelings, or ideas of *any* sexual act being perverted. In the 20th century they read Freud and were puzzled by his texts:

Perversion: We have been forced to perceive in every fixed aberration from the normal sexual life, a fragment of inhibited development and infantilism... The perversions thus prove themselves to be, on the one hand, inhibitions, and on the other, dissociations from the normal development.

The union of the genitals in the characteristic act of copulation is taken as the normal sexual aim.... Yet, even in the most normal sexual act, certain addenda are distinguishable, the development of which may lead to aberrations described as *perversions*.... The perversions represent either (a) anatomical transgressions of the bodily regions destined for sexual union, or (b) a *lingering* at the intermediary relations to the sexual object which should normally be rapidly passed, on the way to the definite sexual aim.

To the Yoshiwara this made no sense, even when Freud went into details of foreplay—what the Okada text calls "trembling silk":

Sexual Utilization of the Mucous Membrane of the Lips and Mouth: The employment of the mouth as a sexual organ is considered as a perversion if the lips (tongue) of the one are brought into contact with the genitals of the other, but not when

the mucous membrane of the lips of both touch each other. In the latter exception we find the connection with the normal.

Since Freud, Kraft-Ebbing, Kinsey, and others have been translated into Japanese, many of the intellectuals have developed guilt complexes. But the vast population of the islands doesn't read volumes on psychoanalysis or sexual inadequacies and thus has remained pretty loyal to the old ways of sexual pleasures, even with rock-and-roll music, Coke-and-sake cocktails and the hot dog.

One wonders what Freud would have made of the Yoshiwara, where almost nothing was too bizarre.

Besides all the true "necking" there was other foreplay described by Okada.

It is the woman's duty with respect, eyes lowered, to gently seek out the guest's pleasure. To hint, to make bold little gestures toward his parts and his body, to see what he will enjoy, and give little cries of delight. Handling of his genitalia with grace and charm took place, then the oral manipulation, mouthings taught from a manual as to tongue and lips, pressure, pace and intensity. If the guest is elderly, this "silk trembling" should not continue to the discharge of his vital juices. But of a young man the pleasure should continue to full flood. Elderly guests who have come stored with their carefully hoarded potency for this night, should be caressed, mouthed, but not brought to full flowing too soon unless that is their way to pleasure.... Rather a wise girl perks his interest till his tree is firm and solid and erect. Then asks which way he wants to proceed to the fruit bursting.

There were love potions, drinks, aphrodisiacs, of course, but until the 19th century they consisted of rhino horn powders, tiger balms, Chinese ginseng roots (*jen shen*) and mixtures with

native herbs such as *jiogen,* made from the orange plant. Most likely the imagination of the guest did the rest.

The ginseng root was important in American history. Rare in the Orient—something like truffles to the French—an American variety was discovered in the mid 1800s. Frontiersmen could get high prices for roots, which found their way to the Orient, where astounding sums were paid by wealthy old men in search of rejuvenation. To this day, in the Allegheny Mountains, ginseng is sought by natives who have no notion of the ultimate destination of the *jen shen,* the ginseng root they harvest.

In the 19th century, deadly cantharide, extracted from the Spanish fly, appeared in the courtesan houses. It was and is a sinister mixture that can kill by an overdose. It does not actually arouse true sexual desire, but irritates the bladder and so inflames the tracts of the genitalia.

One of the favorite foods of the geishas, the courtesans, and their guests was *fugu,* the Japanese blowfish. Not only was it costly and said to be an aphrodisiac, but there was a gamble in eating it at all. Unless properly prepared by an expert, it can kill. It was and still is a great delicacy among the thrill seekers of Japan. An old news item from the *Manchester Guardian* gives us all we would care to know about its history:

> *Fugu,* or blowfish, the Japanese delicacy, last year killed 98 people who had eaten it wrongly prepared. But they need not have died, according to medical specialists. An ounce of its poison, tetrotoxin, is enough to kill 30,000 people. But *fugu* is served in absolute safety at scores of *fugu ryoriya* (blowfish restaurants) as raw fish, slices dipped in a piquant sauce, in bubbly stews, and with its fins grilled crisply over charcoal, then eaten after dunking into hot sake.
>
> High-grade *fugu*—*tora fugu* or tiger puffer as it is called after

its black-green and orange-yellow bands... is handled by a battery of specially licensed male and female 'fish surgeons'. Snout and fins whacked off, then skinned and gutted, the puffer is laid open, first to determine the all important factor: its sex. The female is the deadlier of the species, with poison brimming in its ovaries. Male *fugu* poison, less virulent, though it can kill within half an hour, is found in the liver'... but *fugu's* real weapon is the hidden sac of poison that must be carefully excised, before knife and fork, or chopsticks, can safely be set even to cooked flesh.

Most victims are self-styled chefs, or were. They failed to cut out all the poison or wash away the residual seepage. A 'fish surgeon', trained by cutting up 5,000 of all kinds of *fugu* under a master chef's eyes, can prepare 10 to 12 *fugu* an hour. In fins alone is left the merest suggestion of poison, just enough both to change the taste of heated sake and slightly to numb the sipper's upper lip and tongue tip.

The diner has the sensation, thus, of playing a sort of dinner table Russian roulette. Victims suffer no agony, except mentally, knowing death is at hand. The symptoms of poisoning are numbness, sudden chills, increasing rigidity. Strong poison can kill in five minutes. Induced vomiting is the best remedy.

A complete *fugu* dinner is never cheap. It can range from $2 to $15 depending on the class of restaurant.

The Japanese say *fugu* has slight aphrodisiac qualities, and is beneficial in the same way as hormones.

As some men seemed to have had psychic impotency at times, it was a Yoshiwara courtesan's task to jolly and charm the slow or elderly into the proper state of readiness. "No guest who makes the journey to you is without hope." There are humorous prints by the old masters that depict the scene.

The desired result has been the same in all cultures from

the dawn of history; the full spasm of the orgasm. Sappho, the Greek poetess (popular in Japanese translations), expressed it for all time:

> . . . and through and through me
> 'Neath the flesh, impalpable fire runs tingling;
> Nothing see mine eyes, and a voice of roaring
> Waves in my ears sounds;
> Sweat runs down in rivers, a tremor seizes
> All my limbs, and paler than grass in autumn,
> Caught by pains of menacing death, I falter,
> Lost in the love-trance.

The geishas and courtesans, being the hetaerae of Japan, were skilled beyond the conjugal habits of wives, although wives served their husbands when they could with all the sexual games of the courtesans if it was requested of them. The wife, too, had a text, usually of pictures—a *Pillow Book*—given to her as a bride. But the husband who could afford it preferred what we call "infidelity" to pleasure on his wife's sleeping mat. "Why use the cooking vessel at home when a vase waits to delight?"

When the Yoshiwara guest felt he was ready for it, actual fornication could begin. Most *shunga* prints show copulation taking place not in the nude but in light open robes. The Japanese artists of the best periods of print making, 1680 to about 1880, did not draw from life and they had no interest in accurate anatomical detail or facial expression, so that even the great masters, Masanobu, Kiyonaga, Harunobu, Hokusai, present us often with spineless rubber girls with no bones, men with impossible sexual muscles, pubic hair and vaginas in no acceptable anatomical correctness. But Utamaro's women—he was a great lecher—are marvelous. To the eye trained in Western art, the nude guest and the nude courtesan, when shown in sexual

congress, need getting used to. For in Japan, the popular folk artist is trained to see things not at all in the Western manner of the Greek statues, or of Titian, Rubens, Renoir, Pascin. All those nudes in glowing color and rounded realistic detail come closer to the camera image than do early Japan's more ordered, symbolic patterns of the nude man and the nude woman. At first they are as strange to us as sushi, the native gourmet's raw fish.

What used to be thought of—but practiced in Victorian times—as proclivities abnormal on moral grounds, had no sense of wrong to the guest or the courtesan of the Yoshiwara. They were traditionalists, and coitus could be reached in many accepted ways or byways. All were accepted and acceptable. Prints show many positions for sexual intercourse. Western authorities on the subject often state there are 38, or 48, positions. It depends on what school of erotic postures one reads. The Japanese claim many more, but many are simply variations of one another. Approach from the rear in intercourse was common. And what was called *soixante-neuf*, 69, in our texts (Japanese "bud to bud"), in the Yoshiwara was up to the male partner. No woman feels it polite to demand any sexual attention for herself unless the guest suggests it. "Fidelity to tradition is a woman's best gift."

The well-trained courtesan had her vocal range of giggles, screams, moans and groans of pleasure, sexual pants, the whole quivering game of body frenzy to show the guest what his efforts were producing on her body and emotions. Most of these were playacting. The guest would often grunt like a swordsman going at another in battle.

Many nights of pleasure were group efforts in which a man would invite "some few honorable friends to enjoy with him the pleasure of some of the best courtesans." Such parties (called "daisy chains" in erotic circles of the West) were, if one can believe the erotic prints, like organized football plays,

with various foreplays, positions for fornication, and oral and digital stimulation going on all at the same time. The thing that strikes one as surreal in these pictures is the calm poker-faces of the players, expressionless to us, all serious, as if taking part in some ancient ritual ballet. Boat trips—"Summer Twilight on the Sumida"—were popular mixed orgies on water. But still expressionless.

In reality the pictures fail us. An erotic text states:

> Much noise can be made and drinking of sake can cause gayness and a happy madness of the guests. It is best to keep the guests in order with funny sayings and telling of stories, smutty and laughable.
>
> Sometimes this failed, and next morning there were bills for breakage, or damage to mats and screens, for black eyes and lost teeth. The amount of sake consumed usually was inflated on the bill of the exhausted, befuddled guest. Few *ukiyo-e* artists show the sordid side of pleasure.

A picture book with a text by an unnamed 18th-century writer gives us a close look at the lower-class brothel in describing a dance called the *chonkina*, which preceded modern burlesque stripping by a few hundred years:

> Who dance the Chonkina? [it begins] Low class courtesans or geishas. They think like all public women, low or high. To make you happy, to be rewarded. The party was held in the second-rate teahouse run by a woman called *O-Roma* (Miss Pony). The usual teahouse with its bowing maids, the ritual of removing shoes, clean rooms and sliding screens, the smell of body powder, intimate female life and the scene of a damp garden-plot outside its windows.

Ten guests were bowed into a room and seated at low tables. Food appeared, tea was served, and white jars of sake were opened. Guests offered toasts and bragged loudly.

It was warm in the room, but no one pushed open any of the windows. Behind a curtain a drum began to beat. The guests began to chant.

Chonkina, chonkina, hai! The curtains opened and Miss Pony was behind them, beating on a small drum. One of the girls was plucking on a *samisen*. The music was shrill and there was a beat of sensuality to it.

Ten girls appeared, almost rolling into the room with their mincing walk. They were fully dressed in ceremonial robes, and on their faces and necks was the liquid porcelain powder of their public trade. Some guests did not feel they were women at all; an unresisting maid coyly screamed as guests grabbed at her.

The dancing girls were moving in a slow, swaying movement that seemed to have little violent effort to it and not much passion. Suddenly the music stopped. All the girls froze into position. Only one girl—too late—made a final gesture. She was still moving after the others were still. Everyone laughed. The guests began to shout. The girl who had failed to stop in time began to untie her sash. Expressionless, she dropped the sash on the floor. The music began and all waited; again it stopped. Another loser lost her sash. A girl lost her kimono, then her undershift and stood staring half-naked at the men. The steam of excited breath, spilled sake and the close odor of the dancers filled the room. Someone opened a window screen a few inches. A short girl was pulling off her underpants, exposing red flesh, thighs…

The dancers no longer looked alike. Their bodies with no powder on them were yellow and brown, mottled and with the pubic areas oddly shaved. Sweat ran between their breasts.

Some were still young—only ten or twelve—and had small, budding breasts. Two were older and their breasts sagged obscenely. The game went on and the guests slapped each other across the table, broke sake cups gleefully and shouted like animals in rut, showing their teeth. They twisted their hair from their eyes with oily fingers, making grunting sounds.

The tallest girl was naked now. Her legs were fine, her arms thin. Her breath came with some difficulty. A small girl was becoming animated as she clung to her one remaining shred of attire. Then this, too, fell. The women no longer looked like dolls. They looked patient or amused. One seemed drugged by the music; she gestured in a frenzy and pranced about, legs apart, with large hips and flopping breasts, coming nearer to the guests.

The gestures no longer could be called a dance, or even a game. It was obscenity: enticing, sexual, yet graceful.

The guests were stumbling to their feet, joining the dancers and beginning to get rid of their swords, dropping their robes. Big in chest, short in legs but powerful in the arms, their heated faces turkey-red, they were mauling the shrill animated girls. The drum went on with its booming leer. Some of the lamps were blown out.

One guest rose to escape. Two little maids clung to his arm as he tried to leave, '*Iya*! *Iya*! Don't, don't!' they screamed, sake spraying from their drunken little mouths. They stepped over couples rolling on the mats in shameless frenzy. With drunken, fumbling shouts, the orgy continued.

The Yoshiwara, being unrestrained in its offerings, could match almost any activity to the mood of its customers. For the *voyeurs* there were peepholes. Masochism was not unknown. "Some of the guests may have strange exotic habits, and if they do not break the skin, the gentle girl will work to please him." There is no mention anywhere of flogging, whipping,

spanking, so popular in French and English records.

For all the hard night (if the guest stayed the night) the morning goodbyes remained, on the surface, polite. And if the groggy guest was carried to a bathhouse, and was young, and still had money, the bathhouse girls would rouse his sexuality and rub him to ecstasy again. In bathhouses and in the back of the green-tea houses the maids and attendants were skilled in the handling of the phallus of the guest.

Then they sent him on his way home to his wife, and perhaps a concubine or two.

Concubines bought out of the Yoshiwara are not to be confused with the geisha or courtesan. Usually she was some poor girl, sold to a household with a still ardent husband who felt his wife was getting on or too busy with household duties and children. All this was not enough to make home as entertaining a place as a brothel, so if a man could afford it, a concubine appeared—like a second car in an American family.

Freud on the subject of foreplay games today seems old fashioned.

Unfit Substitutes for Sexual Object: We are especially impressed by those cases in which the normal sexual object is substituted for by another, which, though related to it, is totally unfit for the normal sexual aim.

The substitute for the sexual object is generally a part of the body but little adapted for sexual purposes, such as the foot or hair or some inanimate object (fragments of clothing, underwear), which has some demonstrable relation to the sexual person, preferably to the sexuality of the same. This substitute is not unjustly compared with the fetish in which the savage sees the embodiment of his god.

The case becomes pathological only when the striving for the fetish fixes itself beyond such determination and takes

the place of the normal sexual aim; or again, when the fetish disengages itself from the person concerned and itself becomes a sexual object. These are the general determinants for the transition of mere variations of the sexual instinct to pathological aberrations.

Havelock Ellis, who wrote of sexual habits in great detail, described the products of Japanese sex shops:

Japanese women have probably carried the mechanical arts of auto-eroticism to the highest degree of perfection. They use two hollow balls about the size of a pigeon's egg (sometimes one alone is used), which, as described by Joest, Christian, and others, are made of a very thin leaf of brass; one is empty, the other (called the little man) contains a small heavy metal ball, or else some quicksilver, and sometimes metal tongues which vibrate when set in movement; so that if the balls are held in the hand side by side there is continuous movement. The empty one is first introduced into the vagina in contact with the uterus, then the other; the slightest movement of the organs causes the metal ball (or the quicksilver) to roll, and the resulting vibration produces a prolonged voluptuous titillation, a gentle shock as from a weak electric inductive apparatus; the balls are called *rin-no-tama,* and are held in the vagina by a paper tampon. The women who use these balls delight to swing themselves in a hammock or rocking-chair, the delicate vibration of the balls slowly producing the highest degree of sexual excitement. Joest mentions that this apparatus, though well known by name to ordinary girls, is chiefly used by the more fashionable geishas as well as by prostitutes. Its use has now spread to China, Annam, and India. Japanese women, also, it is said, frequently use an artificial penis of paper or clay called *engi.*

In the 19th century, sex shops sold various devices, such as condoms with demon and rooster heads in which knobs and feathers were embedded, and dildos of fanciful construction.

Some of these businesses exist even today. During the Olympic Games in Tokyo in the middle 1960s, some firms were asked to stop issuing their catalogues (at least until the Games were over). They are written in a halting deficient English. One states on the cover: "We hope your kind favor as before." Several versions of rubber genitalia of both sexes are offered, as well as contraceptives (called "pleasurer increasers") and small pop art sculptures.

The Music Ball described by Havelock Ellis is still an old Yoshiwara favorite, and some prints of it exist, as do other devices used by the courtesans and geishas for centuries.

A phallic crutch is sold as "the Blesser-reform apparatus. This is a blessing to men's feeling and will get young if they see this wonderful thing. We particularly recommend it to elderly men."

Aphrodisiacs were a science in the Yoshiwara—or so it was claimed. The catalogue gives a few clues to the potions used by courtesans and geishas to excite the jaded male.

"Women Happy Medicine" is further described as Jungenol Cream, a new aphrodisiac preparation.

"Long Time Cream for Men," or LAR, is described as a preparation which "ajusts (sic) or moderates over-sensibility."

Other steady sellers are *Yohimborde* Tablets, which promise "you cannot stop all night enjoying your life."

Koseiso "is made from harmones (sic) of misterious (sic) wild animal in Formosa." *Gentopin* is a cure-all.

Such way-out modern preparations would have been considered beneath the art of sensuality of the earlier courtesans. No artifices were needed, only the fine food, the sake, the suitable introductions, and the exquisite sexual play.

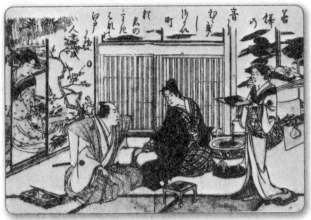

A homosexual romance: Shigemasa, circa 1794.

Will he always love me
I ask his heart,
At dawn my ideas
Hang in disorder
With my hair.
—*Folk poem*

CHAPTER **7** The Many Faces of
the Floating World

The delicate tensions of the Yoshiwara were not all on tissues, nerves, and manners. The geishas constantly caused trouble, for they were competing with the courtesans in the sexual games, doing prostitute's work, besides their singing and dancing. Male geishas corrupted the courtesans with wild love-affairs, their intimacies becoming liaisons that kept the prostitutes from concentrating fully on their professional duties. They read love-poems, wrote some themselves, got drunk, abused the guests, had to be beaten by brothel-keepers to keep them in their respective place in the community instead of acting like tumultuous children. It is clear that the women did not merely gaze into mirrors framed in cryptomeria wood,

or reset their combs of kingfishers' beaks. Yoshiwara was a community of dozens of interacting mortals. Long before modern psychology, Yoshiwara women knew that individuals are complex, integrated organisms, that the lonely self is in continuous involvement with its environment. And so it was hard to say *"Horshiu—*Everything is all right."

The registering and licensing of geishas of both sexes was decided upon in 1779. One Shoroku, the keeper of the brothel Daikoku-ya, gave up his place and took on duties as Director of the Geisha Institution, and he became head of the control of all geishas, *joruri* singers, and *samisen* players. Some attempt was made to keep them from abusing the rights of the courtesans in the sex department. And with tighter control, courtesans could command a cataloging of their fees, charms, and dress. The novelist Shozan, near the end of the 18th century, listed a certain few charmers who were subtly trained to ask not, What is love? but, rather, What does love do to one?

Grand courtesans, in moving about the Yoshiwara, were usually attended by two personal maids called *kamuro*. They wore the same rich dress as their mistress. These maids lost their true names when they served a courtesan, and the brothel bosses gave them cheerful, simple ones such as *Chidori* (Plover), *Namiji* (Wave), and *Nekko* (Cat).

Promising *kamuro* were judged to see if they might be worthy of becoming courtesans some day. The most promising were taught the *koto, samisen,* flower arrangement, the tea ceremony, *senko* (incense-burning), and the reading of texts beyond *hiragana*—the simplest sort of script. They began their careers at the age of five to seven, usually bought from relatives or parents. At thirteen, if showing grace, beauty, spirit, and alertness, they became *shinzo*.

They were given a formal social debut by all the inmates of the brothel, dressed in habutae silk. The *abaremono* (the wild boys), with their incantations and clever sayings, set out buckwheat pasta, rice boiled with beans. Guests were given small presents. The gala lasted for days. Bedding, clothes, and furniture were provided for the *shinzo*. She paraded with another new *shinzo* for a week along the main street. Sake cups bearing her name and crest were handed out to various teahouses, the way advertising books of matches are passed out today, to attract customers and guests who relished the very young *shinzos*.

It is doubtful that many *shinzos* were virgins when they entered the trade, but there would usually be a bidding among the more favored guests for the deflowering.

Upon becoming *shinzo* the girls were honored by a certificate of sale. The brothel-keeper would pay *mino shiroki* (body money). Cunning parents or sellers of a girl, feeling they could do better elsewhere, sometimes used a procurer *(zegen),* a professional girl-agent, to get a better price in another whorehouse.

Not all courtesans were low- or middle-class children sold into the Yoshiwara. The *yakho* were a strange group of women of the highest class of society, from the ranks of the samurai themselves. Punished by the stern rules of the courts and samurai for some fall from virtue, they were sent to the brothels by their families. The term was three to five years. It seems a fantastic thing for the proud samurai lines to have done. In time, many women sold to the Yoshiwara from other localities claimed to be *yakho,* and the term became general and lost its old meaning.

The brothel owner was engaged only in superintending his establishment. The actual overseeing of the place, the courtesans, the servants, the order or disorder, was usually

done by a tough middle-aged woman called *obasan* (Auntie). Her room or office was situated so she could view most of the doings of the establishment. Often an old world-wise courtesan, she knew the tricks and lies of the customers and the girls. She could be cheerful in greeting, and harsh and effective in a crisis.

Auntie greeted guests, spoke highly of the house girls, and tried to fit what she felt were the guest's needs as to the type or temperament *(yukwaido)* of the girl. She kept the girls alert and saw that they respected the guests, laughed at their jokes, jollied them if they were sad, and responded to their sensuality if they desired.

No matter how they bowed or smiled, the maids and courtesans knew Auntie often as a hard taskmaster, cruel, stern, and punishing. Auntie's real income came from the guests' tips and a percentage of the fees collected by the house. They also, like modern butlers and housekeepers, got a kickback on all food and other items ordered for the guests.

Aunties did well. Some brothel owners put up signs of *No Tipping, Please* so that the customer could expect the best of services and treatment without extra fees. It was a failure; no guest dared pass the lynx-eyed Auntie and not drop 20 or 30 sen into her outstretched palm.

Punishment of maids and prostitutes who broke rules or raised the ire of Auntie was cruel. Corporal punishment was swift and hard. The lower-class houses often seemed to have a sadist in charge.

They were also money-lenders. Working at usurious rates among the courtesans, they usually retired very well-off. Although they were cruel to them, the Aunties made exceptions. They had their sugar-plum favorites and lesbianism was common in many brothels among the prisoners *of* the Yoshiwara.

Men-servants, regardless of age, were all called *wakaimono* (young fellows), and a sleek, wise lot they were. They were watchmen, guards, bathroom and bedroom attendants, took care of the shoes or clogs, and got a small cut on any food, drink, or items they handled. Their take, or bite, even went on in those places where the guest paid the courtesan in person. She usually "lacked" the proper change and suggested the guest give it to the young fellow. A *wakaimono* even made a few sen by selling the waste-paper.

Male geishas of a particular class were called *hokan*. They attended sake parties and entertained by singing, dancing, and telling obscene jokes: "He has a wide ass." Many were completely degenerate, others homosexual. They used a fan as they bowed. They waited until the sake bottles and the food and heat of the party had taken effect on the guests, and then the *hokan* did their stuff. They were droll, wild, full of sweet-potato flatulence, involved in smutty pantomime and vulgar, suggestive dancing. The guests shouted for more and more, and (as with burlesque-house patrons today) cried: "Take it off! Take it off!" They too, danced in *"puris naturalibus."*

The Yoshiwara *hokan*, known also as *otoko* (male) geishas, were not treated with much respect, nor held as high in esteem as the female geisha. Their indecent prancing and phallic exhibitions were most in demand when a brothel-party was drunk and needed some way-out excitement to please the jaded guests, eyes rolling in expectancy.

Officially, the shogun government registered the *hokan* as Embankment Coolies (*dote-ninsoku*). Some districts listed them as shampooers, insect destroyers, bailiffs, privy cleaners. All were *gojomono*—obstinate guys.

Dilettantes, lovers of art, poets, the bored and wealthy circles were amused by the hokan. Some of them were educated and even had social standing.

Although regulations and harsh laws existed from time to time against homosexual practices, they were deeply entrenched, often among the highest officials and the rich dilettantes of the arts. Some men dressed as women even imitated the courtesan's coiffure, the *hyogomage.*

The homosexual usually wore a forelock called a *maegami.* Some wrote poetry, and from a 17th-century print by Masanobu one can translate the verse of a male courtesan, or a temple page, of a homosexual priest.

> A Fragrant Plum youth
> Fond of our pederasty
> Gives you the first
> Smile of the year.
> —*Anon.*

Homosexual circles centered mainly around the Kabuki theater. Handsome boys played all the women's roles, as in the Shakespearian theater, and homosexual relationships existed between Yoshiwara actors who were often also male prostitutes.

In the first year of Joo, 1652, there were rulings against the appearance of actors' companies, but at the petition of "certain persons," playacting came back. Actors were ordered to shave their heads above the forehead; hair (as with the hippies of today) being considered sexy.

Actors playing women's parts covered their shaved foreheads with pale lavender-colored towels. In Japanese prints, any picture of a pretty girl with such a headband is meant to signify a male actor playing a woman.

Some native historians reported seriously that the males in female dress were much more beautiful than women: "The prepossessing appearance... so greatly outrivaled the beauty

of real women [that] the habit of enjoying unnatural vices spread through the town."

Called *yaro*, the homosexuals became boldly public in the way they are doing at present in large American cities. Woodcut prints of famous courtesans, geishas, waitresses, and actors were so popular that a publisher brought out pictures of well-known *yaro*—even a text of their habits and history and physical charms.

Homosexual brothels were established in the Negimachi district of Edo known as Children Houses *(Kodomo-ya)*. Young boys offered their services in the manner of the Yoshiwara prostitutes. They, too, were trained to sing and dance and recite, and many became actors of female roles.

Homosexual love had its own sagas, and while there might be official disapproval, many officials, lords, and highly placed people took to "manly love" among themselves or entertained male prostitutes. The novelist Ihara Saikaku, in his story *Gengobei, the Mountain of Love,* tells of a woman who posed as a boy to try to win the love of a famed homosexual.

There was a man named Gengobei… and night and day he was passionately after the bodies of young men. Never had he lain in amorous play or connection with the weaker, long-haired creatures called women.

[But the girl Oman in male dress managed to spend a night with him, he thinking her a boy.]

Gasping for breath, in lust and desire Gengobei moved his hand up her wide sleeve and grasped greedily her naked flesh. What a surprise: this boy was not wearing male underwear! Oman remained amused—but wondered what Gengobei put in his mouth and chewed.

"What have you done?" the girl asked. [He was chewing *nerigi*—an aphrodisiac produced from the hollyhock plant.]

Removing his garments... he kicked them away and proceeded to the game of sexual pleasuring, always an interesting drama, a game for anyone. First off came her obi... then he thought, poor boy, the country air may be too cold for him, so he put a robe over the young body.

"So—we begin," he announced, pressing his head on her arm. He was wild with pleasure—so he went sliding his hand over the smooth back. Not a scar, not a blemish—an untouched, innocent boy!

As Gengobei began with eager probing hands to move down to her hips—and even lower—Oman grew somewhat panicked. The thing to do, she decided, was to make believe she was in a deep sleep.

Eagerly he began some tantalizing love play, and as she wrapped one leg around his body, he saw female underwear—red crepe, woman-styled!

Gengobei in shock examined the body so near him with care—saw that this fine boy had the delicate face of a girl. What a shock indeed. For moments he couldn't utter a sound. He tried to pull away, get up off the sleeping mat. But no, Oman held him in close tight grip...

"I had to do this... dress myself as a boy, come to you. Why blame me for my great passion for you?" With this she thrust her warm beautiful young body more firmly against him. So it didn't take Gengobei too long to feel a sensual lust for this girl.

"There isn't any difference," he said, "the making of love to a man's body, or making love to a woman's body!"

He was carried away—uncontrollable in his animal desire, this overpowering passion which dominates so much of the foolish world. These lusts, desires, rake us all. Gengobei is

> not the only one. Call it nature's trap, but we all put our foot
> in it. Even Buddha may have lost one of his feet in the game.

The author thinks poorly of the lusts in women; widows are the worst offenders. "Can she lure the dead man's brother to take his place... See, there is a trace more powder and paint on her face... her hair has its old oiled shine, and alluring in its whorish wild locks free of the hair dresser. Aho, look at her underwear, aflame with color beneath the simple robe—just showing itself—waiting to be seduced... Nothing is as dangerous as a woman. No force can keep her from her heart's desire; the man who resists will bring on the great flood of tears... It's that way, too, with some men—but then a man who has managed to kill three to five wives, who's to stop him taking just one more."

Most of the guests at the male brothels were priests and the military. These debauchees dressed as women, aped the walk and voices, and wore long hair in the fashions of the women.

By the An-ei period (1780), homosexual practices were at their height. Ten famous male brothels existed and close to 250 inmates for male pleasuring were available. Some moralists lamented the presence of these brothels. One was actually on the grounds of the Yushime Tenjin shrine, and others were near the shrines of Shimmei, Hirakawa Tenjin, Hachiman. Pieties and perversions were being mixed.

By 1830, laws had reduced the male brothels to four, the Yoshima establishment having twenty-two lads.

In the 13th year of Tempo (1842), the 12th Tokugawa shogun, Ieyoshi, commanded Tadakumi, Lord of Ichizen, to destroy the homosexual brothels. "Rooted out," says one naive historian, "unnatural sexuality ceased *almost* entirely in Edo." The italics are ours.

Outside the brothels, the homosexuals became "incense salesmen." Capriciously and richly dressed, with female grace, carrying kiri-wood boxes of various incenses wrapped in blue cloth, they called on the best houses of the gentry and nobility, offering both incense and themselves.

Women of the upper classes did not accept decadence of this sort without reaction. They copied man's habits, attending Kabuki dramas and inviting the more handsome of the actors to teahouses for their sexual pleasures. Female libertines of good families completed their husbands' and brothers' debasing of the actors. High-born ladies broke the bonds—sexually—of the male-dominated home.

A champion wrestler during *la belle époque* of the shoguns in the heyday of the Yoshiwara was the honored guest of the grand courtesans, admired, spoiled, fed, wined, and sexually desirable. Because of his size and weight, the normal, or rather accepted, positions for lovemaking were usually impossible, and the various poses shown in pornographic prints also picture oral gratification. Fellatio, we see, was honorably common, as performed on the sporting figures.

If geishas got a bad reputation, it was because of their great attachment to wrestlers and actors. Japanese erotic romances feature the sexual prowess of the Kabuki actor and the heavy brutes of the wrestling ring as heroes, the great and lusty lovers. Their performances, producing multiple orgasms, were told of in many stories. The actor, a vain peacock if he wasn't a homosexual—as many were—was hardly a loyal heterosexual lover. As for the man-mountain wrestlers, many weighed more than three hundred pounds. Some medical authorities claim that because of their weight and abnor-

mal build their testicles atrophied, and that as partners for geishas or courtesans, many were not capable of acting as a functioning man.

In the text of Shogi Okada, we find a fine description of how a geisha and her lover also went to the *sumo* wrestling:

> The *sumo* house was large and mats for the guests were placed around a padded circle. They sat down behind a barrier made of bales of rice. Seated near them were nobles who nodded and hissed greetings to each other. He knew now that he had been brought here to be inspected. To be met and observed. He tried to look around him without attracting undue attention. They were mostly young, but he noticed some gray topknots among them.
>
> The ring is made of sixteen rice bales. One each for the points of the compass and each of the twelve months. A bale is removed from each side for an entrance. Two huge men entered the ring and bowed in the direction of a Lord, the sponsor. An official with a wand-like fan of office followed them. The wrestlers were amazingly fat, with great flanks and arms, bulging buttocks and cheeks like hanging melons. They were ritual aprons of costly materials and they rinsed their mouths from buckets of water. The biggest one was the champion. He was called the *Yokozuna,* leader of the *Maku-no-uchi*—ones-within-the-curtain. The artist, Shunsho, made a print called "The Strongest and the Fair" of this wrestler, Tanikaze, posing with O-Kita, the famous geisha.
>
> The *Dohyoiri,* the ring entry ceremony, began.
>
> The ceremony of the entry of the wrestlers was impressive. The wrestlers stamping their feet, throwing some grains of salt, clapping their hands and bowing to the sponsor, the official, and the guests. The ceremony over, the two large men faced each other, their aprons off, wearing loin cloths, their

large hands out, knees bent, their little eyes almost lost in fat. Then, with a grunt, they met, struggled for grips, locked limbs, grunted, heaved, and panted. There are forty-eight different falls and throws. The men must stay within those accepted forms.

The great Tanikaze suddenly side-stepped, twisting and gripping the man who faced him. They pushed, turned, and then Tanikaze lifted, turned, and with a back-throw, tossed his opponent down. There was a sound of delight and the big wrestler bowed to the Lord.

The room was getting warm. The guests fanned themselves, the official made some remarks, and Tanikaze again faced the man in the ring. He won one more fall. He bowed, and the ring held two more of the giants. They are Japanese, have the real *Yamato damashu*—Japanese spirit. They eat well and do nothing but wrestle. The sweat and smell of the huge men locked in fleshy combat was not unpleasant.

Then, for the lovers, the time came, and he went back to his father's court in the north. A long time after, he wrote a poem:

> Long ago, when my mind
> Was all on the geishas,
> I never had enough of the *shirokubi*
> —The white-necked ones...

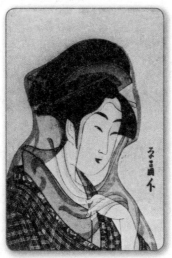

A grand courtesan: Eishi, 1765-1815.

When I see the first new moon
Faintly in the dusk
I think of the moth eyebrows
Of a girl I saw only once.
—*Anon.*

CHAPTER 8 Yoshiwara Fashion

How would they look to us, these famous women? Shocking, at first, because of their makeup. Fashion magazines of the day were fascinated by the styling of the face and body of the courtesans and geishas. From their pages we can see the myths they projected—yet so much of it was true.

Small mysterious elegances, stylized gestures, curious gliding walk. The intense display of polite accomplishments, designed by an ancient and elaborate plan to find supreme pleasure in artifice. Geisha makeup is a masque to screen reality; the traditional wig, immense, weighty, complicated. Layers of

magnificent silk kimonos—of fine sheen. Thinnest, palest
pink next to the skin; then red, then flowered pattern of yel-
low and red, pale plum and black, brocade fastened with a
green obi and scarlet cord.

It is a picture in heightened colors, yet so much *is* decor, so
much a tradition of colors and fabrics, that it is hard at times
to find the individual. The picture a girl of the Yoshiwara
presented to guests was, in a way, a painting.

The making up of the face and head of the courtesan and
geisha was a long, involved process, as ritualistic as Shinto
prayer. With a scrubbed face, the girl faced her battery of
mirrors and studied her features. She first put on a base of
camellia oil, then a half-masque of pink undercoating. Tokyo
geishas brushed white over pink; Kyoto geishas started with
white, added pink later. The masque hardened quickly, so an
agile hand was needed. With a fresh, flat brush, everything was
blended to look like ivory—no trace of the basic skin showed.

Then a brush for rouge around the eyes and for the doll-
smooth cheeks. Eyebrows and lashes were cleansed with a
damp towel in preparation for their color. A quantity of white
powder was put on with a cotton puff to cover everything.
Now came a bit of drawing with a black pencil: the illusions
of sideburns were added. Eyebrows were painted on very red,
then covered with black with just a thread of red showing. The
mouth remained small, expressionless in a bright vermilion.
The eyes were also rimmed in red with a tiny brush, covered
by a second line of soot-black. Lots of the white masque
was brushed over the throat, bosom and—most important for
the male fetish—the nape of the neck, which Japanese find
beautiful and maddening. Finally an elaborate black wig was
added just so, lacquered, jeweled, and pin-stuck.

A popular Japanese book, dated 1791, on the fashions in the Yoshiwara, gives us a detailed look at the styles of the grand courtesans.

The upper garment consisted of white *nanako* dyed with purple clouds among which peeped out some tasteful pattern. Here and there were flowers embroidered in silk and finished by handpainting representing in vivid colors the four seasons, while the crest consisted of a wisteria flower sewn upon the dress with purple silk thread. The underwear consisted of a figured satin garment bordered with plain brown *Hachijo* silk and embroidered with the same pattern in colored silk, and of a lower girdle of claret-colored figured satin lined with bright scarlet silk crepe. As an instance of the beauty and costliness of the night-gown of a certain young miss, the *Keiseikai Shi-ju-hat-te* ("Forty-eight methods of buying courtesans") mentions that "the garment was of scarlet crepe trimmed with purple figured satin and edged with gold and silver threads so as to give the effect of waves breaking upon the seashore, while her night-sash was of *kabe-choro* (wrinkled silk)."

The pattern of the *shikake* or cloak generally represented a cloud with lightning and a golden dragon, or rocks with peonies and a tiger chasing a butterfly; the embroidery being silver and gold.

That the dresses of the *joro* of these later periods were gorgeous, the paintings of Utamaro, Eisan, Kunisada, and others clearly show. It appears that in those times there was a fixed rule in every brothel appointing the make, stuff, color, and pattern of the dresses to be worn by the respective grades of women, and that this rule was strictly adhered to. No courtesan, therefore, was permitted to wear a dress unsuitable to her particular rank in the brothel, even though she could afford it.

Shozan, a popular novelist of the 17th century, put a great deal of detail into the costume his main character is wearing, and even where she is wearing it:

> The gorgeousness of her wearing apparel almost defies description. Her dress consists of a long robe of richly embroidered silk brocade. Her head is ornamented by a dazzling glory of hairpins (made of the finest tortoise-shell) which glitter around her head like the *lambent aureole* of a saint, while her ravishing beauty is such that the mere sight of her face will steal away one's very soul... . From this description, the neatness of her apartments, the tasteful arrangement of her furniture, and the dainty elegance of her personal effects may well be imagined. Every *oiran* of the *Yohidashi* class goes out walking in the Naka-no-cho as soon as it is dusk. She is attended by two *kamuro* (young female pages), two grown-up female attendants *(shinzo)*, a man bearing a box lantern *(hokojochin)*, a footman holding an open long-handled umbrella, and an old woman *(yarite)* who acts as her chaperone.
>
> These women belong to the *hammagaki* brothels. Their business hours in the daytime are from 12 o'clock at noon to 4 o'clock in the afternoon; and in the evening from sunset until 12 o'clock midnight... . Their garments are made chiefly of velvet, crepe, satin, figured satin, or *habutaye,* and their girdles *(obi)* of gold brocade, velvet, damask, etc. A couple of rooms of eight mats each are generally placed at the disposal of each courtesan.
>
> Their futon (a kind of soft mattress) are of velvet or damask (heavily wadded to a thickness of about nine inches) covered on the surface with a specially woven crepe, and each woman possesses two such futon. The coverlets used at night are of black velvet lined with red crepe.

The geisha or courtesan dressing for a party, a festival, or simply a walk was attended to by little maids with *enryo* (respect), for getting into the robe or party kimono was a task for experts in draping and tying (there were no buttons).

An early instruction booklet for proper robing begins: "First put on a white undershirt and a white silk underskirt. Then the white socks. The undergarments are tied at the waist with a waist-tie and an undersash. The robe is slipped on, putting the right side under the left. This is closed tightly with a waist-tie, just below the waist. Pull the cloth into place so that the robe's material will just cover the heels. So, now tie another waist-tie above the waist and wind an under-sash around the waist. Now get into the obi, a wide one. Wind the obi around the waist two times. Tie the ends of the obi behind you, holding the longer end above the knot, and the shorter below. Pull tightly. Fold the longer end over the obi-bustle wrapped in a bustle sash, and tie the ends of the latter in front, tucking the ends above the obi. Fold the long end of obi under into a tube, tuck the short end of obi into the tube. Fasten all this very tight with an obi-tie. Bring the ends of the obi-tie around to the front and tie there tightly."

As the early, loose robes in time became tight kimonos, as styles changed, walking developed a pattern of its own among courtesans, geishas, and high-born ladies. One early American observer, Townsend Harris, wrote: "She minces her steps as tho her legs were tied together at her knees." The walk of a courtesan was special; called the *nukiashi chu-binera*—"grace-footed sway-hips in voluptuous movings."

The women walked on wooden platforms called *geta* (some were twelve inches high and in walking the courtesan often needed the assistance of her two maids to hold on to). Rainy weather *geta* (called *ashida)* were from two to four inches high. In the old days they were provided with a knob for the walker's

toes to grasp. Later came a sort of toe bridle. Expert geishas could make a kind of percussion tap dance of their mincing walk in their special *ashida*.

The Japanese woman's body has sometimes been belittled by Westerners, who find excitement in large protruding breasts. Japanese women *do* have breasts, but they are like those on Greek statues, small and often perfectly formed. Their bodies usually are short-legged, but as the houses and what furniture there is and their robes are designed for that kind of figure, the suggestive silhouette of an island girl can be as fascinating as that of a European or American woman if one is not tied down to the preposterous image idolized in the mass media in the West.

The skin of a Japanese girl can be eggshell tan or as pink as any blonde from Norway; it can be tea colored, mahogany, or any shade in between. Because the face, hands, and arms were usually coated with thick white makeup, this matters very little, as the entertainer or courtesan appeared to greet the guest in her picturesque robes. She presented an enigmatic and elusive quality and exquisite manners.

The woman's submission to male emotions and physical demands, her bowing and kneeling, and the tight binding in sashes and obis were the characteristics of a Yoshiwara beauty. The ghastly white makeup, the painted white neck (even blackened teeth), the bound-off small breasts that became invisible through the many layers of silk were all part of the Japanese dream. Kneeling so much created thick ankles and developed a race of women with bowlegs. Long straight legs were looked upon in old Japan as barbarian.

In a modern novel by Tanizaki, one of his characters described the legs of the woman in his house: "Her legs bulge out at the calves, and her ankles are really not quite trim. But I have always admired the slightly bowed legs of old-fashioned

Japanese women ... rather than those foreign-fashioned slim legs. To me those slender pipe-stems have no interest..."

The Yoshiwara courtesan of early times was presented in costumes of gold and silver stitched brocades, in a red crepe called *hi-jirimen*, and huge obi (sash) tied in front. The geisha tied her obi in back, so at a glance, one could tell one from the other.

Silk was patterned with figures and objects; satin collars covered the slim necks. The costumes of a high-class courtesan could win even a rich man. There were regulations from time to time to strip the whore of her finery. In 1617, one such ruling stated: "Prostitutes are forbidden to wear clothing embroidered with gold and silver, but should wear ordinary dyed cloth."

Of course, the law was forgotten. Figured satin, pongee, gold, silver, fantastic trimmings were fashionable. Fashion notes mention white figured silk underwear, an underdress of red dotted material, another dress over that of sky-blue silk. Purple cloaks became fashionable. By the 18th century, a courtesan named Shigasaki made popular an obi nearly a yard wide tied in a style so extreme that often only the head of the wearer was visible above it.

In 1795 the government again set fashion restrictions for the courtesans as to cloth, size of crests, and other overblown modes. Women have always ignored such laws. The splendor of courtesans' costumes went hog-wild at this time. From the An-ei through the Bunsei eras (1772 to 1829) everything was possible in fashion, and the print artists were at their peak with their series on "The Beauties of the Yoshiwara." Velvet, all sorts of plain or patterned satins, crepes, gold and silver brocades, and damasks were cut in fantastic shapes. The color range was extended, and courtesans no longer followed a trend, but tried to outdo the others in luxury and splendor.

A book of the period, *Behind the Brocades,* gives some idea

of the range of show: The courtesan was topped by amazing coiffures, as were the ladies of the court and the upper classes, who had to compete with the lure of the flamboyant experienced splendor of the popular prostitute. No famous *beppin* (beauty) could shirk the hairdresser. The earliest pictures of beautiful women of the 17th century show that the fashion was to wear the hair long, hanging down their backs. Later, they gathered it simply on the top of the head in gouts of snaky black. Tortoise-shell combs, real or artificial, held up coiffures, and red combs were made from the beaks of kingfishers.

A bathhouse prostitute named Katsuyama was said to have started the rage for special coiffuring by binding her hair up into a ring tied with white cord, and the style was called *Katsuyama-mage.*

Style followed style; to name just a few: the *Keisei-shi-mada, Kinshojo-bin, Nakabin, Tate-byogo, Sumi-Shimado, Chasen-mage.* There are hundreds of others. Their main features were hair as wings, dips, buildups, tie-ups, set with combs, bamboo pins, and a finish of a glossy varnish said to have been refined from elephant dung imported at great cost from India. Only vegetable oil was used in the early days, and even the fur of the red bear served as a base on which to spread the natural hair. (In the West these were called "rats.") On the face, under all this, were painted semi-circle eyebrows called "The Three-Day Moon."

Soon (about 1780) the rage for the professional hairdresser appeared, and ladies and geishas and courtesans all had their favorite hairdressers.

Often courtesans and their lovers sewed their love letters in their obi or robe as memories of gay moments. Many of the texts were of the *hana-iki-sewashiku*, the orgasm — literally "gasping for air through the nose."

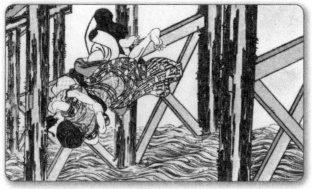

Lovers in suicide: Kuniyoshi, 1797-1861.

In the floating world
Where all things do change
Love does change
When promising it never will change.
—*Folk poem*

CHAPTER **9** Stories of Geishas
and Courtesans

Much erotic lore has appeared about the geisha. A great deal
is nonsense. What is clear is that the geisha, while not a pro-
fessional courtesan, was a sexually free person, whose moral
values were those of any girl who was out to earn her keep
in male society and seldom turned away from a good cash
offer when she found it.

That the geisha and the courtesan had dreams, had hopes
of a romantic escape from their lives, we see in all the stories,
all the tales from the early period right up until Japan went
modern with a howl and roar of rock-and-roll.

For all its sordid details, life in the Yoshiwara had an eti-
quette and a provocative poise. It was in the mainstream of
the culture, with a traditional literature of legends of great
courtesans, love affairs, idylls, mostly ending tragically—as

such tales do end in Japanese story-telling.

Rakes, patricians, shoguns, courtiers, dandies, *hanatare* (hippies—little snots) fell in love with geishas and courtesans, rendezvous and vows took place, flamboyant schemes were made.

The novelists of the times wrote of such events and the prostitutes and ladies read them and wept. The Yoshiwara girls dreamed of a rich, noble, handsome guest who would buy them out of the Yoshiwara and carry them away. Certainly the geishas often made good wives, but of the courtesan romances, no such trend is indicated. In their provocative gestures, their instinctive and trained adaptability to a man's wishes, they existed best in the half-light of a room made for ostentatious sexual play. A courtesan seen in the light of day lost her serenity, the radiant quality fled; what was left was merely bought pudenda.

The courtesans were frivolous elegance, set in a disciplined gaiety at their work. The splendor did not carry outside the great gate of the Yoshiwara.

Their indulgent amorousness was all they had. Unlike the geishas, they did not have to be bright, witty, amusing, though many were. They remained beautiful women, prisoners of their skills in copulation and its byplays. No man, or few, would be satisfied with that sort of routine twenty-four hours a day, away from a brothel.

Yet they were often splendid creatures as we see them in the prints of Utamaro, Hokusai, and others; aquiline young girls with slanted necks painted white, great glossy wigs stuck with pins. Their experienced, smiling composure, the modesty of their curtsying serenely radiant, all that remains of them today are these delightful pictures at their best. Or their amorous ingenuity in the *makura-zasshi*—the pillow books.

The 17th-century Japanese novelist Saikaku tells a story that his contemporaries Shakespeare, Ben Jonson, and Christopher Marlowe would have relished. Saikaku often pointed out how amorous young men ruined themselves with the courtesans of the Yoshiwara, and in his story *The Widow and the Lucky Lover,* he tells of one whore chaser and his lust.

This is the story of a town sport of Edo. Having spent his days in much pleasure with the Yoshiwara courtesan Konishi, he was disowned and came here to seek an acquaintance who lived near Karasumaru Street. Settled in there, he threw aside any idea of work. Day and night he strutted about in full dress to impress the ladies. He knew nothing of making a living and very soon he was broke... .

On the other side of the house where he was living, there was a shop known throughout the city. Its wine was good, not inferior to that vintage called "Flower of Orange-blossom." The owner of the shop had died young, and if one were to ask from what, one had only to see his pretty wife. She was fair enough to be mistaken for the courtesan Yafu... . This beautiful widow... determined to maintain her widowhood...

One day she made a secret visit to Honkoku Temple. Meeting the head priest... she told him: "The young man of the Motoyuiya of Edo on Karasumaru Street is one of your followers—I am a widow, I have completely abandoned the passions of this world. This young man is sending me love letters... . I have refused to reply... but he has continued, unconcerned with what people will say. The other day he wrote to me... I shudder to think of it:

"I will put a ladder over your back wall and climb over. Beneath that is the roof of the privy. To lower myself and use the latch of the door I will land on a rock in your garden. From there I will go to your room... . You should leave the

door ajar. I enter. If you oppose me in this I will kill you, and then also myself… .'

"If the officials hear of this, it would mean his life. I, as a widow, have no husband to restrain him." She returned home.

The priest sent for the young man and repeated the letter to him. "If you get yourself into difficulties, you will have no one to whom you can turn. You will give up such wild ideas!"

"I have no idea what you mean. Such a lie!"

"The widow came herself, told me all that you wrote to her. Your plan of breaking in.…"

The young man had indeed written no letter. He thought, the young widow made a trip here, told the story herself. Very clever. "I abandon my plan," he told the priest.

The young man returned home, waiting the coming of night. He climbed the back wall, as the widow had indicated… completely unobserved… . Hiding in the shade of trees, the young widow grasped his hand and drew him into the room. He followed. From the luxurious bedclothes, warm from her body, came the odor of incense. At the head of the bed was a soft pillow. His whole body filled with both terror and delight. So he mounted her to give her the supreme joy which she had not known in three years, since her husband's death. In the great ecstasy of this act she abandoned her soul to him.

So damning their neighbors' gossip, the two continued the affair, their passion deepening. Through gifts the young man received for sexual skills from the wealthy young widow to achieve success, he set himself up as a silk merchant with the money acquired.

Time passed. The widow became a bore, and the young man began going to the Shimabara whores. He completely lost his mind to the courtesan Samon, becoming more and more depraved. In half a year there was not a thing left of all the cash he had taken from the widow. He sank low, dressed in the

rags of a beggar priest, worked the Bungo Bridge at Fushimi, reciting Buddhist charms for a few coins. His sign read:

> Call on me Day and Night
> A look into the Most Wonderful Events
> Your Future Life!

How does he forecast his own future?

The courtesans, while by code stoically, fatalistically set in their position always to please the male, did not always glory in their martyrdom, as we can see if we study the lives of some of the most famous.

The courtesan known as Tamakoto was considered the most popular of her trade in the Yoshiwara. She set the mode for putting a sprig of a pine-tree called *naki* in the back of the handle of her mirror, the one used for the making up of her face and body. The *naki* tree is sacred at the shrine of Izu Dai-Gongen, in Hakone, in Izu province. He is a god who sees to carrying out of promises between men and women, no matter how heavy the casualties. Like many courtesans, Tamakoto died young—at twenty-five. She is the author of the words of a song: "The Sorrowful Butterfly," which, more than any other, suggests her regrets. (Only a description of the song has come down to us—not the song itself.)

Around 1700 the courtesan Usugumo (Pretty Cloud) was famous. Thin as a sapling, beautiful, with a graceful walk, she gave moon-viewing parties—outdoor gatherings to stare at the sky, sing, joke, and make love. She had a pet cat who, gossip insisted, was in love with Pretty Cloud—and not as a proper cat would be with another cat. Tied to a post one day, the cat, howling, broke loose to follow his mistress to the lavatory, and a frightened cook severed its head with a knife

as it leaped past. According to legend, the head of the cat was found in the lavatory, a great snake dead in its teeth—so devoted was it to Pretty Cloud's safety. It is a typical Japanese story that appears to us more than a bit outlandish. A special grave was pointed out as the last resting place of the reunited parts of the famous enamored cat—a spot now lost in the many changes of the landscape.

Many stories of famous courtesans relate their last illnesses, for most died young of the excesses of their lives, their drinking and overly sensual affairs with many lovers.

Not all the stories are about the courtesans' beauty, poetry, pet animals, or love affairs. Some had a deeper perceptiveness, some appear ludicrous.

The courtesan Kaoru (Sweet Smell) was given to wild parties with rich young playboys, and as her orgies grew wilder, stranger games were invented for the jaded, worn-out pleasure seekers. At one wild party, the sake was being swallowed as fast as the maids brought it in, and great saucers of it were gulped down. A dare went out: to impress Sweet Smell, who would swallow a large saucer of pepper instead of sake?

A young sport said he would and, priming himself with a saucer of sake, he then began to gulp down the fire-hot pepper. But he soon fell down in great agony on the mats.

With this absurd story, the courtesan and her life suddenly become real to us. It could be out of a tale by F. Scott Fitzgerald, or the hippie acid-head culture.

It is not easy to find details of the man's way of life with the courtesans. The 17th-century novelist Ihara Saikaku, one of the most popular writers for the Yoshiwara's geishas and courtesans, wrote a great deal about low life and high dissipation in the brothels, theaters, bathhouses, and of the grand whores and lowly prostitutes. He gives us in many ways a realistic

close-up of the world of sexual pleasure in a changing social order. The old world of imperial rule was breaking up, the shoguns were in power, and the rich merchant class—as in our own times the great corporations and industries—were often the real powers in the land, or were seeking to be.

Saikaku, in his story "Seijuro in Himeji" from his book *Koshoku Gonin Onna* (Five Women Who Loved Love), gives a bawdy, rollicking portrait of a man-courtesan relationship.

Seijuro was not only handsome but witty and charming, so that he and his body were very pleasing to women. He had gone to making sex with women since he was thirteen years old. In his town of Murotsu there were eighty-seven whores, and he had copulated with every one of them.

If one counted love letters sent him, they came to over a thousand, and the women he fornicated with sent him as sign of their love their fingernails—enough to fill a good sized box. As for women's hair, for his favors to their bodies they sent their black locks, jealous of each other as they were, enough hair for making a very thick rope.

Every day came love letters, crested silk garments as gifts to a great virile lover. Then what happened? Seijuro fell desperately in love with the courtesan Minakawa, a wild, uncontrolled passion, a grand lust. He spent his time in the brothel, closed doors and shutters, kept a wild depraved party going, lived only for nights of pleasuring of their bodies. He invited jesters to entertain his guests.... The whore-mistresses themselves chanted joking Buddhist prayers, fed tea to strangers, recited mocking rituals for the dead who were still alive....

Playing a game called Naked Islanders, the whores were forced to strip themselves nude. A young courtesan named Yoshizaki blushed all over her body when on her naked hip there was exposed a pale blemish she tried desperately to hide.

Screaming out as this body secret was revealed, all the guests and women mocked her. They bowed in mock glee saying, "Well, what a goddess!" But on closer examination it was clear none of the courtesans was without some blemish for all their beauty...

The story goes on that the hero was ruined by dissipation and the brothels would no longer serve him without money. The hero laments:

"How fickle are the loyalties of these whores. With a sneer they toss away old lovers."

In tears of humiliation he prepared to leave, but suddenly there was the prostitute Minakawa, all in white, the sign she was ready for death. She hugged him close. "What is the use of life. We have no place to go. It's best we end our lives."

She pulled from her sleeve two knives. Seijuro was filled with delight to find such loyalty and true faith in a mistress. But the whorehouse people, observing all this drama, would have none of it and pulled the would-be suicides apart.

Minakawa was sent back to her owner, and Seijuro was delivered to the family temple at Eiko-in... Here, perhaps, a new life would open for him. At eighteen he could become a monk. What a pitiful story.

As with the mistresses of kings, history abounds with the most celebrated courtesans.

There was a whole line of these elegant, poignant, blatant girls called *Taka-o*. Most appeared to have been bought out of the brothels by great *daimyo* (lords), and they spent their lives as creatures of great charm and rich rewards.

Mizutani Taka-o had a career like a modern Hungarian femme fatale. She was taken from her brothel by a banker to

Prince Mito, but oddly enough, ran off with one of the banker's house-servants, a man of sixty-eight. After this caprice, she married respectably only to become the mistress of a Lord Kami. This didn't last, and she ran off with one of the lord's official staff. Records show her next in Fukagawa, wife of a hairdresser; then married to the actor, Sodeoka Masanosuke. The last husband we know of was a dealer in lamp-oils from Mikawacho. She might have gone on, but she died suddenly on the street fronting the Daion Temple.

Dazomo Taka-o was the sixth Taka-o. (There is no evidence that these women were in any way related; it was just a popular "lucky brand" name.) Beautiful she was, a writer of skill, fine-grained, natural, genteel. She was seen one day by a simple dyer of cloth named Jirobei who, with some friends, was prowling the Yoshiwara eyeing the *yujo*—the whores. (Lack of money was the only vice in the Yoshiwara.)

Dazome Taka-o was a high-class courtesan, and the dyer's first sight of her dazzled him. She wasn't for him. He had neither the station nor the cash even to meet her. Returning to his master's house, he fell into a brooding mood. His master got the story from him and said all he needed was money to buy his beloved's favors at a brothel. That was why she was there.

It took time, but came the day when he felt he had enough to present himself as a guest. He didn't look the part of a rich guest: shabby, dusty, arms dyed by his trade—but he showed the coin, and, at last, he saw standing before him the great courtesan Dazome Taka-o. He poured out his infatuation, and something about this sturdy apprentice appealed to her; his desire to marry her, to take her out of the place—but, of course, he'd never earn that much. Dazome Taka-o said he did appeal to her and, yes, she would marry him when her contract with the brothel was worked out. (The various ver-

sions of the story do not say if he stayed that night or paid the fee, or ordered special food and sake.)

What is said is that she left the brothel in time, married her lusty dyer and he, with her to serve the customers, opened his own silk shop and became very prosperous. It may well have happened like this. Not all the girls ended in frivolous and dissolute friendships.

The tenth Taka-o was in the Yoshiwara in 1728, and the next of the line was brought out by a millionaire, Lord of Echigo. When the lord died, she became a nun and learned that virtue, like money, becomes depreciated in the Yoshiwara.

A poet, Ogiya Uyemon, ran a brothel (shades of Villon!) and the pride of the place was the courtesan Hana-ogi. In 1794, she ran off with a lover, but was discovered and dragged back to the Yoshiwara. Purified by true love, she refused to take guests. The poet-brothel-keeper, writing under the name of Bokuka (Ink River—a perfect name for a writer) presented Hana-ogi with a poem asking her to reconsider. She was touched by the verse and in tears wrote an answering poem. Hana-ogi went back to work. A Chinese sage, Hikosei, visiting Nagasaki, wrote her an admiring letter:

> You, who are the leading courtesan of a superior house of pleasure, are richly gifted by Heaven with a hundred various graceful accomplishments most excellent in woman. I, being a stranger and sojourner from a far-off land, must sail away without beholding your charms, but I shall long for you while tossed upon the bosom of the boundless sea.

One of Hana-ogi's poems survives:

> Even with the shining moon of Autumn
> His face last seen in the Spring

> Still is printed
> In my inner mind…

We do not know whose face—Bokuka's? the lost lover's? or the Chinese seer's? or some passing guest's who carried off her heart?

In the text of Shogi Okada, we find a good description of how a geisha and her lover spent their time away from the Yoshiwara:

> They moved around Edo, enjoying equally the fine weather and rains when they came. She would put on her elaborate twelve-layer kimono of the Heian period, and he donned a fancy long-sleeved robe worn by the sporting young bloods.
>
> The lovers went to view the cherry-blossoms at Asukayama and touched the famous memorial stone for luck. They paraded by the sea at Shinagawa, embarking dangerously in the narrow gondola, their hands trailing in the water, past the wooden bellies of brown ships tugging at the swift salt tides. They stopped at the Takashimaya, the famous rice-cracker shop in the Ryogoku district, a place known for its beautiful women. She chewed on a cracker and said with a smile, "You will leave me some day for one of these beautiful women."
>
> "You may be right," he answered in mocking tones.
>
> "Everyone is beautiful here—the waitresses, the courtesans, the little maids."
>
> "Not as beautiful as you are," he answered—as is proper among lovers.
>
> He bought her a bunch of *ominaeshi*—little yellow buds, called the woman-flower; it was also called the harlot-flower. Her two potted adonis plants were guaranteed, he said, "to be perfect symbols for happiness and long life."

She looked at him as if every glimpse was a pleasure and she could not get enough of seeing this man who was becoming a well-known figure in the streets of Edo. The street-girls in the downtown Honjo district threw gay remarks at him: *"Chotoo poi."* The seller of black hemp kimonos was proud to make a robe for him; and when he passed the *Akatsuta-ya*—the riverside wharf of house of assignation—the girls would lean on their wooden window-sills and shout down to him: *"Shibaraku*—stop a minute!"

Miss Tauda, a Japanese headmistress and herself a Christian, as late as 1906 could state:

That word "love" has been hitherto a word unknown among our girls, in the foreign sense. Duty, submission, kindness—these were the sentiments which a girl was expected to bring to the husband who had been chosen for her—and many happy, harmonious marriages were the result. Now, your dear sentimental foreign women say to our girls: "It is wicked to marry without love; the obedience to parents in such a case is an outrage against nature and Christianity. If you love a man, you must sacrifice everything to marry him."

For love, it would seem, one had to go to the courtesan and the geisha.

Koizumi Yakumo, or as he had once been known, Lafcadio Hearn, wrote at the end of the 19th century about Japanese art, culture, and life, but not often about the Yoshiwara. Yet when he found a good gloomy, romantic story, he couldn't resist it:

There lived in ancient times a *hatamoto* called Fuji-eda-Geki, a vassal of the shogun. He had an income of five thousand koku of rice—a great income in those days. But he fell in

love with an inmate of the Yoshiwara named Ayaginu, and wished to marry her. When his master bade the vassal choose between his fortune and his passion, the lovers fled secretly to a farmer's house, and there committed suicide together.

The sad occurrence was commemorated in a popular song that ran:

> Once more to rest beside her, or keep five
> thousand koku? What care I for koku? Let
> me be with her!

In burial places are to be found many graves of *yujo* who committed suicide with their paramours. On the tombstones are to be found engraved the descriptions of the swords with which they killed themselves, as well as their names and ages. There is something so weird and uncanny about these horribly pitiless records on the gray lichen-covered monuments that the blood of a sightseer runs cold and he becomes so nervous that he leaves the gloomy spot with the intention of never visiting it again.

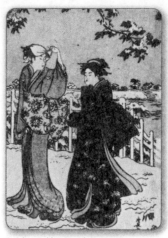
Geisha and her maid: Kuneogo.

Pear in blossom
Moonlight on a woman
Reading a letter...
—*Yosa Buson*

CHAPTER **10** Two Famous Geishas

The true Madame Butterfly story began in 1902 when the American, George Morgan—a close relative of the great womanizer and multimillionaire, Pierpont Morgan—landed in Japan. He was fleeing a broken romance in New York City, and Japan offered a change. At a performance of the geisha theater, *Miyako Odori*, he saw the twenty-two-year-old Oyuki, a geisha since the age of fourteen, a serenely radiant beauty.

George was suddenly madly in love again. Using an interpreter, he declared his passion. But Oyuki—herself in love with a student named Kawakami at an Imperial University—made George a polite "no-thank-you-so-much-Morgan-san." He was to her, no matter if a Morgan, still "a white devil barbarian."

George, indulgently amorous, didn't give up, but kept declaring his passion, even learning some Japanese love talk and a few poems. His uncle, Pierpont, had never had such trouble with women. But Oyuki with feminine elegance was firm—she would not be his kept woman—and please, would he stop coming around—it was most annoying. Politely but firmly she gave her answers.

Meanwhile the parents of Kawakami, her student boyfriend, hearing gossip of his interest in a geisha, cut off his allowance, and the boy had no other resources. Events seemed headed for a popular romantic suicide pact for the two lovers.

But Oyuki was practical and sacrificial. To save the career of the student, George Morgan was fully admitted into her life as her official lover; and George was unaware, it is claimed, that his gifts and money passed on to keep the student Kawakami in school, in fine clothes and well fed—and, one suspects, well loved.

In 1903 Kawakami, now a graduate of the university, not even bothering to say goodbye to Oyuki, left town. Oyuki tried to find him, to plead, to beg, to be allowed to be his love slave. But it was hopeless and she went into a decline.

However, her duties as a Japanese woman called her, and now she transferred her affection to George Morgan. She had used him, played the love act with him, been unfaithful to him, and now she saw her stern duty—the geisha code almost—was to make up for past errors. Modestly curtsying she accepted George's offer of marriage—an offer he had tediously kept repeating for some time.

There was, of course, a catch to a hasty wedding. Oyuki was a slave girl—she had an iron-hard contract of agreement with the geisha quarter for her services for years. It cost the House of Morgan 40,000 yen to buy Oyuki out of profes-

sional bondage. Feelings were mixed among the Japanese at this white devil's ostentation, and Oyuki gave up her Japanese citizenship. In January 1904 George and Oyuki were married by a flustered official of the American Consulate in Kobe. Etiquette forbade full official approval.

Bride and groom still had difficulty communicating, but no interpreter went on the honeymoon when the couple left to sail to New York. A bit of table training and house-breaking, American style, took place on the slow boat to the United States. Oyuki possessed an instinctive adaptability.

The House of Morgan on Wall Street, the Astors, Goulds, Vanderbilts—all social circles the Morgans moved in— rejected the mixed couple (although of lowly peasant and cheap jack peddler ancestors themselves; a society founded in American by fur traders, tin-ware tinkers, scow and barge folk). Oyuki was not invited to Mrs. Astor's balls, and George was dropped from the *Social Register.* In a year the couple, living no idyllic life, were back in Japan.

It was 1905—the war with Russia was on—white barbarians were not popular. Anti-foreign feeling caused riots in the streets of Japan. Oyuki was bitterly attacked as one lower than a prostitute mated to a dog.

A few days showed them the temper of the Japanese toward their marriage. So sadly they wandered away and ended up in Paris where eventually they settled in their own house. It seems they had ten happy years there. Oyuki faced the horror of corsets, of rare steaks, of isolation when the "best people" cut the Morgan ménage dead. The look of expectancy left their faces. They were happy alone. Oyuki mastered the piano, but there is no record of her favorite music—certainly *not* the *Mikado* or *Madame Butterfly,* one hopes.

The year 1914 blew up their private world—the Hun stood

at the Marne. World War One changed the money markets George's fortune was based on. He had to go to the United States to attend to urgent business details. Oyuki, demurely alone, waited in Paris, in the big lonely house, staring at her piano. The German U-boats ruled the Atlantic, and George, once in New York, found it difficult as a civilian to return to his wife in Paris, in a France at war. Determined to get back, he spent months in strange zig-zag journeys. By 1916 he got to Spain. But he was not to be reunited with the waiting Oyuki. George Morgan, weary traveler, died suddenly of a heart attack in the capricious drama of events.

Oyuki in tragic forbearance had the body cremated and when the war ended, she set off on a sad pilgrimage to return the ashes to George's honorable family—as is only fitting and the duty of a widow.

The war had changed many of the attitudes of society. George's will made her a very rich woman. She sent for her piano and settled into a fine New York apartment. She gave recitals at many social gatherings—and those who knew said she was a most skilled performer, still graced with a provocative poise.

The years passed, World War Two came, went, with its Pearl Harbor, two atom bombs dropped on innocent thousands in Japan. The call of home came to Oyuki—like the lemmings for the sea, she wanted the sights and smells and language of her childhood, her youth, her geisha days and nights; not the voluptuous flamboyant times, but the color and forms of her childhood.

She decided to try to regain her Japanese citizenship. She returned to her birthplace and saw burned-out Tokyo and the ravished cities and town.

She was deep in her seventies—nearly half a century had passed since her last sight of Japan. And here, packed in so

many layers of memories of places, of love lost with the base student, Kawakami, and found in George Morgan, she—the geisha—waited for the final embrace from time.

How much better her story is than Puccini's opera and its sentiment.

The most famous of the great modern geishas whose story still excites Japan died in 1948. She was then a Buddhist nun called Myosho, but as a geisha she had been called Okoi (Carp), a name given her when she began her geisha training. The carp (the goldfish is a carp) is greatly respected in Japan for its voluptuous grace and unique coloring.

Okoi's mother had broken ritual and tradition by marrying for love and not according to family demands. The result was deadly poverty, a ruined family business, and pretty Okoi, at the age of four, was given away to be adopted by a teahouse owner. She was then known as Teru. Although greatly loved by her foster parents, when she was seven they too were ruined by business reversals and became servants to a once famous geisha.

The geisha liked the lively, amusing little girl and began to train her as a geisha, teaching the tea ceremony, dancing, singing, and flower arranging. It was in 1883 that Okoi, at the age of thirteen, joined the famous geisha house, Omuja, in the Shimbashi district, and was renamed Carp. She was an exquisite pupil with a quickness of perception and a sensual, capricious nature.

As an apprentice geisha she had to borrow fifteen yen to buy her geisha robes and gear. The girl, excited by the guests, the rich merchants, the famous politicians, the officers and officials who came for pleasure to the palace, already knew she would become a great geisha. She delighted the guests, amused the great, sang and danced to adoring visitors as she strummed her samisen, poured the sake, and recited ribald jests.

Life was costly for a geisha, so she was expected to take a patron, a rich lover. At eighteen Okoi picked Heizo Yajima, a very prosperous stock broker—not young, but interested in a good time and showing his position by signing a contract (always a practical man) to take Okoi as a concubine (or, as we would put it, as a kept mistress).

She had her own teahouse from him as a gift and her dear foster parents as her servants. Her teahouse became the place to go—the most popular geisha house in town. She possessed talent, charm, and a rich patron. She was a beauty; she was frivolous yet adamant.

The Don Juan of Tokyo was a young John Barrymore of a rake and a Kabuki actor, Ichimura Uzaemon, whose love affairs made tantalizing gallant gossip. But even a Casanova is turned down at times. Ichimura had been jilted by a rival famous geisha, and it was known. His fans and admirers decided to make a match (all weddings were arranged by match makers) with the great Okoi that would surely repolish his reputation as a great lover. The fan clubs of the actor made the proposition to Okoi—what a mating it would be of two greatly talented beautiful people! *Omeni kakarete!*

Her foster parents didn't like the idea—actors were bohemians, unreliable fops, rakes, and generally made poor husbands. But Okoi was also a fan of Ichimura, the handsome actor. Like any gushing schoolgirl she, too, had woodcut prints of him in his various stage roles. What if she lost her rich patron—a geisha does not live by luxury alone. Actually the stock broker, Yajima, was pleased by the gossip—his name was part of a romantic love story in progress. He was pointed out as a local celebrity. It must be remembered that prominent Japanese men kept well-known courtesans as status symbols. The dull rich feel the need to be spectacles

at times. Yajima even helped the romance by acting as the official go-between to arrange the marriage in a copiously extravagant manner.

It was a gala ceremonial wedding, and so Okoi became Mrs. Uzaemon; she even got back her original name of Teru. It was customary for the young bride to go to live with the husband's parents, and mothers-in-law in Japan are notorious monsters at times. Okoi got one of the worst; she became a Cinderella—a slave to her mother-in-law, a drudge doing unpleasant household tasks. Marriage for her was reduced to a sad cataleptic state.

Worst of all, Ichimura Uzaemon, having scored with the great geisha as his wife, was back to his love affairs, a most unfaithful profligate husband, in a continual quivering palsy of passion, away from home. Meanwhile his fame as an actor grew and he was to become one of the most famous stars of his time. But with growing success he entertained more, spent greater and greater sums of money, took on more mistresses, wallowed in continuous love affairs.

Okoi had to use her personal fortune to pay their debts, even to pay for the love affairs. She discovered a wife's lot in Japan was not often a happy one. Actually she rarely saw Ichimura—there were just too many parties and sleeping mats for him to visit. The imbecilities of a popular actor go beyond reason—they are creatures of precarious sanities.

Okoi, between a monster mother-in-law and a lost husband, asked politely for a divorce. The husband agreed, allowed her to remove her personal belongings, but didn't bother to say goodbye or good luck. Okoi borrowed 280 dollars and set up a new teahouse; back to business, even if the heart is broken and the cherry blossoms are all fallen. Marriage had lasted two wretched years. Psychological scar tissue had formed on her emotions.

No longer starry-eyed, romantic, or soft, she became the queen of the night town—a geisha-courtesan, greedy for pleasure and gain. Patrons and lovers came and went. Loss and alienation were walled away with shrill passions.

In time, the Sumo wrestlers, who were great folk heroes, came to her teahouse and two of them were attracted to Okoi. As we have seen, these wrestlers had special sexual charm for many women, and Okoi proved to be one of these. They are *so* solid in a precarious universe.

To decide who would win Okoi, there was to be a kind of knight tournament—a bout between these two great wrestlers, Araiwa and Hitachiyama. The winner would possess the charms and comforts of love of the famous geisha Okoi. The excitement of the people was as great as the public copulations, the love meetings of motion picture stars.

The bout ended with Araiwa winning the fair Okoi, and no princess went more willingly to a knight, who had killed a kingdom's dragon, than dainty Okoi to the huge Araiwa. He was a simple simon of a fellow—all lard including his brains. He turned his prize money over to Okoi and begged her to marry him. But the word *marriage* had soured on Okoi with her actor husband. Besides, the great noble, Prime Minister of Japan, Taro Katsura himself, was coming to pay homage to her. In 1903, the Prime Minister gave a geisha party to entertain some Russian guests. Fifty geishas were present, led by Okoi, who noted, when introduced to the main guest, General Kuropatkin, that he was "the hairy barbarian."

As usual, "peace meetings" lead to carnage; next year the Japanese-Russian War broke out and Prime Minister Katsura was deep in war plans, politics, economic worries, and national and world affairs. Prince Yamagata suggested the minister needed cheering up, warm sake, beautiful geishas, and he had invited the famous Okoi again to be present, *konban*—this evening.

The rest is history—not printed, of course, in the Japanese schoolbooks. Okoi and Prime Minister Katsura became devoted lovers. It was a ménage that lasted until the death of the statesman in 1913. The liaison developed into a deep and lasting affection, and Okoi was given a house of her own near his official residence.

Okoi now had a devoted and powerful lover, a man who ran a war and a nation, and she was no longer a wild-living geisha, but a respected woman in a position of much power through the man on her sleeping mat.

The peace treaties signed, under pressure of President Theodore Roosevelt of the United States, caused a great outcry in Japan. They had won a war and America had forced a peace on them—saving dying Imperial Russia until 1917. Katsura and his cabinet were in howling disfavor and were attacked as pawns of the "white barbarians." Okoi, too, was smeared, and she and Katsura were called traitors to their nation.

Protest marches and meetings took place, mobs rioted against Katsura in the streets, officials were attacked, and Okoi was threatened as the mistress of the betrayer of the Sun God. Okoi escaped the mobs and went into hiding. Martial law put soldiers to guard her house. It was many weeks before she dared appear on the street. The mass mind is always infected with the idea that wars produce grand results.

Katsura resigned and publicly announced he was breaking off all relationship with the woman Okoi. At first, like a disembodied ghost, this blow floored her. It was explained to her that this action seemed to be the best thing to do to ensure her safety from the mob.

However, the lovers were soon reunited in a private villa on the Izu Peninsula. Here they would hoard their love by not risking it, and the cesspool of popular politics soon forgets.

In 1908 Katsura was again Premier of Japan, and in 1912, though in a debilitated condition, he held office for the third time. A year later, aged sixty-seven, he was dead, leaving Okoi, at thirty-four, alone again. And abased, for she was strictly forbidden to attend the grand funeral of her lover. The absurdity of social protocol was cruel.

She retired, again with her belongings, but this time with a fortune provided by Katsura, to the Oimachi suburb. Alone, so alone, reciting the Buddhist sutras for the good of her lover's being, wherever he was now.

Five years passed this way, and then again she came back, still attractive, as beautiful as in her prime, to a new world, Japan of the 20th century, hurling itself toward the insane future plans of conquest, of World War Two. Teahouses were passing, the gaudy Ginza—the main drag—was the place to live the high life. Okoi swayed with the times—she ran the famous National Bar. It was the place to go, to see and meet its famous owner and hostess, hear talk of folk who drank Western cocktails, ate "roz bif," hear of the newest imported dances, the Bunny Hug, the Grizzly Bear.

Luck was never long with Okoi. In 1923 the great earthquake destroyed the city and with it the National Bar. Although she did rebuild it, she had tired of it. And now there were hints she was no longer the fashion; she belonged to the past. Jazz was appearing, new talk of Freud, of Marx, battleship tonnage, Picasso, and the Black Dragon Society.

She retired, and should have stayed in retirement, but old geishas never die, they fade away in comebacks. Okoi was lured out of retirement for the last time by a sharp character involved in Meiji politics who got her to manage a teahouse in the Akasaka section of town. Crooked political dealings by her sponsor at the teahouse caused a scandal. Okoi again was the victim of the mob. She was mocked as a court witness

in the case, the victim of others' evil, but a symbol available to punish.

Her friends began to avoid her. Her unpopularity increased. The once powerful sports and jolly guests of her past were dead or senile, and newer beauties and *much* younger ones were demanded by roistering rakes and dandies in the teahouses and in the Yoshiwara. The innate pliability of Okoi shrugged off suicide.

She shaved off her hair in 1938, and entering the Meguro Temple became a Buddhist nun. The great actor, once her husband, Ichimura Uzaemon, died, and the streets were filled with mourners and the nation officially grieved. Police were called out to control the crowds. Buddha had said, "Riches are not an abundance of things or honors, but in the lack of wants."

The nun of Megura made no public comment. In the summer of 1948, at seventy, she died, and the very few surviving friends set up a modest statue of Kannon, Goddess of Mercy, on the temple grounds. It is known today, to those who care to ask, as the Okoi Kannon.

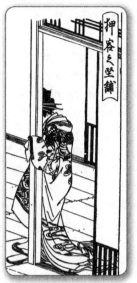

A slave to sadness: Hokusai, 1760-1849.

The flowers spin away
With the wind like snow
Like myself falling away.
—*Folk poem*

CHAPTER **11** **A Life of Bondage**

For all its patterns and colors, tradition, grace, and manners, there was the sad side to the Yoshiwara. The women were in most cases slaves and prisoners. In the prints we see their daily life as boring; hugging cats, fondling each other, looking out beyond the bars at the moon. Melancholia made them its victims. Anxiety, hysteria, and neuroses were common Yoshiwara complaints. Kiyonaga's pictures of the women's lives are masterworks.

No prostitute or geisha was so low on the social scale that at some time or other she didn't own a caged cricket, bird, or dog. The grand courtesans and popular geishas usually had a few Japanese spaniels about.

The origin of the toy Japanese spaniel, sometimes called Chin Chin, is not known. Type and coat varied, and it is probably the breed that carried the blood of Pekingese or Happa Dog and the now almost extinct Loony Chua or feathered Pug. The dog became very stylish in the Yoshiwara, prized for being dainty in a high-stepping action, and loved as a pet.

This breed was introduced into the Western world when Commodore Perry in 1853 was given several little Spaniels as tokens of Japanese esteem. The Japanese Spaniel's eyes are large, dark, and round, and the muzzle is short with a deep stop. Ears are small, triangular, and set high but far apart as seen in some Japanese prints. The body is compact and square above straight legs with feathered feet. A plumed tail is set high and carried over the back. The coat is profuse, long, and straight, with thick neck ruff, and colors are black and white or red and white. "He requires love and companionship of humans," adds one native writer.

The captives of the Yoshiwara—usually childless—lavished affection on their pets. As another writer on the subject of the Japanese Spaniel says, "The lonely women often taught the creatures 'cute' games."

As with most prostitutes the world over, those of the Yoshiwara were steeped in superstition, omens, fortune-telling, and good and bad luck signs. The word for tea—*cha*—was bad luck. It suggested being ground to powder, or out of work, so it was never spoken.

Sitting on steps was bad luck. It drove off customers.

No small animal—bird, cat, or dog—could cross a room. You had to catch it and send it back to retrace its steps, saying *"Gomen kudasai* (please excuse me)."

A prayer of good luck by the Auntie of the house at the Good Luck Altar where symbols of the phallus were kept

did no harm.

Sneezing was full of omens: Sneezing once—someone is saying good things of you. Twice—someone is saying bad things of you. Three times—someone is in love with you. Four times—you've got a cold!

A basket on your head will make you shorter. Stepping in fresh horse dung will make you grow.

A child not sensitive to tickling was born a bastard.

To remove the lint from one's navel will bring on a cold.

Wax in the ears improves one's memory (perhaps because one hears less to remember!).

Curly-haired women are lecherous beyond reason (and rare in Japan).

A mushroom in the navel cures seasickness.

Breaking wind turns your tongue yellow for a time.

Spitting into a privy *(benjo)* will bring on blindness.

Urinating on an earthworm will cause the penis to swell.

People with eyebrows too close together don't live long.

Fan the palms of your hands to cool your whole body.

Unfilial conduct will give you a hangnail.

The Yoshiwara tried a little magic on unwanted guests. At least the girls swore the following worked:

Charms to send away a guest. Take a *ko-yori* (a paper string) and with it form the shape of a dog. Place this on the wardrobe or mirror stand in a room next to the one in which the guest is, making the paper animal face him. Ask the doggie in a whisper to answer you quickly whether the guest will go away or stop.

If the end of the underfold of your waistcloth or petticoat *(koshi-maki)* be tied in a knot, the guest will leave immediately.

Wrap up a small quantity of warm ashes in a piece of paper and place the packet under the night-clothes of the guest near his feet. He will immediately go away.

Stand a broom on end in the room next to your guest's room, and laying out a pair of sandals before it, say in a whisper—"There now, do please go away quickly." The guest will leave at once.

The lot of women in Japan was hard, but at least in the Yoshiwara they had some years of luxury, high life, and a touch of hope for romance. They were great believers in the folk saying, "The gods never shut one door that they don't open another."

In the famous prints of the Yoshiwara, we fail to see the feminine jealousy behind the frivolous elegance. We don't hear the cries, the blows, and sense only rarely the humiliation of these human beings behind the bars of the houses. The nymphets, the little maids that populate the prints of the artist Harunobu, lack the signs of decadence that must have accompanied their lives as *shirokubi* (white necks).

They did have their small victories, their moments of glory. They were loved, desired. And across the centuries we, blind to our own faults and evils, can wonder how such a combination of beauty, etiquette, and tradition could be based on such a disregard of *our* standards of conduct.

The dark side of the Yoshiwara life is hardly ever written about, beyond admitting the slavery of the women. Diseases existed, hysteria and mental breakdowns were many. There are records of beri-beri caused by bad food habits. Unhealthy, dissipated lives led to tuberculosis and dyspepsia. There was a high rate of heart disease, and alcohol took its toll of beauty—and lives—in spite of the Buddhist prayer *Namu Amida Butsu*. Venereal diseases existed before the Americans opened Japan to the world in the middle of the 19th century, but increased shockingly as the sailors of all nations became the customers of the prostitutes. Actual figures are hard to come by and always untrustworthy even in official reports, for the Japanese—as with war casualty listings of all nations—underestimate the truth.

The 1898 medical record of the Yoshiwara hospital lists $6^1/_2$ percent of the women suffering from venereal disease. The rate among the *jigoku* (freelance illicit prostitutes) and the *yo-taka* (night-walkers) is unknown.

The regulations of the Yoshiwara were sometimes strict, at other periods lax. There was the *hike,* or closing hour, set at 10 o'clock. However, while the great gate, the O-Mon, was chained up at that hour, guests were often slyly admitted through a small door cut into the gate. At midnight a pair of wooden blocks were struck together and the Yoshiwara was supposed to be sealed tight; those inside, in, those outside, out. At one period courtesans were classified as having *hiru* (day) guests or *yo* (night) guests. Prostitutes of the Yoshiwara were supposed to be released from their "contracts"—slave commitments—at the age of 25 but, usually by pressure or debt, they remained at their trade until 27—old in a flesh market that demanded youth and beauty besides skill, costuming, lechery, and gaiety. Here is a description of life supposedly written by the famous courtesan Hamaogi, talking of her life:

So I was young, just beginning to be a courtesan. If there was a shy guest, we played a game called "naked islanders," such creatures as are seen on the old maps. All of the courtesans would strip naked. The first time I played, I blushed and my skin turned pink all over. The guest saw my skin and was no longer shy. With a sated old man, of course, it is much harder. We would make like bats crying, the wooden clappers of watchmen. The madame would chant obscene prayers, reciting a service for the death ceremony of the guest who was sitting there alive. We'd burn toothpicks instead of incense. Then we'd feed the jaded old man *nerigi,* made of hollyhock, that fires the desire. One old man asked me to marry him, but respectability is dull and a wife has to blacken her teeth

and be beaten with bamboo rods, and there is childbearing
to distort the figure.

I like being visited by handsome young lords. A short life
and a body beautiful is the best; to please a man, to undo his
sash and, soon, to be *najimi* (intimate).

There is a desperate kind of humor about this statement, one
senses the round of pleasures, the games with unfavorable
guests, the deadly routine of sensual life that, in the end, bored
the courtesans and drove them to drink and to despondent
thoughts. One wonders how deranged some of these women
may have become. But, also, one should remember, most of
them accepted their way of life as being part of their culture.

In the beginning, courtesans were not permitted to leave the
Yoshiwara except to appear in a court of law. Later they were
allowed to travel to fetes. After 1829 the custom of permit-
ting the women to journey for the sights of cherry-blossoms
at Ueno, Mukojima, and Asukayama fell out of fashion. But
in those days, they would sip sake under the tree branches,
dressed in their best. Elated by alcohol and with some freedom
of action, they would dance and shout and carry on.

Sick courtesans could leave in a litter called a *kago* to visit
a doctor or for treatment. The temple bell of Asakusa would
serve as a toll; they had to be back in the Yoshiwara by 5:30.

Drink, the confined life, habits of irregular rising and
sleeping—in time, illness often brought the courtesan to a
breakdown. If she was a popular or famous courtesan, it was
amazing what the master of the brothel would do for her re-
covery. He not only provided the best medical attention, but
would remove her to his own home outside the Yoshiwara,
often in the country. At times, he would journey to some fa-
vorite temple to pray for her recovery. There was a perverse,
exquisite sensibility in such a life.

Unpopular girls, or those in low-class houses, had a harder time of it. Some quack would treat her, and she would be shoved into an unused corner to recover or die. If her condition was very bad, she would be returned to her parents or whoever had sold her, if they could be found.

If she died, and there was no one to claim the remains, she was buried in a sort of pauper's burial ground, the *Dotetsu*. Perhaps with only, as a sad poem said, "but one solitary little maid to mourn her."

During some seasons, runaways became common. Most of the courtesans who escaped were involved in love affairs, and went out to seek their lovers, to make up some amorous quarrel, or to kindle an old passion. These women, so besotted with sex, clung to any sign of affection, any gesture of kindness. They were sentimental, often beyond reason.

Some ran away because of bad debts. It was a heavy burden keeping up their costumes. With no knowledge of bookkeeping, they fell victim to loans and repayments due. So, in panic, with debts growing every day, every hour, they bolted the Yoshiwara. Oddly enough, we hear little of those who just wanted to escape their life and confinement; most likely, these felt some betrayal of a trust put in them. Many had been contracted into the Yoshiwara by parents in desperate need, who could be held to make good the loss.

An escaped courtesan would be the object of a man-hunt organized by a brothel-keeper who sent men out to scour the town and countryside. There were few places an escaped whore could find shelter. The police also assisted in re-capture of a fleeing woman, and so few ever got away. The runaway would be brought back to the Yoshiwara and to the brothel; the costs of the hunt, the tips, and bribes paid out to get her back were all added to her debts. And like a runaway convict

who had years added to his term, so a courtesan extended her slavery on being recovered.

A girl who was a persistent runaway was usually sold to a brothel outside the Yoshiwara, where life was rougher and methods of control more stern. This method of dealing with truancy was called *kuragae*—change of saddles. Her master could inflict punishment, and usually did. But no owner would needlessly cripple or bruise the merchandise.

Love-victims were treated with more kindness, for usually they discovered that the lover, once outside, had often aided in their return to obtain a bribe. Of the romantic stories of escaping lovers, the most popular were those who committed double suicide (called *shinju*—the inside of the heart) when cornered.

Lafcadio Hearn wrote of the sadness of tragic love in Japan.

Falling in love at first sight is less common in Japan than in the West, partly because of the peculiar constitution of Eastern society, and partly because much sorrow is prevented by early marriages which parents arrange. Love suicides, on the other hand, are not infrequent; but they have the particularity of being nearly always double. Moreover, they must be considered, in the majority of instances, the results of improper relationships. Still, there are honest and brave exceptions; and these occur usually in country districts. The love in such a tragedy may have evolved suddenly out of the most innocent and natural boy-and-girl friendship, and may have a history dating back to the childhood of the victims. But even then there remains a very curious difference between a Western double suicide for love and a Japanese *joshi*. The Oriental suicide is not the result of a blind, quick frenzy of pain. It is not only cool and methodical; it is sacramental. It involves a marriage of which the certificate is death. The twain pledge themselves to each other in the presence of the gods, write their farewell letters and die.

No pledge can be more profoundly sacred than this. And therefore, if it should happen that, by sudden outside interference and by medical skill, one of the pair is snatched from death, that one is bound by the most solemn obligation of love and honour to cast away life at the first possible opportunity. Of course, if both are saved, all may go well. But it were better to commit any crime of violence punishable with half a hundred years of state prison than to become known as a man who, after pledging his faith to die with a girl, had left her to travel to the Meido alone. The woman who should fail in her vow might be partially forgiven; but the man who survived a *joshi* through interference, and allowed himself to live on because his purpose was once frustrated, would be regarded all his mortal days as a perjurer, a murderer, a bestial coward, a disgrace to human nature.

Perhaps the survivor reflected on the folk poem:

> I sit at home
> In our room
> Stare at our sleeping mat
> At your pillow.

The most famous pair of suicide lovers were immortalized forever for the Japanese in 1703, by the writer Chika-matsu Monzaemon in a play *The Love Suicides at Sonezaki*. The lovers were a lowly clerk named Tokubei and an ordinary prostitute, Ohatsu. They killed themselves on the grounds of the Sonezaki Shrine. The play—in verse—performed by puppets—was a great hit at the Takemoto Theater.

The last scene of the play is all weeping and horror:

She cries out: Let us talk no more. Kill me and kill me quickly. The narrator recites: She hurries the moment of death. Tokubei says: I am ready.

The narrator informs us: He quickly draws out the dagger. The clerk howls: The moment has come. Namu Amida! Namu Amida! [a call to Buddha].

The narrator takes over to tell us what we are seeing on stage: He tests the blade against the skin, of her whom he had loved, caressed, slept with all those months and years. The hand shakes. His eyes glaze. He tries to get up his courage to face things bravely. But look, he shakes, so when he strikes, the pointed blade wavers. He presses on with two, three strokes.

She cries out, he knows he has slashed her throat. The blade presses deeper. She slumps, he too staggers. He moves his arms. Oh, of all pain that brings life this is the most.

Tokubei cries out: I am not staying behind. We shall mingle our last breath together!

The narrator continues relentlessly: He pushes, twists hard the knife at his throat. Will handle or blade snap off? His eyes dim, breathing is pain. The spirit goes from body like the tide ebbs... Thus they become a model of true love...

Suicide was no sin in Japan, of course, and it became in time a sort of traditional behavior, much admired by readers of sad romances and plays that end tragically, as most great love stories do, from *Romeo and Juliet* to *Camille* to *Mayerling*. The artists of the Yoshiwara, catering to the public of the courtesans and geishas, often made prints of famous doomed couples, showing them leaping from a bridge in each other's arms into the water, or in a love pact falling into Fuji's crater.

There were a series of ritual customs and manners that no well-brought-up, would-be suicide would ignore. Etiquette was all.

Inazo Nitobe, author of *Bushido, the Soul of Japan*, explained that for a woman who appeared in public "a pocket dagger was always carried in the bosom" and when she was ready to take her life, "if time allowed, a woman had first to tie her lower limbs firmly together with one of the numerous small sashes which were part of her clothing, the object being to keep the limbs decently composed during the throes accompanying mortal agony.... Moreover, she was taught exactly where to strike in the throat or breast... Perhaps this was the only lesson in anatomy that girls were taught in olden times..."

The last line can be doubted, for the courtesans, and even lowly prostitutes, had detailed information as to the male anatomy.

It was not too difficult for a gloomy, desperate, or embezzling Japanese lover to draw his sexual partner, casual paramour, or mistress into suicide. As one observer put it: "A Japanese normally defines femininity in terms of submissive behaviour."

In suicide, as on the futon, the males' desires and passions came first.

> And those that come after me
> May they avoid
> My journey of Love.
> —*Hitomaro*

There were other popular ways for lovers to depart together: by leaping from a cliff, or into the sea, arms locked around each other—that was a Japanese "happy ending" for many damp-eyed readers of popular novels. Love is nobler than the destiny that destroys it.

If the society of geishas and courtesans was often referred to as "the floating world," the life of the courtesan was also defined as *ku-gai*—the "painful world."

There is a Proustian overtone to Japanese love stories: They are best only in memory.

> In the penultimate decade of the Eighteenth Century, Edo banquets were characterized by an even deeper measure of sumptuous dissipation than any of the "little suppers" in contemporary Versailles or Paris, and while no less extravagant, they descended to lower depths of license and worse forms of depravity. Gambling was also common and involved stakes in Edo as in Paris, and the austere characteristics of the samurai in the days of Kiyomasa and Joshimune, profligate and self-indulgent roués, eager to acquire money... by any means, for the gratification of their vices.
>
> > The Tokugawa Epoch, 1652-1868
> > *A History of Japan,* J. A. Murdock

Let us look at the Yoshiwara through Japanese eyes and not those of the Parc aux Cerfs of Louis XV.

Some years ago the author, working on a historical novel, used some of the old unpublished text by Shogi Okada on life in Edo, about 1800. Some of this gives us a close-up of the life of a famous geisha of the Yoshiwara during its most expansive period:

> She came awake in her room at the Kataya teahouse in the Yoshiwara pleasure district of Edo. O-Kita, a young and beautiful geisha, not any legend, not an image in a foolish love story haunted by the ghosts from old Otsu-e pictures. One used to bring back these pictures from the village of Otsu. How the pictures were the *ukiyo-e* prints of the pleasure world, the floating world. However true the legend is, one can change the past by what one thinks of it.
>
> O-Kita opened her eyes to a morning sun that felt like warm

tea as it came through the paper panels. She rested on the high wooden pillow she slept on, with the half circle cut into it so she would not disturb her elaborate hairdress. She kicked her naked heels on the softly colored sleeping pad, yawned, stretched small delicate arms out of her sleeping robe, then sat up abruptly. A dream had fled completely and she had gray in her heart. She, the most wanted geisha in the Yoshiwara, like all the other women, was a prisoner here... .

She shouted, "Neko! Oshaku!"

A blank paper panel slid soundlessly open and Neko—Cat—came in rubbing sleep from her small eyes. She was eight years old and still plump with baby fat, and now puffy with sleep.

"Neko, why isn't the tea ready?"

"It's warming. Oshaku is fanning the charcoal."

"You're not maids; you're country clods." Then, feeling sorry, O-Kita smiled and waved an arm, remembering how the little Cat had wept every night for weeks when she first came to the Kataya teahouse, at the age of five, sold by her own father.

The little apprentice geisha went out quietly. O-Kita looked at herself in a mirror. At twenty her smooth face showed no sign of the years of singing and dancing, playing the *samisen* and *koto,* reciting poems, jollying the rich fatties, patting the old boys, and being witty with the actors and artists and people from the castles of the Shogun. O-Kita herself had been four when she was brought to the teahouse, sold by a man who had kidnapped her from somewhere up north near Nagano. He looked like a Fukusuke dwarf, they told her later. She hadn't cried; she just bit to the bone of the arm of the woman who bought her. Later, she quickly learned her skills and became an apt pupil and house favorite.

At fourteen she had already been famous, but she wasn't spoiled. Yet what had she to show for all the years, all the long nights of entertaining with wit and music? This room, that red

chest of costumes, two *samisen* with catskin heads, two dozen books and gold coins worth ten *koku*—and a *koku* could buy five bushels of rice; also a chest containing the prints the artists had given her instead of pay for her amusing talk and music. On the wall hung a painting of Goro, the wild hero of myth, sharpening his arrows; she owned a six-panel screen showing in soft gray and dense blacks the ravines and the sharp pines, the winding river like apple peelings, the little boats of the fisherman, the cruel crags touching rainclouds. The screen was a subtly beautiful thing, telling of the hardness of existence, and the passing forms of nature ever renewing themselves. Hokusai, her greatest admirer among the artists, would stand in front of the screen and sigh. Usually Hokusai was more fun.

O-Kita didn't often play and sing for the artists; they were poor in their tattered gray robes, always hungry, begging their publishers for a few *sen*. O-Kita looked away from the tall gray screen and its bewitching landscape. It was for solitary hours when she could stare at it uninterrupted and feel a glow, like being one with Kwannon, the Goddess of Mercy, who was actually a man but worshipped as of neither sex. O-Kita, waiting for her morning tea, remembered Kwannon had gone down to Hell to call on Amida for compassion for the damned, and a rain of lotus petals fell and Hell was broken open, and the damned all escaped. But such easy solutions were only in stories; in life one didn't escape, not even from morning tedium and melancholia. "Oshaku, tea!"

Oshaku came in with the tea service. She was twelve and already a woman, and she would be a dancer as soon as her training was over. Oshaku was over-refined, and the other apprentices made fun of her, but she would just lift her dark head higher and tilt her curved little nose at the ceiling, ignoring them. Cat followed Oshaku into the room, carrying the charcoal glowing in its container of hard-baked clay. She

was bubbling over with some morning gossip, but she waited seated on her haunches in anticipation until Oshaku had properly served the geisha her morning tea.

Oshaku placed a spoonful of powdered tea into the simple white bowl and poured the steaming water over it. With a small whisk she beat the tea for a moment, then bowed low and handed the bowl of tea to O-Kita.

O-Kita raised the bowl level with her eyebrows, lowered it and sipped. "So, Cat... Some tasty bit of gossip, I'm sure."

Oshaku said, "I don't see why you permit her to spread gossip."

"There is a packet with the great seal of the castle on it. It came by a servant wearing the crest of the Shogun. It has your name on it!"

O-Kita looked up and handed the cup to Oshaku. "So?"

"Madame Hairy Lip said you must be bathed and dressed in ceremonial robes to get it from Madame Hairy Lip herself."

O-Kita waved off the fresh cup of tea. She began to fling off her sleeping robe. "Get my bathing things."

O-Kita tried not to show her excitement. Twice as a young dancer she had been asked to entertain at the great stone castle of the Tokugawa Shogun. But never since she had become a famous geisha had she gone through the Nijubashi—the double bridge—and walked past the white towers to entertain the guests of the Shogun Iyenari Tokugawa.

In the steaming heat of the bathhouse, O-Kita stood slim and naked while the two young maids, naked also, poured cleaning water over her shoulders, flat belly, and shapely legs. Her skin was marvelously golden and a young poet had written a poem to it. He had killed himself, not because of the owner of the skin, but because of his gambling debts, playing *goban* for high stakes.

"What an honor, a call to the castle," shouted Cat, pouring

hot water from a cedar bucket. She had a child's big stomach, round and firm, and her skin was the color of those brown-amber plums that came from Kochi. "A bigger honor than ever came to this house. The Shogun is wonderful, just a year as ruler. He always looks so pale and bored when they carry him through the town. I wonder what he wants?"

"It's his seraglio," chattered Oshaku wisely. "It contains over fifty women. Such a task for a man who married a daughter of the Shimazus—of the *Fujiwara* house, too. None of the Tokugawas ever have enough women."

O-Kita slapped Cat's little rump with a wet towel. "Now, let's soak in the hot water."

The three girls stood in the large hot water tank, the almost boiling water up to their necks. It was an almost unbearable pleasure.

O-Kita wiped her brow with a dry towel and said, "They need someone to play the *samisen* or the *koto*. The nobles of the house of Hitotsubashi must be coming to visit the castle." Cat shook her head. "Stingy, the Hitotsubashi are. They pay the rate of service, and give you a cage of *hotaru* as a gift, as if fireflies had any practical value."

The steamy atmosphere of the bathhouse was invaded by shrill cries. Naked girls and some wearing only a brief undergarment began to circle the hot pool.

"One of the princes must be in love with you," said a fat girl.

"It's the young Shogun himself. He must have been here the other night, his face hidden under one of those straw baskets the priests wear when they go to the courtesans."

O-Kita, ignoring the shrill giggling, smiled and stepped gracefully from the bath, her pearly skin steaming, the beautiful curves of her body relaxed.

Cat stuck out her behind.

With dignity, O-Kita and the two young girls, wrapping

themselves in their bathing robes, left the bathhouse, now an animated scene of two dozen girls and women bathing, steaming and scrubbing themselves in an atmosphere of wet wood and hot brass.

Madame Kataya was the tenth of her family to run the Kataya teahouse. And legend had it that the first Kataya had been among those who, almost two hundred years before, had petitioned the Shogun to establish the Yoshiwara pleasure district. The present Madame Kataya, a lean old biddy with sharp eyes, sat this morning on a red Chinese chair, pinching tenderly the cheek of her favorite girl apprentice with much affection, feeding the greedy little mouth sweet rice cakes. Madame Kataya remembered when O-Kita had been her favorite, at just this age, and she rubbed her fingers together and dismissed the child. "Go practice the tea ceremony, Jita."

She looked at the table where lay the crested, silk-wrapped message tied at both ends and fastened with the castle seal. She warmed her thin bones in the glory of her house receiving this wonderful honor and thoughtfully rubbed the down on her upper lip that had given her the name the girls never used to her face. She stared at the old *kakemono* painting hanging on the wall. It was a religious text of remarkable calligraphy of the Shin-Shu sect of Buddha, whose founder discouraged celibacy among priests and preached that all men are the same. A good thing, too, mused Madame Hairy Lip, or there would be a great deal less business in the pleasure houses.

O-Kita came in. Her hair was done in the *tsubushi-shimada,* the most elaborate of the geisha styles. Her neck and face were freshly powdered an even, lusterless white, and her eyes were made up. She bowed low and stood waiting, her hands in the sleeves of her ceremonial kimono of gold, red, and pale blue. The sash was very wide and the color a deep purple; the bow

was tied in back, indicating that O-Kita was a geisha and not a courtesan; the courtesans all wore the bow in front. Madame Hairy Lip's trained gaze went down to O-Kita's white socks that were divided at the big toe, and to the polished wood sandal-like shoes.

O-Kita kept her head down, staring at her reflection in the table. Too many thumps on the face had taught her long ago one didn't answer the old hag in kind. "I have dressed to do honor to the house of Kataya."

Madame Hairy Lip made a harrumphing sound in her ancient windpipes and took up the message from the Shogun's castle.

She broke the seals and removed a scroll of smooth paper that crackled as she unrolled it. She read it while she fingered her upper lip. Then she looked up at the expressionless geisha.

"You have been requested to go to the Shogun's castle and take your musical instruments, your bedding, and your maids with you. Your best robes, of course. I don't have to tell you I'll skin you like a fish for pickling if you misbehave, or steal, or insult a guest. As for your morals, that's your own affair. But respect your duties as a great geisha."

Madame Hairy Lip remembered how much she had loved O-Kita once; she put her arms around her and said softly into her ear, "For you are a great geisha, more beautiful, more witty, more graceful than any I have known. Even as great as the Gi-O of legend, who long ago was loved by Kiyomori himself. And remember not to scratch your head."

O-Kita felt numb with wonder, and remembered the blows and caresses Madame Hairy Lip had once given her. Times do change. She bowed and went to her room to set her maids to packing.

O-Kita sat down on a *tatami* and thought of her situation calmly. She was no fool, and she had no illusions left. She

had grown up in the teahouse, in this woman-trap, this vice section, and she knew intimately the gloss of pleasure and gayness of its brothels. She could thank certain gods that she had enough talent to be a geisha, and not to be condemned to the ranks of low prostitutes who lived and died in the Yoshiwara, doomed to hopeless slavery and a ghastly destiny.

What had kept O-Kita from going to drink, to debauchery, as so many geishas did, was her temper and her personal pride. She had taken what she had to take, but she kept herself privately on the alert against fuller exploitation and disease; she was not one to wallow in the vice around her. There were things to regret in her life; humiliations, defeats, moments of horror she did not want to recall, but as a realist she knew she had survived, and survival was everything in this place, this city, this world. One could so easily become *baka, kuso*—a fool and dung. Years ago—oh so long ago—she had dropped a coin between the stone foxes that guard the temple of the god Inari, who brought rich fat husbands to desirable girls, but now she no longer wasted money on such dreams. She would be free some day, but she would not be a diseased drab, stinking from spoiled fish and horseradish, one more to be gesturing lewdly through the grills for the attention of drunken louts and their ideas of pleasure.

There were thousands of women here. Few escaped, but she would. She would be free from the whole miserable system of slavery, enforced services, the ritual obedience to the great and the rich who lived off them. All of this she would escape, she told herself, but it was hard to believe sometimes. There was so much tradition piled up behind this dreadful life. There was so much tradition behind everything. Hokusai was right when he said, "The dead, my dear O-Kita, are the real rulers of Japan."

What would come of her visit to the castle? If the fruit be bitter, or if it be sweet, the first bite tells.

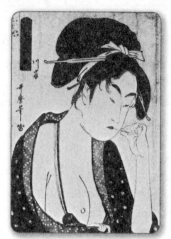

Prostitute of low rank: Utamaro, 1753-1806.

Now the O'Bon festival has come.
A man without passion in him
Is like a Buddha of wood,
Metal or stone.
—*Folk poem*

CHAPTER **12** A Foreigner's Views
on the "Soiled Doves"

Soon after Commodore Perry banged open the doors, eager
visitors began to appear from the Anglo-American countries.
Their writings are of value as outsiders' impressions—citizens
of the Victorian morality—which, on the surface, cast a cold
eye on what it termed vice, sin, degeneracy, and sex habits
of "lesser breeds." We know today that this morality was a
veneer, and that the Victorian ideal in England and America
was a pious fraud.

One 19th-century writer of newsletters home to England,
and a world traveler, was Clement Scott. Under the proper
Victorian title *Soiled Doves in Cages,* he told of his visits to
Yoshiwara.

He begins in that moral 19th-century style:

I now come to a serious and vitally important question in connection with the civilization of Japan, on which I would far rather have said nothing at all.

There is a form of slavery in Japan today that cries aloud for redress with a voice as strong and as eloquent as was ever raised for the negro or the barbarian, the Hottentot or the savage! I have seldom traveled in a ship round the world without finding it filled from stem to stern with missionaries, American missionaries, English missionaries, missionaries of every form of religious thought, men and women sent out from home at an enormous expense to live on luxury and to catch into the net an occasional Mohammedan, a chance Buddhist, or a Brahmin.

But it is strange to me that they should so systematically shut their eyes to the female slave markets that can be found in any important and many unimportant cities of Japan. Why do not these highly paid missionaries occasionally leave the heathen temple for the human Yoshiwara? Why don't they cease trying to convert the Japanese Buddhist and turn their attention to the degradation and soul slavery of women in Japan?

Do they not know it is a recognized custom for parents in Japan to sell their children to a life of shame? Are they not aware that a foreigner can go before the recognized authorities and calmly submit to a sham custom of marriage in order to obtain a female companion during the time of his visit to the Land of the Mikado? Are they ignorant of the fact that, when men hire the women who cook for them, darn for them, mend for them and market for them, they buy concubines, and that the law assists the mercenary parents in trading inhumanly and selfishly with their own flesh and blood? Is it

not an admitted fact that in every Yoshiwara in Japan, there are hundreds of girls who were sold originally by their parents to the keepers of these infamous places for so many hundred dollars, and here they must stay until their ransom can be provided by some charitable person?

The husband and wife who are brutal and unnatural enough to sell their children into such disgusting and deplorable slavery, who would calmly at the outset ruin their bodies and souls alike, are not very likely to take much trouble in ransoming the poor girls. Quite the contrary. Girls are to them a permanent source of income. All their savings are not put by to pay off the original deposit, but are sent home to the whining old parents who are always hat in hand, and never intend that their children shall be released at all. In fact, cases have been known where some good fellow has bought out a girl from a Yoshiwara with his own money and restored her to her parents. She has been sold back again to the greedy wretches who trade on their own flesh and blood, who sacrifice their children on the altar of lust.

What is a Yoshiwara? Well, come with me.

Our ship has arrived at Kobe on one of the bitterest nights. So, off we go, across that waste of black water, in the pitch dark night. When we arrive at the shore, the *jinricksha* men rush at us and pin us in with their light perambulators.

Where shall we go? Our mentor advises a journey to the Yoshiwara of Kobe—the district set apart for the exhibition of female slavery in the public streets. Here we are to see for the first time in Japan the soiled doves in their cages. Once more we mount the 'rickshaws and the hooded Japs trundle us away to the quarter where Japanese women are exhibited for hire.

I could scarcely believe my eyes. It was literally true: hundreds of gaudily dressed girls were sitting behind wooden

bars in shop fronts in barred cages waiting to be hired. There were dozens of such houses even at Kobe. There the girls sat in a semicircle warming their pudgy little hands over the firebox, smoking their little pipes, and sometimes varying the monotony of the proceedings with a melancholy song.

What a dreadful and appalling exhibition! Here you could stand and talk to the girls behind the wooden bars, penned in like so many animals; here bargains and arrangements are made; here you can throw down your glove to whomsoever takes your fancy. On ordinary nights, to expose women in this fashion is loathsome to the European mind, but on such a night as this, it was positively cruel and inhuman. But I suppose it pays. Even in this awful wind, there were found ghoulish Japs who wandered among the cages and selected a victim for today's or tomorrow's sport. For do not think these cages are kept for the foreigners alone. The soiled doves in their finery are for home consumption for the most part. Scarcely a Japanese man is faithful. Their wives do not expect it. And the notion of a spree in Japan is to go to a Yoshiwara and enter into a two- or three-day's debauch with several chosen companions.

When a detective is set on the track of a youth who has robbed his employers or a man who has forged, the first place he goes is to a Yoshiwara. There the delinquent is pretty sure to be found, treating right royally and in the centre of a whole cage of soiled doves. But it was too cold to thoroughly investigate the matter...

I renewed the investigation at Tokio, which boasts the largest Yoshiwara in all Japan, and I should say, by far the most daring and unblushing immoral district of any city in the world... . When we got into our rickshaws, I imagined we were within a stone's throw of the revolting place we were to visit.

Tokio is not a small city. We scudded for the five miles that night in an open 'rickshaw. We endured the unspeakable cold for five miles of low streets and slate-colored shanties, in order to pay a visit to the famous Yoshiwara of Tokio, which is not a colony but a positive city in itself. Here you have at least a couple of square miles of houses, all with women exposed in cages, affording the most extraordinary spectacle that civilized eyes have ever seen. It was not a menagerie, not a cat show or a dog show, but an exhibition of lost women who are being advertised in order to satisfy the greed of men.

Let us enter. Directly we cross the threshold a bell rings, and there is a scurrying and a scuttling all over the house. Strangers have arrived. They are not apparently satisfied with the goods exposed in the shop windows. They want to see what is on the shelf. They have looked and they want to touch. Sliding panels are squeaked all over the house. A voice summons the poor little women to the ghastly muster roll. Patter, patter, patter, we hear their slippers and clogs all over the dry boards of this dreadful house and we, who have been ushered into the best parlor or waiting room, calmly anticipate the exhibition.

Suddenly the door opens, and in come the victims, the heroines of the evening, of all shapes and sizes, but always of the same color and pattern. They all bow, all scrape, all grin, all submit themselves as the slaves of the "honorable" strangers. They are awkward, shy, ill at ease. In their hearts they hate the foreigner. His contact is loathsome to them. They cannot disguise their disgust from any man of a sensitive nature. One of those lost sheep would, I presume, be as good as another. The hair of all is black and greasy. Each head of hair is arranged in precisely the same fashion. All have beefy cheeks and arms and the hands of kitchen maids.

The only girl who makes a success with the European has let down her hair. The pomatumed headdress, flecked with

dust, is too hideous for words. It is a sorry exhibition.

All that can be done is to stand treat to these poor little women, who feel the cold dreadfully. Some choose sake, a dreadfully sweet distillment; others tea. The keeper of the caged doves prefers bad champagne, or whiskey more poisonous. Had we all been tipsy, I am told there might have been forced hilarity and feeble fun. They tell me it is no earthly use going to a Yoshiwara unless you have dined well. You must drown your conscience at such places. You must forget you have mothers, sisters, wives and sweethearts at home. You must disbelieve for a moment in the sanctity of women. These victims waiting for selection were pure doves once, but they have been soiled. They are imprisoned by man's force and desire in cages from which they cannot escape...

All of this other-world comment made little sense to the Japanese. It seemed pious cant from nations where white slavery was a prosperous business. England exported girl-children to vice centers all over Europe, to Arabian degenerates, to South America by the thousands—and few laws could touch these businesses until the reformers fought the free-enterprise system in girls.

The treatment, mutilation, despoiling of children and women were a disgrace in civilized nations, and even the Tsar of Russia freed the slaves (at least on paper) a year before Lincoln did. Homosexual scandals rocked British and American society. Kept under polite and rigid cover, the widespread conditions of vice in Europe were totally unlike those of Japan, where all was exposed in a public Yoshiwara. The dissolute life of the latter was accepted tradition. A man in Japan aspired to be a rake, a sake drinker, a libertine in a special environment of full license. It took wealth, or least some financial means, to obtain the best there was to offer, but the

reward was that every whim, every fantasy or desire could be gratified, or at least attempted. The male was supreme, yet all men were equal there from the merchant to the samurai, as long as the cash held out. No wonder it was called in the prints, *Ukiyo-e,* Picture of the Floating World.

The meanest-looking citizen, the most ugly, the most despised, if his wealth carried him to the Yoshiwara, could hire a whole street of teahouses and he and his friends roister in a Nirvana of alcohol, flesh, and lusts. He ruled by buying courtesans, sake, geisha music, jests, and ribald stories until his money ran out. It was no furtive pleasure, no sneaking away ashamed to sin in fear and shaking. *Hatamoto* (knight), samurai, gambler, rice speculator, all were welcome.

The hierarchy of courtesans raised a man as high as his purse would take him. He could buy his way beyond the marvelous patterned kimono, the colorful sashes, the cob webby, flimsy undergarments. He could reach for the naked flesh, fondle the white neck, spread himself in sensual variety, be gratified by any act, normal or what some con sidered abnormal.

The male company of the Yoshiwara was good; artists, actors, writers of frivolous novels, dramatists, makers of wild Kabuki plays, promoters, merchants. All were there to pass the night in drink, laughter, and exotic female company. No wonder the story of the Yoshiwara spread all over the world. Tales of its luxurious sensuality became a legend during and after the Tokugawa era.

> The sun sets
> To tolling evening bells
> In the Yoshiwara
> The grand courtesans
> Wait in full costume.
>
> *—Anon.*

When Westerners objected on moral grounds, Japanese intellectuals of the 19th century could hint at the customs of the early Greeks, "founders of Western culture." There, they pointed out, the hiring of women as sexual companions was one of the innovations of city life. Solon himself first established brothels throughout Athens. "You did well for every man, O Solon," said one Greek poet. "You, seeing that the State was full of men, young and possessed of all the natural appetites, and wandering in their lusts where they had no business, bought women and in certain spots did place them, ready for all comers." It protected wives, was a good business venture, and Solon built the temple of Aphrodite Pandemos with the profits of the Greek Yoshiwara. Hadn't another ancient Greek written, "They cling greedily together and join their watering mouths, and draw deep breaths pressing teeth on lips ... At length there is a short pause for a while in the furious burning. Then the same frenzy returns, and once more the madness comes..." The secrets of the Yoshiwara were not too secret to the visiting male from across the sea; Western women apparently did not visit there. But the female Victorian tourist was shocked almost beyond words at the bathhouses surrounding the district and in cities all over Japan. *A Lady's Visit to Japan,* written (in the 1860s) by a lady hid behind the name of *Annie d'A,* says she was "little prepared for the absurdly indecent scene. At the further end of the room a portion partitioned off by a low wall within which enclosed space numbers of men and women were bathing *puris naturalibus...* reminded me forcibly of a presentation of souls in purgatory I once saw outside a church."

Still another Victorian lady commented on the same sights:

In Japan the bathing-place of the women was perfectly open (the shampooing, indeed, was done by a man), and

Englishmen were offered no obstacle, nor excited the least repugnance. Indeed, girls after their bath would freely pass, sometimes as if holding out their hair for innocent admiration, and this continued until countrymen of ours, by vile laughter and jests, made them guard themselves from insult by secrecy. So corruption spreads, and heathenism is blacker by our contact...

Speaking once with a Japanese gentleman, I observed that we considered it an act of indecency for men and women to wash together. He shrugged his shoulders as he answered: "But Westerns have such prurient minds!"

Not all the bathhouses were as innocent as they looked, and the ones patronized by the knowing sensual male were often brothels where the girl attendants were trained and skilled in all the acts the West called perversions. The bath water was always nearly boiling hot, which also discomfited the Western visitor and he resented being washed and scrubbed and doused with buckets of water before getting into the bath. He bathed for cleanliness, not for pleasure.

When the first American consul, Townsend Harris, insisted on taking his morning baths in cold water, the Japanese were sure Americans were truly barbarians. The idea of the pleasure principle in bathing came hard to the first Americans in Japan. An Ensign McCauly, in his journal kept while he was with Commodore Perry, reveals his Puritan upbringing and his pious rejection of what he saw with shipmates on his first visit to a Japanese bathhouse: "Girls of seventeen, old women, young women, old men were squatting on the stone floor, without a rag enough to cover a thumbnail ... invited us to join in and take a wash—but I was so disgusted with the whole breed, with their lewdness of manner and gesture, that I turned away with a hearty curse on them."

This may, of course, have been an innocent public bath—or not. He tells us nothing of the reaction of his fellow sailors, whether they too turned away with "a hearty curse." One doubts it. There are woodcut prints of bearded American sailors consorting with the Yoshiwara prostitutes.

Actually the Edo courtesan was no worse off—most likely, better off—than the prostitute in the Western world. One has but to read *Moll Flanders, Fanny Hill,* or the horrifying details of *My Private Life,* to see that the Japanese were more honest in their wide-open approach to sexual intercourse as a biological pleasure away from wife and home. Our 19th-century forebears pretended that it didn't exist and if it did, it was revolting and despicable. Kings, dukes, and most of the "quality," the middle-class and the newly rich, sported with whores. And worst of all, cant and pious slogans floated over vast cesspools of semi-secret vices under the rule of Victoria and Grant.

Our own ideas of morality are based on a guilt-ridden puritanical concept of sex. They did not prepare us for the Japanese morality, which consisted of family devotion, respect for ancestors, and loyalty to the God-Emperor. Sexual repression had nothing to do with their morality. A Japanese man was free sexually with no barriers of guilt or moral condemnation.

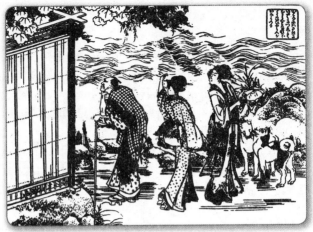

Geishas at a shrine: Hokusai, 1760-1849.

Look! there rises the high peak of Fuji
Between Kai and the wave-swept Sirruga.
The clouds of heaven avoid it,
No birds dare fly above it.
The snow swallows the flaming fires.
Embers dissolve the snow,
Language and words fail,
It is a god mysterious...
—*The Manyoshu (8th century)*

CHAPTER **13** Faith and Ritual

The Western world could not understand how Yoshiwara could exist well into the 20th century, or how the majority of Japanese could accept the state of female slavery under the polite term of "contracts."

For all of its modern place in the world, Japan has held on to certain ancient and traditional values that seem outmoded to the rest of the world.

The Japanese themselves for centuries have accepted the idea printed in their school books that "the line of Emperors are sacred and inviolable... Japan is ruled over and governed

by a line of Emperors unbroken from ages eternal. For the Meiji line is of divine origin."

There is no ingrained skepticism in this statement. The legend goes this way: A long time in the past—in the beginning—when the earth was sea and mist and without much form, the god Izanagi and the goddess Izanami were floating in the clouds above the world in affability and graciousness, hovering in space as gods will. From the phallic spear of Izanagi fell heavy sperm-like drops that spread and congealed on the waters of the earth as it was then, and became an island in this atmosphere of a god's prodigality.

The two gods, curious to see this happening, came low to observe and then glided around the island in opposite directions. When their paths crossed, the female goddess, aware now of the potent male element, spoke up: "How delightful to meet such a handsome man."

Now, Izanagi, in the mood of Japanese men toward forward females, was angry that a mere woman—even if a goddess—should have the vulgarity to speak to him first, and he pushed her off to circle the newly formed island alone. When he met her on her return, he confessed: "I am much pleased to meet such a beautiful woman." The two, watching some love-birds copulating (no explanation of how birds came to exist so quickly) set to in furious sexual embraces and mighty fornications. From these bouts of passion and lust, a son was born, and—incidentally and enigmatically—also more islands. These islands, together with the first island created, became Japan. So goes the story in the ritual *chroniques* of Japan's past.

Later the goddess Izanami, having all the hard work of creating a genetic pool, was burned to cinders giving birth to man's great friend, Fire. This left the male, Izanagi, alone to produce offspring from himself. The results of this self-fertilization

by the god were the three major gods that dominated Japan. Their births are rather unique:

Amaterasu, the Sun Goddess, was born from her father's left eye; Tsuki-no-kami, the Moon Goddess, from the right eye, and Susa-no-o, the Sword God, from the fatherly right nostril. Susa-no-o was a problem son, given to great sexual orgies, chopping anyone up with his great sword at any slight hint against his honor.

Even in the days of Emperor Hirohito in the 20th century, it was taught in the schools that Susa-no-o's lusts drove him to the rape of his sister Amaterasu, the Sun Goddess.

She, in shame and anger, retreated into a deep cave, swearing she would never appear again. And so the world was dark, for she was the sun.

To lure her out, the warriors put on a party outside the cave with much dancing and singing, and when she asked whether this was a time for celebration, she was told that the most beautiful of all goddesses was entertaining the warriors. Asking who could she be, she found a mirror held to her face; thinking it a portrait, she rushed out of the cave in rage to compare herself with this rival. In the outer air, she produced the son engendered by her brother, and the baby was called Ninigi.

Ninigi came down to the earth and became the ruler of the Japanese islands. The first Emperor was his grandson, Jimmu, who took the throne in 660 B.C. (as it would be recorded on the calendars of the white barbarians). Jimmu was still not all human; his mother was a crocodile with a fundamental incompatibility of temperament. But, as Jimmu's great-great-great-grandmother was the Sun Goddess, he was "the Son of Heaven, God of the Sun, purely divine and founder of the Japanese Imperial line, unbroken" direct to Hirohito.

This unrestrained, and to some imbecilic, fantasy of proud blood lines saturated Japanese culture. It was the practice up

until World War Two for many people to enact a ceremony that called for a bow for one minute in the direction of the Imperial Palace—"worshipping at a distance." Then they recited a Rescript that many (even prostitutes and geishas) knew by heart:

Question: "What is your dearest ambition?" Answer: "To die for the Emperor."

The geishas and courtesans, not being able to die in battle, felt it an honor to recline without a death for the pleasures of the Emperor's officials, warriors, and politicians with forbearance and grace.

To some historians, these lusty and savage beginnings of the gods of Japan, and the divine origin of the emperors, are in many ways no harder to believe than the cherished beliefs of Egyptian, Greek, Hebrew, Buddhist, Moslem, and Christian peoples: the mighty seductions and fornications of the Greek gods in the shapes of swans or eagles or in their own forms; orgasms that last ten thousand years in the heaven of Mohammed, whose coffin is suspended between heaven and earth; the sun standing still in Hebrew battle; or Christian miracles.

To those of one faith, those of others are incredible.

The Japanese royal line, in its human vices and its overwhelming arrogance, reminds one of those kings and emperors of Europe where thrones were held at times by eloquent fools, murderers, philosophers, weaklings, saints, tyrants, debauchers, heroes, and perverts. Often, some court favorite, some Machiavellian whore, ruled through influence. One advantage of the Japanese court was that a disgraced favorite could atone in affectionate regret by ripping open his entrails with a short sword in ritual suicide, the sacrificial *seppuku,* in contrast to the ax and block of bloody Henry's Tower. In Japanese theology, any other kind of culture would seem odd.

Psychologically, what confluence of rituals united these peo-
ple? The faiths that held together the courtesans, their owners,
the managers of the green-tea houses, the common people, the
artisans, the samurai, the shoguns, and the court were those
long established in Yamato (the ancient name for Japan).

Actually, three faiths of some breadth and spaciousness
existed, to be joined later by a feeble Christian one. *Shinto*
means the Way of the Gods—and there were millions of these
gods. Some are birds, animals, trees, shrubs, mountains, and
a vast court of demons in many agonies. Each house had a
God Shelf, and here would be found a copy of the sacred
text, *Kojiki*—Record of Ancient Matters. It is the oldest text
of Japan, dating from A.D. 712. In it are detailed the sacred
legends of the gods and their earthly descendants and God-
Emperors in vivid imagery.

The big celebration in every village was the yearly festival of
the Shinto shrine, celebrating the olden times when the first
deity in ferocious dignity came down and graced the earth by
his residence here. These shrine fetes consist of swirling, chant-
ing mobs that take over from the Shinto priests in their ancient
traditional white robes with black pronged headdress—often
seen as they file into the temple. Festivals used to become
vast orgies of eating and pouring down of sake and that led
to uninhibited sexual carousing, a derangement of all the
senses—a wild, gay time.

Temple offerings were simple: One washed one's mouth
out, for water is the true source of purity, and made one's
offering. No matter what the design of a Shinto shrine, it
contains the *torii* gate around which priests recited old prayers
and maidens dressed in scarlet and white danced to ancient
music. It was a mass religion, and was looked down upon
by the intellectuals, the men around the courts. It was primi-

tive without being decadent. It merged, in many cases, with Buddhism, and the two often shared the same temple area. In their folklore, the proud, brave Shinto gods would protect the milder Buddha from mean and crafty Japanese demons. It was a respected combination. Particularly the women of the Yoshiwara especially held a reverence for Shinto and Buddhism free of aesthetic subtlety.

In 1868, the government ordered the separation of the two faiths, but this had little effect. The two altars still were found on many a Japanese woman's God Shelf. They were not, of course, compatible. For Shinto teaches that the present is the most desirable and splendid of worlds, and that the next world is a foul place, cruel and packed with monumental evil. The Buddhist, however, believes the present existence is a foul thing, cruel and evil, and the next world, if it exists, will be desirable and fine.

One Japanese theologian wrote: "Christians understand this conflict, for they, too, believe one thing and act against it. They talk of brotherly love and peace on earth, and make dreadful wars on each other and the colored races, all with pious mouthings of the Golden Rule and the Sermon of the Mount. Proclaiming peace in their hearts, their bombers move overhead for a non-Christian, non-spiritual, material domination."

The follower of Shinto knows, as we have told, that the gods produced the Japanese islands from giant copulation and incest, and from the sea-foam. The Buddhist believes that the universe has been eternally here and that no creator exists. Yet there are, actually, men who are both Shinto and Buddhist priests, inhabiting a world unbelievable to us.

The courtesan knew, no matter how low her station, that as a follower of Shinto, she had a relationship with the Imperial family. The Emperor, so Shinto theology taught her, is a direct

descendant of the Sun Goddess. His rights are divine, not made by mere man, so a woman could feel comfort in his rule.

As an ancient writer put it: "The Sun Goddess left her descendants to reign over us forever and beyond. This is true *only* of our own country, and nothing like it can be found in any foreign lands. That is why we are called the Divine Country."

No wonder the Western world has, at times, been baffled by Japanese chauvinism. For Shinto is as pure a nationalism as the German super-race, a kind of gothic hysteria, often venomous. The Imperial family that returned to the throne in 1868 with the passing of the shoguns gave Shinto the position of state religion. The Emperor in return—favor for a favor—was made Chief Priest. It became the warlike ritual to carry Shinto gods overseas, spearheading them into captured territories on the mainland and on the islands of the Pacific.

The Vatican of the Shinto faith is the great Grand Shrine of Ise, on the river Isuzu, where pilgrims wash. The shrine is enclosed in clumps of cedars and though the buildings may look old, they are actually rebuilt as true replicas every twenty-five years. Lanterns glow at dusk, the fireflies come out to gold-fleck the night and, if a changeover to new replicas is due, in the dark of night the Sun Goddess is escorted to the new shrine in a tent of white silk carried by priests. Invisible to most, the true believer, joyous in pagan affirmation, knows she is there.

The Gion Festival at Kyoto during July is a gay and wild event to *kon-chiki-chin* music of flutes and bells. A sacred car to carry images, gorgeous in iridescent colors, is dragged out and washed down in the Kamo River. Everyone comes to inspect the *yama* and *boko* (the floats and music-makers' wagons). These are days of feasting and dancing, the time for courtesans and geishas to perform their tasks and be pleased with Shinto.

The Fire Fete at Kurama is even more feverish in its vo-

luptuousness. The drunks carry torches, everyone cries out *"Saireya sairyo!"* to the tune of the festival song. The night becomes wilder, the torch-bearers strip to their loincloths. Women, also half-nude, join in to visit the "gods' traveling spot." All the proud, lonely island people, fused in sparse living and a sense of destiny, meet in Shinto.

The Shinto priesthood is a trade union, rigid with protocol, and the office usually goes directly from father to son. Hereditary rights fill the temples dedicated to Amaterasu, the Sun Goddess, and Izanagi, the Creator God.

Korean priests of the Buddhist faith came to Japan near the end of the 6th century; an import of the culture of India and China to still half-barbaric islands. They introduced not only texts of fine writing, but paintings, statues, scrolls, at a time when Shinto had hardly a line of text or an ornament for its temples.

The priests brought the Chinese characters and language, with the knowledge of the most civilized nation on earth. It was no accident that by the 7th century, the new faith could produce an Emperor who honored the religion of Buddha and despised "the old Way of the Gods."

The Buddhists made readers of people who had not thought much of reading, and the monks tried at first to explain the sacred writings. It was nearly impossible. What came to the mass of Japanese was a much simplified, much wrung-out Buddhism. But the court was pious, and the people followed its example, erecting in the 8th century, at the capital of Nara, very early temple pagodas. They completed the great bronze image of Buddha, over 50 feet high, in A.D. 749. While not the most beautiful Buddha in the world, it is one of the most impressive, though badly scarred by fires, earthquakes, and human vandalism. Its majestic simplicity suggests the depths of human experience.

At first, the Buddhist teachings were esoteric in Japan, for only the highest minds to speculate upon—hardly for prostitutes, girl-singers, or for the masses. Pupils spent a lifetime with a master to get some idea of his spiritual content. Initiates struggled and waited for light to come to them.

Disenchantment gave way to a popular simplification. It became fashionable, one monk wrote, to wear merely the outer wrapping of the religion. Court ladies, high courtesans, put Buddhist scrolls on their walls, and had fans painted with texts from the sacred books as if to fan faith into themselves while cooling their heated skins.

The fashion to take part in the outer show of faith brought on a period of play-acting, in roles of nuns and priests (just as Marie Antoinette played at milkmaid while France fomented). The lady or geisha or courtesan would have the tips of her hair cut to symbolize the shaving of the entire head of a true nun. The game of leaving the world, as nun and priest, took over, in pleasant retreats, often with libidinous sport.

And Buddha and his *Bodhisattvas* looked down, unblinking, from their temple shelves. The mass of people still preferred Shinto, as closer to their own sense of themselves.

After rape and civil war in the 12th century, Buddha became universal in Japan. Called Pure Land Buddhism, its priests warned that the last degenerate hours of the world were at hand, and salvation would not come by one's own efforts alone. Amida, a Buddha of the Western Paradise, must be called on to save all, so one could come again after death— even if a prostitute—to live in paradise.

Every great gush of revival of a faith, in ordinary people, uses this sure-to-rouse-them method. To call out "Namu Amida Butsu!" was enough, and Amida would hear. Dancing and singing, everyone shouted "Namu Amida Butsu!" So the

simple cry replaced study, a song took the place of hard-to-crack texts. Even though the individual had to admit being nothing and owning nothing, in times of turmoil or of great disaster this was the salvation people wanted. As with the early Christians who hated life on earth and its fleshly sins and groped for life in heaven, so the Pure Land Buddhist hoped for paradise in some other world.

The Peter and Paul of this new truth was the priest Nichiren (1222-1292), who cried out that Japan was the true land for the revival of Buddhism. He offered on earth only fire and war and rape and disaster, and the Mongols came to prove him right.

To the debased women of Japan in the brothels, in the inns, to wives treated as mere chattel, as sexual toys, Nichiren preached the true faith of enduring one's suffering here on earth. In paradise, all would be grand. No wonder that so many beat drums to the rallying cry of the sect: *"Namu Myoho Renge-kyo* (Hail to the Lotus Sutra)!"

The lords and princes and the samurai demanded a more exotic form of Buddhism. For them, Nichiren Buddhism would not do. It was a bit vulgar in its promises to all. They preferred the Zen cult, which demanded meditation, solitude at times, and rigid disciplines. Zen depended on Buddhist texts used to study exotic problems presented to its pupils. Logic could not solve everything. In Zen was the sudden flash of inspiration or insight, the enlightenment. Its interlocking thought, like weaving, appealed to cultists.

Dogen, in the 13th century, became the most respected of the Zen masters. He did not particularly insist on the sudden burst of knowing, but rather on the value of silent meditation to bring one to the true self-reliance—the Buddha inside each of us. With sobriety and gravity the subjective fantasies of life would be clear.

Zen masters in portraiture became images in the temples. The men of strong, humorless will, the generals and military, found Zen discipline worthy of study. Zen monasteries and temples had appeared every place by the 14th century. The stark beauty of their simple design strike us, even today, as major art forms. The severity and rigid discipline in art was startling. It is still magnificent in gardens at the Daitokuji and Ryoanji temples at Kyoto. One sees a bit of moss, areas of raked sand and gravel, rock shapes—everything of aesthetic pleasure is there.

The monks also developed the tea ceremony—a graced simplicity in a few significant movements.

The tea ceremony became a standard ritual in the Yoshiwara, not that many would connect it with the mysterious credos of Zen.

Buddhism has about eleven major sects in Japan, and while all get along together more or less, the Nichiren group has been at times hostile to the others, particularly when it became ultra-nationalistic and reactionary and, like national Christianity, smug with cant.

After the 16th century, the basic philosophy of the various Buddhist sects did not much interest the common people. They knew little of the actual history or the deeper meaning of the texts. They were "Buddhists" and that was enough for most. They were pious to the extent they would clap their hands at a Shinto shrine, bow the head in a Buddhist temple, and accept a few other simple acts and accessories. It fitted the needs of the Yoshiwara perfectly.

Those Japanese who came under the scientific and literary influence of the West observed that much of the priesthood was lazy, greedy, incompetent, made soft by begging, and ever perverted by pederasty. After the Restoration of the Emperor,

some called the religion a superstition. But there remained for the Japanese behind their *Shoji* screens the Buddhist belief of the impermanence of all things in this world, of the futility of all human endeavor, and it fitted their often dour moods. It was taught in geisha and courtesan training and in school books.

> What if the colors be full of odors
> Flowers will die.
> Will any of us in this world
> Last forever?

The Zen graces and disciplines survived in strange places. Few noticed how their ceremonial aspect of life was taken up by the courtesans and the geishas as a way of living. They graced their lives with superficial Zen in their music, their singing, in performing the tea ceremony, the settings for their meals, their very way of walking and dressing. One could sense that the very costumes and hairdressing styles came over from the Zen ideals.

They were not pious Zen followers, or even readers or students of the texts. But the women offered their sensual charms and services in a pattern, with rhythmic arabesques—quite different from the often coarse and brutal directness of Shinto forms, or even other sects of Buddhism.

It has been observed by anthropologists that a cult can have a different effect on different branches of a tight social order. So, while the adulterous court ladies played at being nuns, the prostitutes and serving-maids of the brothels and teahouses assumed the mannerisms of the creed.

It was pleasant for the guest of the teahouse, the eating place, or the brothel to have the women in fashionable hairdos politely bowing, humbling themselves before him, assisting him in removing his shoes, leading him to a beautifully balanced room, with little decor but that of the best. Here

his tea would be properly prepared and he would be offered tidbits by women endeavoring to amuse him with witty sayings, and singing or playing or dancing for him. Then, if he so desired, he would proceed to the courtesans' ceremonial love-play, which could make him feel like one of the gods (for the Japanese gods, as we have described above, given to sexual pleasures, taken in great leisure, were divine masters of the art of fornication).

Disciplined preparation for carnal games was one of the charms of the Yoshiwara.

Buddhism softened the sad fate of the captive courtesan, the sweet sad songs of the geisha.

> Others do forget you
> I can't, haunted as I am
> By a handsome ghost...

At the end of the 19th century there lived in Japan a Koizumi Yakumo, who has been quoted earlier in this book. He had been known as Lafcadio Hearn, an American writer with a Greek mother. He wandered unhappily for a long time until he came to Japan, adopted a Japanese name, and avoiding the courtesans, took a Japanese wife and had children. He dressed, ate, and lived as a Japanese. As a writer he collected native fairy tales, wrote of the islands, studied the Yoshiwara, but was wary of writing in great detail. He became a Buddhist and understood, perhaps better than the Japanese, the tragic inner life of geisha and courtesans.

In 1878, he wrote: "Everyone has an inner life of his own, which no other eye can see, and the great secrets of which are never revealed, although occasionally when we create something beautiful, we betray a faint glimpse of it—sudden and brief, as of a door opening and shutting in the night."

He understood the calm smile of the courtesan behind Yoshiwara doors, keeping her secret self isolated from her duties. From Buddha she had won, he felt, "the highest truth ever taught to man; the secret unity of life."

Hearn found in Buddhism a similarity between the theory of heredity, evolution, and the doctrine of Karma, or transmigration of character. This doctrine of Karma maintains that one has unconquered evil instincts because one is allied to ancestors who possessed them. What an aid this was to the courtesan and geisha facing a world set in a pattern from which they could rarely escape!

> All grasses in the field
> Sprout and wither in the same way.
> Every one is bound sooner or later
> To come across the autumn.
>
> *—Folk poem.*

As Hearn put it:

> All our emotions and thoughts and wishes, however changing and growing through the varying seasons of life, are only compositions and recompositions of the sensations and ideas and desires of other folk, mostly of dead people.... It is incontrovertible that, in every individual brain is locked up the inherited memory of the absolutely inconceivable multitude of experiences received by all the brains of which it is the descendant.

No wonder Hearn, like the prostitutes and Yoshiwara folk, loved ghost and horror stories, a hinted-at world that made this one seem roses, roses all the way.

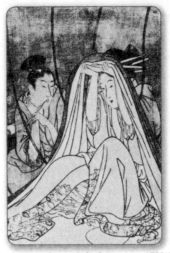
Courtesan and guest in bed: Utamaro, 1753-1806.

Alone, alive
In a crack of the rocks
Away from the city
No one to see me
I abandon myself to sorrow.
—*Saigyo*

CHAPTER **14** The Role of Men and Women

In a crowded island, solitary living was not only rare—it could become frightening, as the above poem suggests. In the city or village, a constant exchange of close-packed society animated the Japanese. Even when naked in mixed bathing, everyone— even the two-sword samurai or the *sumo* wrestler—was aware of the ritual. An 18th-century text describes it in this way:

It is according to the natural creed of Heaven and Earth that all men—the most high, the most low—must strip and become naked when they go to a bath… . All become as a new-born baby and are made free of all desires, all hates.

To be alone and far from home was sad, as the poet Basho wrote:

> Autumn—a full decade
> And my mind is on Edo
> When I speak of home.

Did the Yoshiwara abound with such thoughts?

The courtesan, the concubine, the geisha, the apprentice maid, or waitress—all felt themselves part of the family that was Japan. It is around the solid family system that the society was built (just as it was in the Jewish culture during tormented centuries). Family was anyone remotely connected: ancestors, even if part myth and legend; distant relatives with family names merely listed as honorary relationships. The Emperor was one's father, to the average Japanese, as he was even to the lowly prostitutes or the brothel manager they served under.

Words like *giri* (duty), *ko* (filial piety), *on* (obligation) were ingrained. All these came from Confucian ideas of social order. As the nation was cut off from the world a good part of the 17th, 18th, and 19th centuries, when ruled by the Tokugawa clan shoguns, ideas of intimate family relations were a sacred national need, with all outsiders excluded. The island people became close-knit and egocentric, with their ingrown pride.

Giri, ko, on—to his family, his nation, to the Emperor who might need soldiers, or the shogun, an army for his wars. Only a son carried on the family line, the clan crest, and offered prayers for the departed souls of the ancestors—ghosts quick to anger and damned if neglected. Girls didn't count. If cursed with only girls or with no children

at all, the family would hunt out a likely young man of its class, educate him, train him in the family trade and see that when he married a daughter, he took the family's name as his own. He was the true heir. Any good apprentice, when trained, accepted a name that was akin to his teacher's. He could be an outsider, but the family's forefathers—and their graves—became his to pay homage to. He would not dare marry on his own.

Family was more than close blood relations. It was the custom for many families to live under one set of roofs, a clan in themselves, surrounding some old grandfather, sleeping beneath the family Buddhist or Shinto altar. In a broader sense, a family could be a trade, a guild all by itself, connected with some branch of an art or craft, such as theater managers, actors, umbrella-makers, keepers of inns and eating places, dancers, singing groups, gamblers' syndicates, brothel owners, fish cooks, even gangsters.

Each craft had its own *iemoto*—family head and clan father—whose word was law to perhaps thousands of members. Such a man was usually stern and fair, so it was always hoped. And the title *iemoto* went usually from father to son. What he said and did affected the lives of all his "sons" and "daughters." There were no Ruths among the alien corn in Japan. The lowest apprentice-prostitute knew where she was in the order of things.

It was a feudal system, and in the arts it resulted in many sons becoming as great, if not greater, artists than their fathers. The adopted sons of true genius added to the glory of the name. Premier Eisaku Sato's father was adopted into his mother's family. His brother Nobusuke was adopted into the Kishi family, served in the Tojo wartime cabinet, and in 1957 became Premier before Eisaku.

With girls, there were always problems. Dancers, singers, players of the *samisen* or *koto*—if they were admitted into a family because of their talent—had to pay high fees and take the family name. They would turn over much of their earnings. They could perform only in the style or tradition held by the family to which they became so attached. There was no free improvising nor bursting the classic bonds to express ideas in some new manner. Curiosity for new horizons had to be controlled.

Once a name ceremony had taken place, the apprentice craftsman or artist was ready to appear in public. The trade-union system was so tight that no freelancer could break in. Puppet-theater chanters were all from the Takemoto and Toyotake families; the workers of the puppets were Yoshidas or Kiritakes. So with each craft: bakers, banner-makers, theater-poster artists, bronze-casters, mirror-makers, brothel-keepers, firemen, geishas—all were members of groups that held such rights.

Girls who were sold or traded or accepted for training as geishas or prostitutes went through the usual system (with less rights, of course, and no freedoms). As slave girls they were valuable only when trained to their crafts. The hierarchical order—with everyone in his or her place and that place sanctified by tradition—made the life of the Yoshiwara inmate less degrading than the low café entertainer or dancehall girl in the Western world.

In the 20th century, the family relationships, real or invented, still existed. But the rigid confinement to one craft or art did not remain, and the quality of most declined. The West was imitated and its markets flooded. Old traditions were often more ritual than real. The impeccable ceremonies of the exalted courtesans and geisha became shoddy.

The immediate family also followed a traditional pattern:

The husband was (and mostly still is) supreme in his house; the wife and children rigid in their respect to him. As one guide to proper manners puts it: "When your parents are mentioned, you sit up straight and listen politely, even if you must get up from the sleeping mat."

It was best not to build one's own house away from the father's; the parents would select the bride (a love-marriage was for hoodlums); a man followed the profession of his family; the younger children call the older "elder brother"; the sole heir was not addressed by name but as "honored elder brother," and he and the father would get the best of the food served and most likely would not share it. In a way, it led to a morbid self-preoccupation.

A female's one duty was service to the male, fulfilling all the needs of the father, brother, husband, lover, customer. From the government official's wife to the girl of the lowest brothels, her station in life was somnambulist in a strained dream. If she should have sons, they would lord it over her, and she must be submissive. Under such a social code, self-sacrifice was a woman's lot until she became a mother-in-law. Then, like Cinderella's stepmother, a mistress of predatory exuberant cruelty, life turned to hell for the daughters-in-law. Nothing was too mean or degrading for the new bride. Bewilderment and pain were her lot. Her sole task was to please the male.

The husband rarely had any great regard for his wife, her happiness, or her interests. Love was rare, and she was there to serve him, keep house, and beget children. His most intimate pleasures came in sexual adventures through the gay green-tea houses, in the Yoshiwara, in extra-marital encounters with waitresses, geishas, and that class of courtesans he could afford. He would often tell his wife of his pleasures outside the house and of the women with whom he copulated, away from

her. A hedonist, greedy for his own gratifications, he was not to be berated for his vices. No wife would dare! Such was the old code that she expected no fidelity, made no protest, for it was all too complex, contorted with tradition.

A man's personal life in old Japan was his to do with as he wanted; stay away or not, spend his money on fine robes, sake, give grand parties in teahouses for his male friends, entertain Kabuki actors, keep a geisha or a demimonde in a private house, get drunk and return home in that condition any night. This was not at all the extreme. Yet a sensible man could be tolerant, kindly, and pleased with his home, with his wife's efforts to see that he had a good meal at all hours and kept the children clean.

Wealthy men would take their concubines to live with their wives. The wives could only bow and keep her thoughts to herself. A sign of jealousy, of anger, was a show of bad manners and disrespect. Her friends would be impressed by her calm and say she was a splendid woman to take it all like a good Japanese wife. We can view some of this with ironic skepticism, yet the majority of women did not revolt against male freedoms.

Too much has been made of the Japanese love of children. They are beautiful, "cute as dolls," and they are well cared for. But a man filled his house with children because it was his duty to do so.

As for sexual relations in the home, it has, in many sections of society, retained the old Japanese low viewpoint. One contemporary research survey reports:

> Sex is an ambiguous aspect of marriage. In traditional marriages it is the wife's duty to submit to her husband's advances.
>
> The sex act itself usually is a brief, business-like affair with a

minimum of foreplay. The husband, after waiting in the quilts
at night for the rest of the household to settle into slumber,
grasps his wife and satisfies himself as quietly and inconspicu-
ously as possible, releasing his tensions and settling his duty
to posterity at the same time.

Lafcadio Hearn also gives us a clear picture of the Japanese
woman in her society at the end of the 19th century. No
other Westerner wrote of her in such detail, or with as much
knowledge.

I may broadly state that a great deal of our literature, besides
its fiction, is revolting to the Japanese moral sense, not because
it treats of the passion of love *per se,* but because it treats of
that passion in relation to virtuous maidens, and therefore
in relation to the family circle. Now, as a general rule, where
passionate love is the theme in Japanese literature of the best
class, it is not that sort of love which leads to the establish-
ment of family relations. It is quite another sort of love, a sort
of love about which the Oriental is not prudish at all—the
mayoi or infatuation of passion, inspired by merely physical
attraction; and its heroines are not the daughters of refined
families, but mostly *hetaerae,* or professional dancing girls.

The typical woman often figures in Japanese romance as a
heroine; as a perfect mother; as a pious daughter, willing to
sacrifice all for duty; as a loyal wife, who follows her husband
into battle, fights by his side, saves his life at the cost of her
own; never as a sentimental maiden, dying, or making others
die, for love. Neither do we find her on literary exhibition as
a dangerous beauty, a charmer of men; and in the real life of
Japan she has never appeared in any such role. Society, as a
mingling of the sexes, as an existence of which the supremely
refined charm is the charm of woman, has never existed in

the East. Even in Japan, society, in the special sense of the word, remains masculine.

It is not the custom in Japan for the husband even to walk side by side with his wife in the street, much less to give her his arm, or to assist her in ascending or descending a flight of stairs. But this is not any proof upon his part of want of affection. It is only the result of a social sentiment totally different from our own; it is simply obedience to an etiquette founded upon the idea that public displays of the marital relation are improper. Why improper? Because they seem to Oriental judgment to indicate a confession of personal, and therefore selfish sentiment. For the Oriental the law of life is duty. Affection must, in every time and place, be subordinated to duty. Any public exhibition of personal affection of a certain class is equivalent to a public confession of moral weakness.

That everything is not lost from the past, that men still act in the old ways, is seen in an item in the *Los Angeles Times* of December 31, 1968:

PREMIER SATO USED TO BEAT HER, WIFE SAYS

Her revelations about forty years of matrimony—that Sato used to beat her, would frequent geisha houses—promptly raised eyebrows among Japan's younger set, but many older Japanese merely shrugged their shoulders as if to say, "So what?"

Mrs. Sato's version of her marriage appeared in an interview with Shusaku Endo, a playwright and humorist, in the magazine *Shukan Asahi*. Her "beatings" began soon after she was married to Sato, a cousin, after a family-arranged betrothal.

Later in a report to *The New York Times* she maintained that the English word "beat" is incorrect, although it was "more

than a pat." She also denied that her husband had affairs with geishas, merely calling her husband in his early years a "playboy"—he hired geishas for traditional entertainment at some expense when his salary was quite small.

The interviewer, Mr. Endo, had noted a twinkle in Mrs. Sato's eye as she told her story. An aide to the premier said Sato laughed when he read the interview, but offered no comments. Her husband had been chosen for her while she was still in grade school. Asked if she loved Sato when they first were married, she replied, "No, I had no special liking for him," adding, "That's why the marriage held little interest for me. Don't you think that if we love and suffer, marriage will be more interesting?"

The reaction of the Japanese male to this interview was in itself interesting. It indicated that the citizen of Tokyo might still yearn for a return of the old days.

"If a wife gets out of place, there's nothing better than a slap or two to put her back in place. Your wife will respect you for your authority." So said Haruo Kato, a seventy-three-year-old retired businessman, commenting on the interview.

Japanese married couples, when questioned, generally supported Sato's disciplinary method, but they stressed wife beating should not be overdone and should be confined to the home. Most, like Mrs. Sato, said they saw nothing wrong with men being entertained by geishas since they are professional entertainers, part of Japan's tradition.

"I can't see what all the fuss is about because many European husbands also beat their wives," said Mrs. Akiko Nagashima, twenty-eight, wife of baseball star Shigeo Nagashima. Kazuko Sato, a forty-one-year-old housewife and no relation to the prime minister, said she could condemn Sato if he was a failure. "But look at him now," she said. "He's prime minister of Japan."

"It happened so many years ago—years before he became prime minister," Sato's office said. The interviewer Shusako Endo himself said, "Mrs. Sato improved the image of Mr. Sato from a colorless politician to a human character. She is a wise woman who did a great service to her husband."

Yet the modern version of the geisha can still produce scandalous effects on an international scale. Here is an item in the April 13, 1967, issue of the *Los Angeles Times:*

BITTER TEA OF MAYOR YORTY
GEISHA GIRL EXPENSE BARS YEN FOR POLITICO

The newspaper reported that Mayor Sam Yorty of Los Angeles disapproved of a councilman who listed an item of $485 paid for geisha girls while on a trade delegation to Tokyo. The mayor felt this was done to embarrass him, and the councilman counter-charged that he had done so on orders from the mayor's own commission. The mayor, through his press secretary, conceded. Many Americans, of course, were not at all clear about what a geisha was or were astonished that such a traditional creature still existed. The incident was, perhaps, the first in decades to involve American politicians.

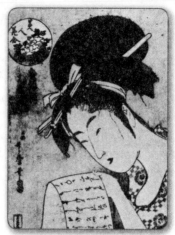
Reading a sad romance: Utamaro, 1753-1806

It is important that a lover should know how to make his departure. To begin with, he ought not to be ready to get up, but should need a little coaxing... One likes him too, to behave in such a way that one is sure he is unhappy at going and would stay longer if he possibly could... Both lovers should go out together at the double doors, while he tells her how much he dreads the day that is before him and longs for the approach of night...

—*The Pillow Book of Sei Shonagon, 11th century*

CHAPTER **15** Literature and the Arts of Love

This book is not to be confused with the popular erotic Pillow Book of the time of the geisha and the courtesan. The first contains the musings of a noble lady on life, love, and sex, and was popular reading in the Yoshiwara. The second was an erotic textbook on the secrets of sexual intercourse—with many pictures as to positions for full sexual gratification. By the 20th century, pillow books were printed for sailors and others visiting Japan, and were often merely obscene, created for a new market.

Sei Shonagon wrote of love and life at a chrysanthemum-colored emperor's court. As a writer she was a sort of an *okashi, medatashi* (charming, splendid) Colette. In old copies of the book there are always passages marked off as precious, no doubt by women readers of the Yoshiwara.

> To meet one's lover, summer is the right season. True, nights are very short, dawn creeps up before one has had a bit of sleep. All the lattices have been left open, one can lie and look out at the garden in the cool morning air. There are a few endearments to exchange before the man takes his leave. The lovers are murmuring to each other; suddenly there is a loud noise. For a moment they are certain they are discovered. It is only the caw cry of a crow flying past the garden...
>
> A storm wind. At dawn one is lying in bed with the lattices and paneled doors open, the wind blows into the room and rubs one's face—most delightful.
>
> A cold, winter wind.
>
> In the Third Month a moist, gentle wind blows in the evening and excites me. Also exciting is the cool, rain wind in the Eighth and Ninth Months. Curtains of rain blow violently. I enjoy people who cover their robes of unlined silk with padded coats put away after summer rains. Now they would like to take off the unlined robes, which are hot and sweltering. They are caught off guard by the change in weather and have to dress warmer than before...
>
> An attractive woman... receives a letter in the dark. Too impatient to wait for a lamp, she takes fire tongs and lifts a piece of burning charcoal from the brazier, reads by its pale light. It is a charming scene.

In her favorite reading, the courtesan sighed for a more romantic age and found it in the *Pillow Book* of Sei Shonagon.

"Through the screen one hears the lady's hushed voice, then the youthful voice answering her and the rustling of clothes as she approaches. It is time for the lady's meal; there comes the sound of chopsticks and spoons, the clatter of a jug as it falls. Over a gay robe of fine silk the lady's hair hangs with grace upon her shoulders. So, late at night, almost everyone has gone to sleep; one hears courtiers talking outside the house..."

The courtesans of the Yoshiwara read the book over and over, dreaming of how fine love and sex must have been in those long-ago days. And they combed the love-poetry of the past to discover a truly romantic memory, as in this haiku verse by Basho, the first great poet of the Japanese "renaissance"—the Tokugawa era.

> The snow we two saw
> That year, is it
> Falling again?

We can't date or identify the author of all the poems as they appear in old literature—but they often sound the true note. A woman courtesan's poem, in contrast to the great poet, reads like an old version of "My man."

> Morning, night
> I part my uncombed hair
> As one fingers rice sprouts
> And wonder, when
> Will you come.

Or this frankly erotic symbolism:

> Sad is my body
> A weed needing to float

> Those roots that held it
> Tempt me with water
> To float again.

Yoshida Keno, an ancient writer, gives us the thoughtful man's attitude on the subject of love, but he must have been old when he wrote it:

> It is well a man does not become addicted to that lewdness, as a constant and familiar lover of women…. Of all things that lead the heart of a man astray, there is nothing like the lust for flesh. What a weak organ is our heart… a man is always stirred by a faint perfume, even of incense burned to give an odor to clothes….
>
> In all things it is the Beginning and the End that are the most interesting. The love of men and women. Does it only exist when meeting face to face? To feel sad at missed meetings, to grieve over worthless vows, to spend sleepless nights, alone; to yearn… to think fondly of what is past—all this is what love is.

Yes, Keno-san was living in the lusts of his past.

With the introduction of Buddhism into Japan, certain erotic Hindu texts on the sexual pleasures also were translated and published, often with woodcut prints by Japanese artists.

There were several editions available to the Yoshiwara of the classic, the *Kama Sutra,* the book of the Hindu Ritual of Love. There is a whole section (for the man's benefit) labeled *Various Ways of Hitting a Woman, and the Accompanying Sounds:*

> Sexual intercourse can be compared to a lover's quarrel, because of the little annoyances so easily caused by love and the tendency on the part of two passionate individuals to

change swiftly from love to anger. In the intensity of passion, one often hits the lover on the body, and the part of the body where these blows of love should be dealt are: the shoulders; the head; the space between the breasts; the back, the *Yaghana.*

The game sounds half playful, half sinister. "Blows of love" could, with a mean, sadistic guest, be painful. Nothing is left to guesswork in the *Kama Sutra;* there is full detail:

There are also four ways of hitting the loved one. With the back of the hand, with the fingers slightly contracted, with the fist, with the palm of the hand. The man should hit the woman with his closed fist when she sits on his knees. She should return his blows with force and scold him as if she were angry with him, accompanied by weeping and cooing sounds.

Japanese husbands could take warning as to what could happen at home while they were away at the Yoshiwara with other women. Japanese wives, while docile and accepting the husband's world of geishas and courtesans, could become irked:

The chastity of a woman is often endangered for the following reasons: frequent visits to parties and social gatherings, lack of reserve, debauchery of the husband, a lack of prudence in her relations with other men, frequent and prolonged absence of her husband, long visits to foreign lands, the destruction of her love and finer sensibilities by her husband, the company of dissolute women, jealousy of the husband.

There are poems and documents which show that the Japanese women of the upper class and court did take lovers, elope— and read the advice of the *Kama Sutra.*

Under special and particular circumstances, a man is allowed —without incurring moral demerit and reproach—to propose to the wife of another. But a sensible man must first carefully examine all the problems involved in such a situation. For instance, how easy or difficult is it to possess a certain woman, her aptitude for such a love-affair, the dangers involved, and the far-reaching results of this union. For instance, it is quite legitimate for a man to pursue another's wife because he and his life are in danger, if he cannot live without her and the intensity of his passion increases from day to day.

THE MAJOR ARTISTS OF THE YOSHIWARA

Moronobu	1625?-1694
Sukenobu	1674-1754
Kaigetsudo	fl 1704-1716 (?)
Harunobu	1725-1770
Shigemasa	1739-1819
Kiyonaga	1752-1815
Utamaro	1753-1806
Eishi	1756-1829
Hokusai	1760-1849
Toyokuni	1769-1825
Sharaku	fl 1794-1795
Kunisada	1786-1864
Hiroshige	1797-1858
Kuniyoshi	1797-1861

These and their pupils are the real historians of Yoshiwara. They did many series of woodcut prints on the great courtesans, geishas, waitress girls, actors, street crowds. Their folk art, not considered of any great value in their time, is now prized, at its best, as very great art. Like jazz, the music of the sporting houses of New Orleans, some of the *ukiyo-e*, or

pictures of the Floating World, moved from the brothel to the art form; but it took time.

The earliest Yoshiwara pillow pictures of erotic scenes appeared in the mid-17th century as guide books. The "Pillow of the Poets," drawn by Kasenmahura, depicted the sexes in repose, talking, and taking tea, rather than in procreative attitudes. One of the early Japanese woodcut artists, Moronobu, turned frankly to the subject of "spring pictures" or *shunga,* dedicated to the eros of Yoshiwara—depicting not only courtesans and their lovers in various positions of intercourse, but all the decorative characters of the Floating World. The little maids, the men servants, jesters (male geishas), brothel-keepers, and even the fighting of drunken guests. For over two hundred years, the street scenes of Yoshiwara, the *abuna-e* (suggestive or pin-up prints), *shunga,* and famous geishas, courtesans, and Kabuki actors were portrayed by the great print artists. Kiyonobu (1664-1729) was noted for erotic prints and Kabuki dancers. Mosanobu followed, and drew such subjects several decades later. In the mid-18th century, the *shunga* (forbidden at various times) found the talents of Utamaro, one of the finest printmakers, and creator of the "Song of the Pillow," showing a fierce clinical drawing of sexual delights. Hokusai (with his daughter, O-ei) and Kuniyoshi became in time the favorites in the West.

Shunga disappeared again for a while early in the 19th century, under strict shoguns. This did not drive underground the fantastic and sometimes comic erotic art of Japan. Hiroshige was probably the last of the great print artists of the shoguns' Japan, before the coming of Commodore Perry and the censorship of the Meiji period. He drew with masterful artistry and unabashed sensuality the scenes of Yoshiwara. His view at the Great Gate of the place at dawn, with drunken samurai helped on the way toward home and courtesans in the still-

lighted doorways, is one of the most famous prints of the city of pleasure. By 1900, the sense of Western shame had taken over, and in the Tokyo Autumn Art Show, police draped cloth over the fornicating figures in what became known as the *Koshimaki* (Loincloth) Affair. No nudes of any sort were permitted.

One of the 18th-century publishers of the woodblock prints was Tsutaye Jusaburo, called Tsuta-ju for short. He was a round butterball of a man, always in a sweating hurry, always talking very fast, ready with a joke or dirty remark to keep one off guard, always telling about something he believed in with a shrill high voice. His business ability, his good taste, and his generosity were well known.

His printshop was not one of the biggest ones; it was just a square box-like shop stuck in next to the Miyako-za Kabuki theater, hung with woodcuts shaking cheek-to-cheek in the breeze. The doors were removed daily so one could walk into the shop itself almost as part of the street. The remaining three walls were hung with colored woodcuts. Piles of prints were on low tables along with volumes of love poems and erotic novels illustrated with delightful or gory scenes. In the back room, there were more bundles of prints tied with ribbons. An assistant trimmed prints with a sharp tool. An engraver made some last-minute changes on the block of cherry-wood before him on which could be a drawing of a famous courtesan or a noted geisha. He would carve through the drawing by Utamaro, Sharaku, or some other master, and make a raised engraving of it.

A printer working on such a block, his arms covered with red and blue dye to the knuckles, shook his head over a proof-sheet of damp mulberry-pulp paper, pointing out where the cutter had failed to correctly match the color blocks. And, always,

Tsuta-ju himself, standing between some of his hired help, about to fight, shout, or strike a blow, or go running forward into the shop to bow to some samurai wanting a set of prints of the Forty-Seven Ronin, or an erotic series on the art of love. Although samurai were forbidden to go to the common people's printshops, because prints were thought to be a dangerous influence, these military men remained steady customers.

Tsuta-ju was not a very successful print publisher compared to those who published the more classical and popular artists. But he had an eye for design and enthusiasm for his work. He had discovered the great Utamaro, and now he had a new young man whose prints caused the publisher's fat face to break out into a close-eyed smile of satisfaction, excitement, and pleasure. "Toshusai Sharaku!"

But the housewives, the courtesans, the geishas, the actors, the professional gamblers and merchants who bought a print, or half a dozen, at ten to sixteen *mon* each, were not impressed with this newcomer. Most of the customers ignored the startling Sharaku prints; the large heads of actors, the twisted bodies of dramatic action, in scenes from great plays, the homosexual actors playing women's roles. They bought more pallid pictures: either cheerful children, or the long, graceful sensuality in prints by Harunobu or Utamaro, the three-sheet series by Shunsho and Kiyonaga of parties of women and their lovers on the river while fireworks went off overhead, or scenes of clashing actors as warriors by Sukenobu or Moronobu.

Like the texts, documents, official reports, novels, the guidebooks to the pleasure houses, these pictures bring us the color, the patterns, the effects these women left on their culture. That it was an important art form no one seemed to realize until much later. A harlot as art was a new thought.

The theater delighted courtesans and geishas.

For a Western view of Kabuki, let us look at a 19th-century travel letter by Clement Scott, he who wrote of the women of the Yoshiwara as "Soiled Doves." His prose is proudly Victorian, and he maintains the white man's burden as a theater critic:

> The Japanese are, to a man, woman, and child, passionately fond of the play. Drama and romance in some form or other are essential to their daily enjoyment of life. All the great temples, up hundreds of steps, and the ugly caged gods, smeared over with bits of chewed prayer paper and masticated intercessions with the gods, are surrounded with booths, wrestling shows, acrobat tents, and penny menageries. Religion and amusement go hand in hand, and are invariably cheek by jowl.
>
> The chance of seeing Danjiro, the great Japanese actor, at the largest and best of theatres of Tokio, was one not to be resisted. Danjiro is a great institution. He is the Henry Irving of Japan. Whenever he acts, the prices are raised, but still the house is crammed full. And the Danjiro is in his way a reformer. Hitherto men and women have never been mixed on the Japanese stage. There have been plays entirely acted by men and boys; and also by women and girls. But recently Danjiro has allowed his two daughters to go on the regular stage and to mix with the male performers. I was lucky enough to see their first performance at the Tokio theatre. A visit to the Japanese theatre is a serious undertaking, I can assure you. If you would follow custom it will be necessary to take your seat before ten o'clock in the morning, and it is not likely that you will be dismissed before nine or ten o'clock at night.
>
> All the same, you are not allowed to starve. Each theatre owner is also the proprietor of several tea houses in the immediate neighbourhood, and if you want to give a very swell theatre party, you will take care to order into your box several

repasts during the course of the day. There you sit on your haunches, with a square fire box in front of you and your friends around, in a deep well sunk into the ground floor of the house, and in this four-sided pen you can tiffin off raw fish and soy, and dine off sweet mashed chestnuts served up with sea-weed, and poison yourself with an offensive vegetable called *daikon*. And you can drink cups of *sake* and smoke little pipes literally from morning till night, while the never-ending play is going on. There are plenty of long waits and *entre-actes* at a Japanese theatre. You begin with a grim historical romance. This is usually followed by a dance or series of posturings that lasts for two good hours to the tune of the most horrible music that ever maddened human ear and nerves, and you are seldom dismissed without a modern drama of the most intensely realistic kind, full of murders, and suicides, and happy dispatches, and copious floods of rich red blood.

Where they go to be amused, they elect to eat, drink, smoke and talk freely to their friends, and in the course of the long theatrical day, if the more curious-minded in the audience choose to wander on the stage between the acts, or during the progress of the play, no one appears to raise the slightest objection. In fact, when the theatre is unusually full, the overflow is accommodated on the stage, and it is very often difficult to tell which are supers and which are merely interested spectators of the scene.

In shape, the Japanese theatre is almost square; in size, it only admits of two tiers at the most above the pit and stall space, and it has this distinct advantage—that everyone in the audience can see and hear wherever he is seated. The Japanese playhouse is the most convenient shape and design for the spectator that I have ever seen. This facility for ingress and egress makes the Japanese theatre terribly cold and draughty.

But then, I have never seen a house, hotel, or theatre in Japan that was built with a view to winter weather. Paper windows, panelled doors, and match-board partitions do not suit a temperature of twenty-eight or thirty degrees.

On the other hand, there are novelties in a Japanese theatre. The most curious of these is the broad path leading from the stage proper to the front of the house called the *Hanamichi* or Flowery Way. This path is not for the spectator but for the actors on the scene, and I can only compare this Flowery Way to the pathway put across when a conjurer is on the stage who desires to mix with the audience. In some Japanese theatres there are two of these Flowery Ways. In every theatre, one is indispensable. It is invariably used when one of the characters is supposed to be starting on or returning from a long journey. The Japanese actor—particularly Danjiro—is very great at entrances but greater still at exits, and loves when he is thus acting in dumb show to be right among his audience, in the very centre of stalls and pit, in order that all assembled may study every facial expression. I have seen a pathetic exit by Danjiro along the Flowering Path that took at least ten minutes, and all the time he was tottering straight across the auditorium without a word spoken.

In the matter of expression, the Japanese are very keen, and there are plays where demons and hobgoblins, supposed to be unseen, gambol about the stage in order to throw a light under the actor's face. Strange to say, the limelight is unknown and the general lighting of the stage is wretched in the extreme.

The stage-proper is provided with a circular turntable, beautifully worked and dovetailed into the floor. Thus a scene—actors and all—can be turned completely around without dropping the curtain, and one scene can be completely set at the back of the circle, while they are acting in the front. Not that the Japanese dispense with the drop-curtain, altogether.

Every actor of eminence has at least a dozen drop curtains of his own, the presents of devoted spectators. Some are the most beautiful and costly, embroidered silks and gorgeous satins, decorated with devices and adorned with poems and dedications in the actor's honor. In Japan, they do not throw flowers or wreaths to an actor. They give him a drop curtain and it becomes his personal property.

In Japan they applaud freely, they weep copiously, but they never hiss. It is said the Japanese are unemotional. But I have never seen such floods of tears shed in a theatre as I did one afternoon, the situation being the parting of an old mother and her favorite son. The women spectators were literally rocking with grief, and I thought their tears would put out the fires in all the little private boxes or pit wells.

Not being familiar with the language, it is impossible to criticize the acting, but I noticed that no actor uses his ordinary voice on the stage nor talks in a natural manner. Danjiro chants his sentences, his voice ranging from a deep bass to the squeakiest of falsetto. What we call natural acting is unknown. Tradition and conventionality are paramount.

The dramas usually played are based on some historical or legendary romance; and they are divided into two parts—one conversational, the other choral. The actors carry on the conversation, but the chorus is sung to the accompaniment of a *samisen* by a person or persons in the *tsubo,* a screened seat on the right of and above the main stage. The chorus explains the meaning, emotions and characters of the personages, and while the appalling music goes on, the actors make the gestures only. In this respect, the Japanese drama resembles the theatre of the Greeks.

Never have I heard such sounds as come from the *samisen* when the Geysha girls dance at a Japanese dinner, or when there is an interlude of posturing between the acts of Japanese

plays. Danjiro is the greatest actor on the Japanese stage; but conceive an artist of his eminence dressed up as a woman with kimono and obi and going through the most tedious posturings for over an hour, bending and swaying his body and playing tricks with a paper fan. Danjiro must have been on the stage posturing and gyrating for at least an hour. But the people like nothing so well as one of these interminable dances accompanied by music. Various dances were arranged in Japan for my especial edification. When they are not dull, they are dirty.

I was at the large shrine on the hilltop at Kamakura on the day before I saw the legend of this shrine enacted by Danjiro at Tokio. On the left of the steps of this temple stands a splendid *icho* tree, said to be more than a thousand years old. Behind this very tree, Kugyo stood in 1219 waiting for the approach of his uncle Sanetino, the Third Shogun of the Minamoto family, who was going to visit the shrine to avenge his father. As Sanetino descended the steps, Kugyo rushed out, cut him down, and carried off his head. This was the sensation scene of the play. The procession came slowly and solemnly up the Flowery Way; but when the doomed uncle came down the temple steps, out popped Kugyo and polished off the old gentleman in true pantomime style. He fell with his body close to some drapery, so that a bleeding head was easily passed to the actor. With his uncle's head in one hand, and a sword in the other, the actor went through a transpontine combat. The intrepid murderer was attacked in front and behind by the avenging army, but he slew them all single-handed. Having settled those in front, he made a bound into the air and attacked his enemies in the rear, and then with the stage literally littered with dead bodies, he bounded off down the Flowery Way, the sword and bleeding head still in his victorious hands, to the rapturous applause of a delighted

audience who cheered him to the echo and almost mobbed him at his exit.

They love executions in Japan. Then the curtain fell, and the tragedy was at an end. But one of the most favorite scenes with the general public is where Danjiro, with intensely realistic detail, enacts the death of a criminal by his own hand, known as the "happy dispatch." The judges, the executioner and the victim are all on the stage, and you can hear a pin drop as the actor plunges the sword into his own body, as the blood gushes out on the stage, and the awful death contortions are imitated with singular vividness and apparent reality.

The more horrible the death or murder scenes, the more the people like them. No one can possibly say that you do not get enough for your money in a Japanese theatre. If we cannot quite understand it all in its serious sense, it affords the most intense amusement to the spectator.

From poetry, novels, and other writing about the geishas and courtesans, we know they delighted in scenes of bloodshed and horror on the stage. They and their lovers came to the theater with food and drink, and stayed for hours, feasting, jesting, and engaging in erotic play, while on-stage the most bloodthirsty action raged to their pleasure.

Brothel-keeper: author's sketch, 1935.

O Edo
In the night
Through the hall of memory
I come away
To you
Secretly.
—*Anon.*

CHAPTER **16** The End of the Yoshiwara

The original Yoshiwara, home of the great courtesans of the woodcut prints, had a long life beginning in 1717. It changed a few of its habits and some of its patterns with the passing of time. In the 20th century the decline of the Yoshiwara can be clearly charted. In Western terms, *gula* and *libido* (intemperance and wantonness) were still its selling points. World War One did not destroy the Yoshiwara; it continued to exist and other brothels spread across the city. Trolley lines, buses, and taxis made travel simpler for the citizen or visitor wishing to test his sensuality. The great

earthquake and fire of 1923 destroyed many brothel districts, for a while only.

Between the two world wars, Yoshiwara itself became degraded, even shabby, losing all the elegance it had been known for. Geishas grew old and their numbers diminished. Courtesans were outnumbered by low-grade prostitutes—some in high heels and Western face makeup. The moral climate of Japan was affected—influenced by Western values, industrial conversion, and international tourism.

Then even the sites that the early Yoshiwara occupied in many cities became difficult to define, for the great-grandsons of Commodore Perry came in bomb-carrying fire-dragons and burned out the cities. After World War Two, new buildings replaced the old teahouses, and instead of lanterns there were new neon signs: GIRLS, BEER, DANCE, JAZZ.

Prostitution was taken over by freelancers. Japan imported the concept of the call girl, she who waited in false Dior finery for the new *daimyos* (big shots), the visiting board of directors, company men, U.S. butter and egg men. She waited at the end of a telephone line by a Princess phone, with no *samisen* or tea service in sight. The B-girl, the dancehall hostess, the show girl, the chorus girl, the singer-harlot of jazz and rock-and-roll, they all flourished in many places on the modern Ginza, and to such an extent that the Main Drag assumed some of the functions of the Yoshiwara.

The green-tea houses, the decor of refinement, the artful grace, were gone. And you could buy as paper cocktail napkins Utamaro's prints of *Twelve Hours of the Yoshiwara.*

As in the Western world, premarital sex and new standards of female choice were accepted and encouraged by the Japanese male of the avant-garde set. The amateur bed partner, the equal sex-game player, was preferable to the professional prostitute demanding payment.

The whole philosophy that had created the Yoshiwara, the ritual, drama, and pattern, was becoming dated. Willing or not, Japan in the jet age was part of a disintegrating world, uncertain of surviving its scientists, materialists, and political fanatics. No longer did one have to put a rush basket over one's head to slip off to visit a courtesan. And most Japanese women, no matter what class they belonged to, were sexually available to the men of their choice, able to break with tradition without the stigma of disgrace and dishonor.

The codes of Shinto, Buddha, and missionary Christianity were losing their grip. After the Second World War the status of women was rising. Wives refused calmly to accept their husband's beatings. They cried out against money spent on geisha parties, teahouse girls, and whores.

The philosopher-journalist Arthur Koestler, who knew Japan well, observed in an interview:

> A serious manifestation is the militant Puritan spirit that seems to have taken possession of a vocal minority of Japanese housewives. They demanded that the government abolish the age-old system of paid pleasure and the city of the Floating World was their target. Old guard sensualists fought in rage and bitterness to save the Yoshiwara. In 1949 laws were introduced to abolish the place and all places like it. For nine years the old guard, the ancient rakes, the men with memories of better times and wilder joys fought the government. But Puritanism had come in with TV, Coke and stretch pants. The nation was dedicated to jazz, floor shows, rockand-roll, levis, and miniskirts.

Finally in 1956 all brothels in Japan were ordered closed. Two years' grace was permitted for "the women to get other work." It did not, of course, affect prostitution; it merely

pointed up the remark someone had once made: "Hypocrisy is the tribute virtue pays to vice."

On April 1, 1958, in a sort of April Fool's farewell to the past, the Yoshiwara was legally abolished as well as any copy of it any place in Nippon, in sight of Fuji or not. It did not do away with sex outside the home or marriage. Nor did it eliminate the prostitute, the bathhouse girls, the bar hostesses, the night-club and gyp-joint whores or their erotic games.

The decline of the geisha and courtesan tradition along its classical lines still left a strong residue of male domination in the relationship of husbands and wives. In the matter of the rights of the male over the female, even today Japanese men have the advantage.

The *Los Angeles Times* in 1969 carried a news report of how the man still holds the position something like that which he had when the true geisha and the grand courtesan flourished. It pointed out that Japanese divorce laws had set a new record. During the year, 86,921 marriages had been legally ended. Most of them were believed to be carried out in the traditional style, a simple declaration by the husband that he wanted to end the marriage, acknowledged by the wife's signature. The paper commented that this was probably the world's cheapest and easiest dissolution of marriage—no lawyers necessary nor even a fee for registration of the document. It was even simpler before World War Two, when the wife's signature could be dispensed with. In those days, a woman could literally be put out on the street with a small cash settlement, and even this was not a strict requirement. Custody of children was no problem; under general Japanese law they were and still are the property of the father.

Close observers, looking at Japan's conformity to the modern world, see only such modifications in the native sexual manners and patterns. The music may today be electronic, the

sake may have a rival in Scotch, but the sexual games are the same, and the desires of the male remain dominant. There are surface changes, a cynical bow to Western morality, yet the deep roots of social tradition continue to survive.

Mrs. Aiko Noda, a judge in the Tokyo Family Court, put money problems and drunkenness at the top of the trouble list among blue-collar couples. In higher-income marriages, she said, social change and the tensions of urban life are generating more problems. A big factor in Japanese divorce, she said, is the increasing rebellion of wives against the rule of the husband's mother, once the supreme domestic dictator.

How much of the hedonism of the past still exists?

An entertainment guide to Japanese night life presents advice about modern Japanese girls available for the tourist who thinks of himself as a sensualist.

> Japanese woman is a national treasure. At her best, she is a living art form ... and much too good to be true. But she *is* true.... Japan puts armies of young women to work in factories and offices, but it also employs thousands more like lilies of the field, neither to toil nor spin, but mainly to gladden the heart and beautify the scene ...

The writer describes the club hostess as a second cousin to the traditional geisha, and points out that Tokyo has 10,000 bars and cabarets. He assures the tourist that the Japanese office worker spends an hour or so lingering with one of the girls on his way home. In the evening every businessman entertains his clients at one of these spots and many a girl there expects to be asked to spend the night with the visitor. The tourist is assured that the charmer is both "a nice girl and a courtesan," and she is described in traditional terms:

A *maiko* slips into geishahood around 20, and then may acquire
a patron. He must pay for both the girl and her costumes.

According to the guide, if he can support her only part-time,
she delivers to her close girl friends a bowl of rice dyed red,
which indicates that she will still be going out on parties. If
she offers white rice instead, her partying days are past, and
she will go only with her patron.

The sound of the samisen is now usually heard only on tape,
projected from the wall in a bastard version of Muzak. The
Ginza showgirl meets you at the bar wearing slacks. The call
girl looks as if she came from Hollywood and most likely has
never heard of the Yoshiwara. Modern Japanese men in the
cities go now to a *sutorippu* (strip joint) where the dance is
from Minsky's and the rock-parlors of the Los Angeles Strip.
Not from Kabuki and the Noh dramas of the ancient courts.
The Beatles' din is on the soundtrack as the guests dance the
newest dance fads. Gone are the voices of the Danjuros, for
generations the most famous dynasty of actors in Japan.

How true is the old saying, "A king can be known by the
state of the dancing in his kingdom."

Even the Sunday travel sections of American newspapers
no longer devote themselves just to luring the traveler to see
Japan's cherry blossoms, the temples in *mujo no kaze* (the un-
certain wind), and the places to eat with chopsticks. They are
selling Japanese sex hints, modern versions of the courtesan
and geisha, and the clubs that have replaced the Yoshiwara.
Here are some excerpts intended to lure the tourist to the hot
spots of Tokyo:

The nightclub rises like some ornate pagoda... just down the
street from the New Japan Hotel. It is three levels of... Japan's

prettiest butterflies. There is a cover charge at the outset of 1,300 yen... The butterfly sharing your company sips fruit juice at 400 yen... So long as you bring along your credit card you may remain till closing time.

In the bar in the basement of a noted theater building, the dolls are forbidden to sit with the customers. Instead, they stand before them... gowned in micro-minidresses with slits up the side, lace stockings and silver pumps...

This club is known as a tea room, and the tourist writer confides that after hours one of the Rumiki "twitched" for him, noting that the girl said, she was "twitching" to support a sick mother.

Another of the favorite haunts is a huge place, gaudier than its American namesake. "Girls in mini-togas chatter away, smiling and snuggling while a combo plays rock tunes."

At another spot, a girl swings on a trapeze over the drinking customers. As one sporting customer put it, "Tokyo is a town where a young man wishes desperately he could remain young forever, and those of us who are older wish, wistfully, we could be young again. Just for one night."

The object, as in the old Yoshiwara, is still song, food, drink, and sex. But gone is the native grace—*Fumizuki* (the Poem Month), the traditional *romei* (my dew-like life) music, the calm and dignity of ceremony, the leisure and contemplation of beauty of the green-tea houses. The unknown poet wrote:

> If I could make
> This night of autumn
> Become a thousand nights.
> So many sweet words
> Remain unsaid...

The fine creatures drawn by Utamaro and Kiyonaga are gone. Their idealized beauty exists today only on paper. The modern Japanese prostitute has adapted herself to apartment life, to her new environment. Her body has changed shape through exercise, and sports, diet and the exigencies of Western-style clothing. In general, gone from everyday life is the kimono, the ceremonial symbols of the tea service, the poetry of the slow walk, the respectful bow. Japanese women have become taller, but not more graceful. The tiny historic delight has become the sweaty tennis partner. The five-dollar surgeon has altered the almond-shaped eyes by snipping the epicanthic fold of the lids.

As one Tokyo doctor proudly put it: "Since the war, Japanese women have begun to develop in most highly satisfactory ways. The breasts, for centuries bound by tight body-punishing clothes, are fuller and the hips are becoming pronounced."

And his memory is of the streets of Yoshiwara.

> Dream of spring
> When the streets
> Are scattering
> Cherry blossoms...

And a lady at an ancient court, writing of the sexual games of her time, recorded with a lost grace:

One is awakened in the middle of the night by the voice of a gentleman who has come to pay a secret visit to a lady in the house. One cannot make out what they are saying to each other; but one hears a man laughing softly, which is delightful and excites one's curiosity.

This sense of ease, of leisured pleasure-taking, is gone. The detailed amorous rituals have been perverted to a basic cash-on-the-line, with no nonsense, poetic or otherwise, about the sex trade. Yet even the natives wonder just how much Japan can really change its sensual habits, or if it wants to.

This book is dedicated to the best of editors, ELLIOTT W. SCHRYVER
To whom this book owes so much
And with whose wisdom, skill and love it comes into being.
Thank you, Godfather, San.

Published by Tuttle Publishing, an imprint of Periplus Editions (HK) Ltd.

Library of Congress Cataloging-in-Publication Data for this title is in progress.

ISBN: 978-4-8053-1543-9

Distributed by

North America, Latin America & Europe
Tuttle Publishing
364 Innovation Drive
North Clarendon, VT 05759-9436 U.S.A.
Tel: 1 (802) 773-8930;
Fax: 1 (802) 773-6993
info@tuttlepublishing.com
www.tuttlepublishing.com

Japan
Tuttle Publishing
Yaekari Building, 3rd Floor
5-4-12 Osaki
Shinagawa-ku
Tokyo 141 0032
Tel: (81) 3 5437-0171
Fax: (81) 3 5437-0755
tuttle-sales@gol.com

Asia Pacific
Berkeley Books Pte. Ltd.
3 Kallang Sector, #04-01
Singapore 349278
Tel: (65) 6741 2178; Fax: (65) 6741 2179
inquiries@periplus.com.sg
www.periplus.com

ABOUT TUTTLE
"Books to Span the East and West"

Our core mission at Tuttle Publishing is to create books which bring people together one page at a time. Tuttle was founded in 1832 in the small New England town of Rutland, Vermont (USA). Our fundamental values remain as strong today as they were then—to publish best-in-class books informing the English-speaking world about the countries and peoples of Asia. The world has become a smaller place today and Asia's economic, cultural and political influence has expanded, yet the need for meaningful dialogue and information about this diverse region has never been greater. Since 1948, Tuttle has been a leader in publishing books on the cultures, arts, cuisines, languages and literatures of Asia. Our authors and photographers have won numerous awards and Tuttle has published thousands of books on subjects ranging from martial arts to paper crafts. We welcome you to explore the wealth of information available on Asia at www.tuttlepublishing.com.

First edition
24 23 22 21 20 19 6 5 4 3 2 1 1909CM

Printed in China